250/
IVIN

D1024805

THE GERMAN BAROQUE

Literature, Music, Art

THE GERMAN BAROQUE

Literature, Music, Art

EDITED BY

George Schulz-Behrend

Published for the Department of Germanic
Languages of The University of Texas at Austin
by the University of Texas Press, Austin & London

Library of Congress Cataloging in Publication Data

Main entry under title:

The German baroque; literature, music, art.

"Four of the five papers presented here were read on November 13–15, 1967, at a symposium sponsored by the Department of Germanic Languages of The University of Texas at Austin."
Includes bibliographical references.
1. The arts, Baroque—Germany—Addresses, essays, lectures. 2. The arts, German—Addresses, essays, lectures. I. Schulz-Behrend, George, 1913– ed. II. Texas. University at Austin. Dept. of Germanic Languages. III. Title.
NX550.A1G4 709'.43 70–38923
ISBN 0–292–70703–7

Composition and printing by The University of Texas
 Printing Division, Austin
Bound by Universal Bookbindery, Inc., San Antonio

CONTENTS

ILLUSTRATIONS

PREFACE

Four of the five papers presented here were read on November 13–15, 1967, at a symposium sponsored by the Department of Germanic Languages of The University of Texas at Austin. This meeting, ninth in a series still continuing, was entitled "The German Baroque," and its subtitle, "Literature, Music, Architecture," was intended to point out that this symposium, like preceding and subsequent ones, meant to look beyond the traditional fields of language and literature in its interpretation of German culture. Unfortunately, circumstances beyond the control of the editor prevented publication of the lecture on architecture, and a paper on art is published here in its place. Moreover, a series of untoward events delayed the publication of the papers until now.

The editor is, of course, aware of the fact that four or five lectures can do no more than afford a glimpse of an extensive landscape whose exploration could well occupy the better part of a lifetime. The lectures as delivered at the time had a stimulating effect on university audiences. It will be of value to have them in printed form, for they present, in varying degree to be sure, the results of original research, and thus satisfy the superficially different but ultimately congruent requirements of the interested student and of the widely read and experienced specialist. During the symposium further interchange of ideas took place in discussion groups where scholars, veterans and tyros, guided by expert moderators, discussed

the various aspects of the lectures. Unfortunately no transcripts of these discussions can be published here.

Throughout the volume the term *baroque* is used pragmatically and no attempt has been made to circumscribe it, nor will the editor try to fit the contents of the various papers into the Procrustean bed of such a definition. During the twenties and thirties of our century he could not well have escaped the attempt, for that was the time when scholars felt under obligation to subsume the myriad cultural phenomena from about 1600 to 1750 under one heading—the recently reevaluated concept of the baroque. German baroque specialists at that time were eager to defend the baroque against detractors who readily denigrated the era as gaudy, undisciplined, dishonest, and lacking in good taste. General defense of the baroque has yielded to close investigation of specific phenomena and, in the wake of this trend, baroque studies have gained support in the English-speaking world to a relatively greater extent than among the Germans themselves.

The editor has refrained from paraphrasing the contents of the papers. This device, though time-honored, interposes at best an unwarranted curtain between author and reader.

GEORGE SCHULZ-BEHREND

GERMAN ALEXANDRINES ON DUTCH BROADSHEETS BEFORE OPITZ

BY LEONARD FORSTER

Cambridge University

We have all been taught that Martin Opitz brought about the reform of German poetry in 1624 with his *Buch von der deutschen Poeterey* and *Teutsche Poemata*. We know of what this reform consisted: The main achievement was to make verse ictus coincide with word stress, and this was exemplified by the use of Romance verse forms like the Alexandrine and stanzaic forms like the sonnet and the ode.

One of the questions that no one has so far explicitly answered is: How long did it take for this reform to become generally accepted? How long do we have to wait before we find, for instance, Alexandrines being written by people who were not personally acquainted with Opitz—people who, for instance, do not appear in Zincgref's *Auserlesene Gedichte deutscher Poeten* in 1624? One would need to discount those who are known to have been working in the same direction independently of Opitz, some of whom had produced Alexandrines before 1624—Henrich Hudemann, Martin Ruarus, Johann Plavius, Tobias Hübner, and Dietrich von dem Werder, quite apart from the very isolated early case of Johann Engerd. There is also the odd case of Caspar von Barth, who knew Opitz at Heidelberg, but whose *Deutscher Phönix* (1626) is provocatively un-Opitzian.

There is a task for a bibliographer here, but the data available in Goedeke and Faber du Faur suggest that among Opitz's non-Silesian contemporaries only August Buchner actually published work in Alexandrines between 1624 and 1630. Buchner worked in Wittenberg and did not know Opitz personally, though they had friends in common and soon maintained a friendly correspondence. They did not meet until the summer of 1625. Buchner was interested in metrical questions and evidently seized upon Opitz's prescriptions eagerly, for he exchanged Alexandrines with him as early as 1624, and in the same year another poem shows that he had become converted to Opitz's doctrine of accentuation.[1] It was not until 1634 that the *Buch von der deutschen Poeterey* went into a second edition; there were four editions in that year and one further edition in each of the years 1635, 1638, 1641, 1645, 1647, 1658, 1690. These figures seem to suggest that for Opitz's contemporaries one edition was enough, but that a younger generation felt the need of more intensive study of the acknowledged textbook of the poetic art. This is a rather peculiar state of affairs. It gives rise to a further suggestion that for Opitz's own contemporaries what he said was not completely new; the principles expressed briefly and clearly by Opitz could be immediately understood and put into practice. Paul Fleming and his friend Georg Gloger in Leipzig, without contact with Opitz, were already writing Opitzian verses in 1630 when they were still students, without the aid of a new edition of the textbook.

The *Buch von der deutschen Poeterey* had been published at Breslau and evidently had an immediate success in Silesia. It was through his friendship with Gloger and other Silesian students that Fleming became acquainted with the Opitzian rules. It seems to have been a matter of local patriotism among young Silesians to write like Opitz. This is a matter which still requires a good deal of investigation, but there can, I think, be little doubt that it was partly through Silesian students that the knowledge of Opitz spread.

[1] H. H. Borcherdt, *Augustus Buchner* (Munich, 1919), pp. 104–105.

Silesia, it will be remembered, had no university, so that promising young people were forced to study elsewhere, taking the reputation of their local celebrity with them. Thus we find Christoph Coler, a young Silesian friend and admirer of Opitz, publishing a poem in Alexandrines at Strassburg in 1628.[2] There is reason to believe, however, that in certain respects the ground had already been prepared. I shall have something to say about this later. Even so, it seems that it took between six and seven years for the precepts of the *Buch von der deutschen Poeterey* to become generally known and recognized outside Silesia by a generation younger than that of Opitz. All things considered—the state of communications, the military operations, and Opitz's own absence for a time in Transylvania—that was not a very long time. It would be interesting to find out whether Gottsched established himself as quickly as this. Fleming and Gloger were what we would nowadays call forward-looking young intellectuals, whom one would expect to be abreast of the latest movements; they were twenty-two years old. It is thus surprising to find that in an entirely unintellectual genre there were anonymous writers turning out passable Alexandrines for popular consumption considerably before this.

Hans Michael von Obentraut (1574–1625), a successful cavalry general in the Palatinate army, took service with the Danish army in 1625, and, after a spectacular action in lifting the siege of Nienburg in September of that year, was killed in battle against Tilly's troops in Seelze on 25 October/4 November 1625. His death was a serious blow to the Protestant cause in the Thirty Years War, and Georg Rudolf Weckherlin, hearing the news in England, wrote the following epitaph for him in pre-Opitzian style:

> Fill nicht, wer du auch bist, mit unruh deine brust,
> Daß ich zu meiner Ruh durch die Unruh gekommen.

[2] Karl Goedeke, *Grundriß zur Geschichte der deutschen Dichtung*, 2nd ed. (Dresden, 1887), III, 52. Another relatively early piece is Johann Christoph Gebhard Jun., *Juvenals Satyra oder Zuchtschrift der Ordnung . . . übersetzt und nach Opitzischer Poesie gebunden* (Nuremberg: S. Halbmayer, 1630).

> Dan kämpfend ritterlich und sterbend mich, mit lust
> Von meinem Vatterland, mein Got zu sich genommen;
> Daher Ich den gewin, und die Pfalz den verlust.[3]

Obentraut was killed a bare year after the appearance of the *Buch
von der deutschen Poeterey*, yet in that same year a broadsheet
appeared, probably in Heidelberg, and at all events certainly in
connection with the Electoral Court, in regular, almost Opitzian
Alexandrines:

Ewig lobwürdige Ehrengedechtnuß des recht-Edlen thewren Teutschen
 Helden/
Herren Obristen Hans Micheln von Obentraut/ auß der ChurPfaltz/ &c.
[Engraving, showing Obentraut lying dead on the battlefield]

Schaw Teutscher Adel/ schaw/ vnd schawt jhr Herren zu gleiche/
Ja schawt jhr Teutschen all im Heilgen Römischen Reiche;
 Schawt an/ schawt an mein Leich/ die Tilly gfangen helt/
 Vnd mich zum spectacul euch für die nasen stellt.
Tilly hat zwar mein Leich in seinem zwang vnd gwalte/
Aber der liebe Gott/ an den ich mich steiff halte/
 Der hat mein seel vnd geist/ der Leichnam ghört der Erd/
 Daß er widrumb zu staub / vnd wenig äschen werd.
Mein Namm von Obentraut/ mein Waapen vnd Kleinothe/
So ich durch göttlich Gnad erhalten biß in todte/
 Bey der posteritet bleibt ewig vnversehrt/
 Auch bey den Feinden selbs wol g'achtet vnd geehrt.
Solchs gwinnt ein redlich Hertz/ das trew an seinem Herren/
Vnd sich von jhm nicht wolt zu jemandt anders kehren.
 Der Namm eins frommen Manns ist aller Ehren wärth.
 Ein fauler Mamaluck ist ein flûch auff der Erd.
O weh der losen Rott/ die Spannisch gelt gefressen/
Vnd seind zur Widerparth wie Judas nider gsessen.
 Die straaf kompt auch mit hin/ meyneyd hat kein bestand/
 Es sey zu welcher zeit/ oder in welchem Land.

[3] Georg Rudolf Weckherlin, *Gedichte*, ed. H. Fischer, Bibliothek des Literari-
schen Vereins Stuttgart, no. 200 (Tübingen, 1895), II, 300.

Meinn Feind hab ich verfolgt/ vnd war bey mir kein schimpffe/
Sůcht weder bey klein Hans/ noch auch bey groß Hans glimpffe.
 Mein König war mir lieb/ und das gantz Vatterlandt/
 So leyder/ Gott erbarms/ jetz steht in disem standt.
Der Spannier trotzt vnd pocht/ vnd tritt Teutschland mit füssen/
Alß wann sich alle Landt jhm vnderwerffen müssen.
 Das that mir schmertzlich weh/ vnd macht mir angst vnd bang/
 Daß ich im Vatterlandt solt sehen solchen zwang.
Ach hett meins sinns gehabt die gantz Teutsch Ritterschafft/
Vnd hette Gott der Herr geben sein gnad vnd krafft/
 Man hett der Lieben Pfaltz/ vnd andrem Teutschen Landt
 Nicht anthůn sollen den spott/ vnd vnerhörte schandt.
Nun hat vns Gott gestrafft/ der wirdt sich auch erbarmen/
Vnd widrumb schaffen raht den vndertruckten Armen.
 Keiner poch auff sein glück; Gott ist im Himmel g'recht/
 Der seinem Völcklin hülf[ft vnd] rett sein trewen Knecht.

<div align="center">1625.</div>

<div align="center">[Kurpfälzisches Museum, Heidelberg, Kupferstichkabinett 113.]</div>

This is well in advance of the general reception of the Opitzian reform in literary circles. The explicit references to the Palatinate suggest that the anonymous author was in contact with the circle around Lingelsheim and Gruter in which Opitz moved; he may even have been Zincgref himself. However this may be, he was writing for a wide popular audience which could evidently be expected to appreciate poetry in this meter. The same holds for the author of another anonymous broadsheet, dated 1629, *Schampatas Der Liestigen Buhler Spießgeselle,* preserved in the library of the British Museum [pressmark 1750.b.29(118)] and reprinted in Appendix A, below. By 1631, Alexandrines in broadsheets had become frequent; but even these, as we saw, are abreast of developments on the higher literary levels.

 The battle of Breitenfeld, in which the Imperial forces under Tilly were defeated by the Swedes under Gustavus Adolphus, took place in 1631. On the Protestant side this was felt to be fit revenge

for Tilly's brutal sacking of Magdeburg earlier the same year. Both
events called forth poems by reputable poets—the sack of Magde-
burg elicited one by Opitz. They were also celebrated in a number of
broadsheets. An anonymous Protestant publisher reprinted the texts
of eight broadsheets, without the engravings which had originally
accompanied them, in 1631.[4] Magdeburg was stormed in May;
Breitenfeld was fought in September. The poets must have worked
quickly. And yet these verses, put into the mouth of Tilly, run
easily and have an Opitzian ring:

> Wer seiner stärcke trawt/ prangt mit viel steten siegen/
> Wil sich nit für der macht deß großen Gottes biegen/
> Vnd fast bey guter Zeit jhm gar zu hohen Wahn/
> Der komm vnd sehe mich/ Ach mich! jhr Menschen an.
> Das Glück hat nie so wol gegeben zuverstehen/
> Wie schnell vnd vnverhofft die Stoltzen vntergehen/
> Als ich jetzt zeugen muß. Den[n] ich mit frevler That
> Veracht/ schawt nun mein End. Worzu geholffen hat
> Mein frecher Vbermuth/ daß ich mich auch verwegen/
> Ich könte Könige zu meinen Füssen legen . . .

and so on for 128 lines. Of the eight items in the reprint, five are

⁴ *SechBerley gantz newe ankommene AVISO, I. Seltzames Gespräch/ zwey
frembder Nationen/ eines Lap- vnd Irrländers/ so im Schwedischen Feldlager
einander vnversehens angetroffen/ vnd solches vom Zustand jetzigen Kriegswesens
gehalten. II. Dreyfach beschriebenes Confect/ von Kön. Maj. in Schweden und
ChurSachsen dem General Tylli vnd seinen Näschern bey Leipzig auff einer Breiten
Taffel vorgesetzet vnd gesegnet. III. TYLLIUS POENITENS, Tyllischer Judas-
Buß/ vnd darauff erfolgete Absolution nach allen dreyen Päpstlichen stücken/ als
Rewe/ Beicht vnd Gnugthuung/ gethan vnd empfangen nach erlittener Leipziger
Niederlage. IV. Schwedischer Postbott den verlornen Tylli zusuchen. V. Der
Magdeburgischen Dame klägliches Beylager. VI. Magdeburgica puella dormiens,
das ist/ Nicht todes sondern schlaffendes Magdeburgisches Mägdelein. Alles mit
Teutschen Reymen zierlich beschrieben/ vnd aus vnterschiedenen particularien, so
alle lustig vnd kurtzweilig zu lesen/ de novo zusammen getragen vnd Gedruckt im
Jahr 1631.* Copy in Cambridge University Library. Other poems in Alexandrines
on the battle of Breitenfeld and subsequent events in Julius Opel and Adolf Cohn,
*Der Dreißigjährige Krieg: eine Sammlung von historischen Gedichten und Pro-
sadarstellungen* (Halle, 1862), nos. 45, 53, 61, 65– 68, 71. See also W. A. Coupe,
The German Illustrated Broadsheet in the Seventeenth Century, 2 vols. (Baden-
Baden, 1967), I, 193.

in Alexandrines. Not all are as good as these; some are pre-Opitzian in character.[5] Breitenfeld is close to Leipzig, and the reprint was probably produced at Leipzig, as were doubtless some of the original broadsheets. Perhaps it is no coincidence that at that time Fleming and Gloger (and, for all we know, others as well) were already writing Alexandrines in Leipzig. The fact that Alexandrines appear on broadsheets suggest that, rather than just a group of avant-garde students writing new verse, there existed an audience able to appreciate the new verses, as well as the traditional *Knittelverse*, of which the anonymous publisher also included specimens in his reprint. The public was obviously a wide one and presumably not composed only of people interested in new poetic techniques.

This publication does not stand alone. From 1631 onward the Alexandrine takes its place beside the *Knittelvers* as the vehicle of political and social comment in broadsheets, especially in those put out in great numbers by Paulus Fürst of Nuremberg, whose activity begins in 1635.

Here we see how the reception of the Opitzian verses in popular literature runs parallel with their reception in formal poetry, to a surprising degree. The extent to which the broadsheet was a recognized literary vehicle in the seventeenth century still needs to be

[5] For instance, the beginning of the *Dreyerley Sächsisch Confect* in *Sechßerley ganz newe ankommene Aviso*; these verses, for reasons which appear later, are almost more interesting than the more Opitzian ones:

> Es war ein starcker Tisch in einem Breiten-felde
> Vnd stunden hart darbey zwey fromme Tapffre Helde/
> Confect war drauff gesetzt so Edel zugericht/
> Daß man fast weit vnd breit dergleichen findet nicht.
> Nemlich *Religio* vnd *Regio* darneben/
> Freyheit vnd *Dignitet*, Gut/ Blut/ ja Leib vnd Leben/
> Da kam ein frecher Mann/ vnd wolte diß Confect
> Aus lauter Geitz vnd Haß vom Tische nehmen weg.
> Die Helden schaweten/ wie mit raubrischen Händen
> Er in geschwinder eyl zugrieff an allen Enden/
> Darumb der eine kam sehr eyffrig vnd geschwind/
> Nahm eine Schal' vnd schlug dem Räuber auff den Grind.
> Der ander sahe/ daß er billich war geschmissen/
> Vnd schlug ingleichen zu frewdig mit gutn Gewissen/
> Biß daß der Räuber ward erschrocken vnd verzagt/
> Vnd endlich Ritterlich ins freye Feld verjagt.

investigated. Much of the formal poetry of the period was "Ge-legenheitsdichtung," first published in a form which often barely differs from the broadsheet in that it consists of a folio leaf printed on one side only. The same leaf folded twice and printed on both sides gives the octavo pamphlet which was the favorite vehicle of the time for verses by reputable poets on dynastic, national, or family occasions.

I would now like to cast a glance backward to the period before Opitz.[6] Here, too, there are parallels between the broadsheet litera-ture and the experiments of poets properly so called. Here too it is a question of the use of Romance verses, the Alexandrine, and the *vers commun.*

In general, Romance verses (*vers communs*, Italian hendeca-syllables) and stanzaic forms (the madrigal, the villanelle, etc.) are used successfully in German at this time only when they are sup-ported and accompanied by music. Jakob Regnart, Christoph von Schallenberg, the anonymous author of the *Raaber Liederbuch*, Theobald Hock, can write songs to existing melodies. The only s p o k e n v e r s e they can use is the *Knittel*. This is quite clear in Regnart and Schallenberg. The music helps them to overcome what for them was evidently the most difficult technical hurdle in the use of the new verses—counting syllables and placing stresses. The same is true of Ambrosius Lobwasser's version of the Huguenot metrical psalms; he sticks to the melody, and, with the aid of the melody, he can reproduce the meters used by Marot and de Bèze. Paul Schede Melissus's version of the Psalms was evidently intended not only to be sung but to form the subject of private meditation (hence the prose translation of the Hebrew text which he appended to each psalm) and also therefore to be spoken. Melissus further produced one impressive Alexandrine sonnet.[7] His memory was

[6] The rest of this paper runs parallel with the argument in my publication, *Die Niederlande und die Anfänge der Barocklyrik in Deutschland* (Groningen, 1967) and uses some of the same material.

[7] Printed in *Auserlesene Gedichte Deutscher Poeten gesammelt von Julius*

respected in Heidelberg, but the influence of his German poetry was slight. Until the advent of Opitz the *Knittel* held the field.

Coupe has observed a gap of about ten years in German broadsheet publication—from the aftermath of the battle of the White Mountain to the appearance of Gustavus Adolphus.[8] Opitz's *Buch von der deutschen Poeterey* falls in the middle of it. In this work Opitz elaborated, codified, and rationalized existing poetic practice in the circle at Heidelberg in which he had become the leading spirit. This circle, through Georg Michael Lingelsheim, Opitz's patron, was in close contact with Palatinate policy. Opitz himself had written and published a Latin oration on the Winter King. There was a mass of broadsheets on the Palatinate side, mostly originating in Prague but many in Heidelberg as well. Despite the interest in Romance forms which distinguished the Heidelberg circle, I have found no broadsheet about the Winter King or his affairs written in Alexandrines or *vers communs*. They are either in *Knittelvers* or in stanzaic forms to well-known tunes. Opitz himself, it will be remembered, observed ruefully that during his time in Heidelberg his verses were being sung without his permission on street corners.[9] This in itself is significant: They were acceptable to the public because they were accompanied by music. In the eventful years from 1618 to 1620 Palatinate propaganda hardly used the Alexandrine, even though, as we know, it was being practiced with considerable success in Heidelberg in circles connected with high policy. There were, however, political broadsheets in those years which did use German Alexandrines. They originated in the Low Countries and had nothing at all to do with Opitz.

The Netherlands, both South and North, had adopted the Romance forms very much earlier. As a result of intensive experiment

Wilhelm Zincgref, 1624, W. Braune ed., Neudrucke deutscher Literaturwerke des XVI. und XVII. Jahrhunderts, no. 15 o.s. (Halle, 1879), p. 13.

[8] W. A. Coupe, *The German Illustrated Broadsheet*, I, 75.

[9] A. Reifferscheid, *Quellen zur Geschichte des geistigen Lebens in Deutschland* (Heilbronn, 1889), I, 316.

in literary circles, the public in Holland was able to appreciate
topical sonnets on political events as early as 1600. There is no
need to insist on the importance of Daniel Heinsius's verses in the
development of Opitz's practice; but it seems that there were others,
earlier than he, who were able to write Alexandrines on the Dutch
model. I do not wish to deal here with the extremely interesting
and important case of the German translations of Jonker Jan van
der Noot in the 1570's. I want to consider broadsheets only.

Let us start just after the middle of the sixteenth century with
the Antwerp *rederijkers* Willem and Godevaert van Haecht who
designed a number of engravings which appeared as broadsheets.
The *rederijkers* were the Dutch equivalent of the mastersingers.
Willem van Haecht was born in 1527 and held office in the Ant-
werp Chamber of Rhetoric, "De Violieren," in 1558. In 1585
he fled from Antwerp, apparently to Germany, and disappeared
from view. He was the author of some versified psalms and of one
or two dramas. Godevaert was born in 1546 and died at Deutz in
1599. He was an artist and a member of the guild of St. Luke; he
is chiefly remembered for his Chronicle of Antwerp in the years
1565 to 1574. He was the nephew of Willem van Haecht. Both
were Lutherans.[10] They were closely associated with the well-known
Wierix family of Antwerp; three Wierix brothers were accomp-
lished engravers.[11] The result of this association was a number of
symbolic prints, the designs seemingly furnished by one or both of
the van Haechts and the engraving done by one of the Wierixes.
As the van Haechts were Lutherans, they naturally thought of selling

[10] On the family of van Haecht see A. von Wurzbach, *Niederländisches
Künstler-Lexikon* (Vienna, 1910), I, 628; U. Thieme and F. Becker, *Allgemeines
Lexikon der bildenden Künstler* (Leipzig, 1907–1950), XV, 424; Jan te Winkel,
De Ontwikkelingsgang der Nederlandsche Letterkunde (Haarlem, 1922–1927),
II, 482; R. van Roosbroeck, ed., *De Chroniek van Godevaert van Haecht* (Ant-
werp, 1929); J. van Roey, "Het Antwerpse geslacht van Haecht [Verhaecht],
tafereelmakers, schilders, kunsthandelaars," in *Miscellanea Jozef Duverger* (Ghent,
1968), I, 216–218.
[11] On the Wierix brothers see Wurzbach, II, 879; L. Alvin, *Catalogue raisonné
de l'oeuvre des trois frères Wierix* (Brussels, 1866); Thieme-Becker, *Allgemeines
Lexikon*, XXXV, 537.

their products in the neighboring Lutheran parts of Germany. The prints are frequently accompanied by illustrative text, often in four languages—Latin, Dutch, French, German—in verse. The Latin verses are usually elegiac distichs, the French are *vers communs*, the Dutch are *rederijkersverzen* (a free *Knittel*, often with internal rhyme). The German verses are *Knittel*, sometimes strict (four beats, eight syllables), sometimes free (four beats, varying number of syllables, up to twelve or fourteen); they contain a number of Dutch features in spelling and in vocabulary. No indication is given of who was responsible for the texts, but, as they are engraved on the plate, it is probable that they originated in the workshop of the van Haechts or in connection with it. Similar engraved verses, with similar Dutch peculiarities, are also found on the famous views of cities produced by the Netherlander Frans Hogenberg, who was working at this time in Cologne. The commercial relationship between Antwerp and Cologne is clearly reflected in this circumstance as is the religious connection of the van Haechts with Germany. Most of these prints are undated. One of the series of Vices and Virtues bears the date 1579; another allegorical print, the *Arbor Religionis*, has been dated, on internal evidence, in 1565.

The Dutch verses are the characteristic Dutch variety of free *Knittel*, as one would expect from the *rederijker* Willem van Haecht; the German free *Knittel* often tend to have twelve or thirteen syllables and an iambic rhythm. The free *Knittel* was not commonly used in Germany on broadsheets, and verses of this length are comparatively rare; the strict *Knittel*, with which we are familiar from Hans Sachs, was much commoner. In the Netherlands the free *Knittel* fell into a well-known category; they were called *hollandsche maet* and were very common indeed.[12] A verse could thus be produced which had twelve syllables with a caesura after the sixth and which was apparently meant to be read with four beats, but which could be read with six; one might call such verses

[12] F. K. H. Kossmann, *Nederlandsch Versrythme* (The Hague, 1922), pp. 29–31.

involuntary Alexandrines. Here is an example from the eighth of
the series of Virtues and Vices, dated 1579:

> Durch aynes minschen Sundt sind wir des todts gestorben
> Aber durch Christum Leben vnd gnad erworben.

The first line reads like a fairly good Alexandrine, but the second
line of the couplet shows that this can hardly be intentional. There
is a similar case in reverse on another print (one of the seasons):

> Der wol mist und sehet wirt wol zshnijden han
> Aber ein gutter augst es al verbeßeren kan.

The print, *Arbor Religionis*, studied by C. G. N. de Vooys,[13] bears
a text of eight lines of free *Knittel* of ten to fifteen syllables; the
Dutch verses are also free *Knittel*, without internal rhyme. It is
noticeable that both Dutch and German texts observe the alternation
of masculine and feminine rhymes, suggesting some contact with
the usage of the Pléiade; oddly enough there is no alternation in the
French text.

Arbor Religionis.

> Laet Gods ordonantie wercken door den Tijt,
> Den boom der religien sal weder groeijen,
> Dus geestelijck ende weerlijc, wie dat ghij sijt,
> Vertreet discoordt met ghewelt, en wilt v moeijen.
> Met liefde en Trouwe, den Tijt sal af snoeyen,
> Die vuil Coruptien, dier op syn verbreyt,
> Al wat god niet gheplant en heeft sal hy wt roeyen.
> Maer gods woordt sal blijuen in der eewicheyt.

> Last nur, gottes ordnung durch den zeyt arbeyden recht
> Der Religions baum sol widder zo wachsen ahnfangen.
> Derhalben geystlich vnd weltlich fon was geschlecht

[13] C. G. N. de Vooys, "Een allegorie van Willem van Haecht," *Oud-Holland,*
XLV (1928), 147–158, with illustration; since reprinted in C. G. N. de Vooys,
Verzamelde Letterkundige Opstellen, Nieuwe Bundel (Antwerp and Amsterdam,
1947), pp. 37–38.

Vertrettet zweyspalt mit gewalt fleyssich wolt ahnhangen
Liebe vnd Trow den zeyt wirt wol affschniden
Das stinckendt vnflat, So sich darauff hat gespreyt
Al was Godt nicht gepflantzet hatt wil ehr nicht liden
Aber gottes wort wirt pleyben in der eewichkeyt.

Si au vouloir de Dieu nul ne contreuencoit,
Larbre de Pieté en ce temps floriroit.
Vous donc spirituels, et temporels aussy
Dechassez le discord, et la force dicy.
Par foy et Charité: lors le Temps purgera,
L'orde corruption, quil y rencontrera.
Ce que Dieu n'a planté defaudra, en tout lieu,
Mais tousiours durera la parolle de dieu.

[Amsterdam, Rijksprentenkabinet FM. 426.]

The broadsheets produced by the van Haecht–Wierix combine thus contain German verses written in the Netherlands, apparently intended for a German public. These verses are of a kind which, though not unparalleled, was at any rate unusual in Germany at the time. We must rest content with this very modest result for the time being, for this particular line leads no further.

After the turn of the seventeenth century other broadsheets of a similar kind appear in the northern Netherlands. Now we have a combination of engraving and printed—not engraved—text. Broadsheets with text in Dutch, French, and, of course, Latin, are fairly common. In Holland, as we have seen, the general public was prepared to accept topical news set out in the form of the Alexandrine sonnet; the Alexandrine was therefore no longer a vehicle of literary experiment but was widely accepted and could be used for a variety of purposes. This stage was not reached in Germany until 1625 at the very earliest.

Would the situation in Antwerp in the 1570's recur in Amsterdam? Would there be German verses produced in Holland on the Dutch model?

The Herzog-August-Bibliothek in Wolfenbüttel possesses two

broadsheets, apparently by the same anonymous artist, entitled *Die schandtliche flucht der wolfischen Papisten, veriaght van*[!] *den Schaffen Gottes* and *Die letzte fart der Bapstischen Galeien* (fig. 1), consisting of engraving and printed text. They are undated and difficult to date on internal evidence, but the style of the engraving suggests a date before 1600. The text is in German ten-syllable verses, *vers communs*, and is set in a Dutch type dating from the late sixteenth century. The unknown author of th everses uses apocope and syncope of inflectional endings in much the same way as do Schallenberg and Hock; for example, "Das sein volck mus in langr verachtung stan." There are a number of Hollandisms in the language, and the rhymes *beqwame—name* and *ericht—stifft* point to a Dutch original. It is interesting to note the attempt to maintain the alternation of masculine and feminine rhymes, as in the case of the broadsheet by Willem van Haecht. There is an earlier version of *Die letzte fart* in the Stadtbibliothek Ulm under the title of *Die letzte Reiß des Bapstes Galea* which has a German text, in prose, apparently going back to the same Dutch original as the German verses. Unfortunately I have so far been unable to trace a Dutch version of either of these two prints. The verse texts are reprinted in Appendixes B and C, below.

Both prints have a generalized anti-Catholic tendency, which would be welcome to a Protestant public without reference to any specific event. Though it is clear that they arose in the context of the religious wars in the Netherlands, and more particularly of the Twelve Years Truce—although W. A. Coupe suggests to me that the "Frantzoisisch vertrag" mentioned in the second stanza of *Die letzte fart* is the Treaty of Vervins in 1598—what the prints express is Protestant triumph over the Catholic party, in general terms. They would therefore be as acceptable to German as to Dutch Protestants, the more so as I find nothing either in the texts or in the engravings which touches upon the differences between Lutheran and Reformed.

The Stadtbibliothek Ulm possesses an engraving concerned

with the affairs of the Netherlands accompanied by a printed text in German *Knittelverse* dated 1607 [pressmark K 76, Einblattdrucke 3316]. The engraving consists of a central panel flanked by two others; each panel has an engraved legend in German verse. The verses are couplets, one consisting of ten, the other twelve, syllables. Though the placing of the caesura is clumsy, the intention evidently is to produce German Alexandrines:

> Des Papsts Gesanten, strik, vnd Anschlag sindt gericht
> Das er dich fang, o Belgisch' Lew, vertraw jhm nicht.

or:

> Der Morder gibt sein leib um ein gering gewinn,
> Stetz Friden rufft, hat doch nur eitel Krieg im sin.

The engraving is concerned with Maurice of Nassau and the continuing negotiations for the Twelve Years Truce which were finally concluded in 1609.[14]

In 1615 there appeared a broadsheet in three parallel versions: *La Boutique du grand Pontif Romain ses effects et opositions— De Winckel van den grooten Hooghe-Priester van Roomen/ syne Werckinghen/ ende teghenstellinghen—Der Kram des Romischen Papst, sein werck vnd furnemen.*[15] The French version is evidently the original; the Dutch uses the same engraving and the text is obviously based on the French. The German version (fig. 2) is only a fragment; the engraving is a copy in reverse, larger in size, and the text is arranged differently. The broadsheet was called forth by the Jülich-Cleves War of Succession in 1613—a German concern, but

[14] J. Scheible, *Die fliegenden Blätter des XVI. und XVII. Jahrhunderts* (Stuttgart, 1850), Plate I.

[15] F. Muller, *Beredeneerende Beschrijving van Nederlandsche Historieplaten* (Amsterdam, 1863–1870), Supplement, pp. 144–145, no. 1309. The Rijksprentenkabinet Amsterdam uses Muller's numbers as signatures of its collection. It possesses all three versions of this print; the Dutch and French texts are complete, but the lower half of the German is torn away. I have been unable to trace a perfect copy of the German text, though it seems that the Stadtarchiv Kleve possessed a copy which was destroyed in World War II.

one which involved the United Provinces, France, and Spain, be-
sides the German states, since the succession determined whether
this strategically placed area was to be Reformed or Catholic. Our
three broadsheets are on the Reformed side; the Reformed Elector
of Brandenburg, who was one of the claimants, had called upon the
help of the States-General. All three broadsheets are the work of an
otherwise unknown "Antoine Lancel N'atache le Lion," in Amster-
dam, who claims to have "inventé et composé" the French text; the
Dutch translator addresses to him a five-line poem, which contains
the letters of his own name and from which it appears that the
Dutch text is the work of a well-known controversialist and trans-
lator, Reinier Telle. The fragmentary German text, which is re-
printed in Appendix D, below, contains no translator's name, but
the engraving bears the name Antoine Lancel and the date 1615. It
is clear that there is a close connection between the three versions.
All three texts are in verse. The French contains two Alexandrine
sonnets, "La Pucelle de Hollande" and "La Patrie," which are ren-
dered in the same form in Dutch (there are other sonnets by Telle
on record).[16] The German translator could make a show at Alex-
andrines, but he could not cope with the sonnet form. He renders
the sonnet "La Pucelle de Hollande" in sixteen Alexandrines as
"Die Holändische Jungfraw," but "La Patrie" as "Hollandt das
gemein Vatterlandt" in only twelve. They are, however, Alex-
andrines and important as such. The German translator makes no
attempt at alternating masculine and feminine rhymes and prefers
the masculine. This seems to indicate that he is a rather old-fash-
ioned writer trying hard to be up-to-date and not quite succeeding.

It is difficult to establish the precise relationship of the three
prints, owing to the differing distribution of the subject matter. The
French print, for instance, begins with the two sonnets "La Pucelle

[16] Reinier Telle (Regnerus Vitellius); see A. J. van der Aa, *Biographisch
Woordenboek der Nederlanden* (Haarlem, 1852–1878), XVIII, 49; Jan te
Winkel, *Tijdschrift voor Nederlandsche taal- en letterkunde*, III (1883), 167–
173.

de Hollande" and "La Patrie," followed by an address to the States-General by Pallas. The Dutch print begins with the speech by Pallas and puts the two sonnets at the end. The German keeps more closely to the order of the French, but several of the items are rendered in different form—for example, the speeches of the Duke of Brandenburg and Prince Maurice of Nassau, which in the French are in Alexandrine couplets, appear here in four-line stanzas of three-beat verse rhyming *a b a b*:

> So lang mir Gott das leben
> Vnd krafft verleichen thut/
> Will ich dem Spannier geben
> Gut stöß auß Helden muth/...

The poor peasants of Cleves and the Jesuits say their piece in *Knittelvers*, the Pope in *vers communs*, rhyming *a b a b*. The German translator treats his material very freely, often abridging, sometimes substituting matter of his own. In the French and Dutch texts the complaints of the peasants and shepherds of Cleves are conceived in exaggeratedly pastoral terms:

> Las! quand reverrons nous l'Ancien siecle doré
> Sous l'Estoillé pourpris richement Azuré!
> Hélas, quand pourrons-nous en repos et en ioye
> Heureux sans rencontrer nul effroy par la voye,
> Par les champestres lieux mener noz Agnelets
> Aux plaisantes chansons de noz doux flageolets...

The corresponding German passage deals with facts, hard facts, in rough *Knittelverse*:

> Ach Gott wann solls geschehen doch/
> Daß du zerbrichst das Spannisch Joch/
> Darunder mir mit Weib vnd Kindt/
> Von schwartzen Moren trenget sindt/...

There is a faint echo of the French original, but it is immediately swamped by realistic detail:

> Die wir vor diesem hatten gsungen/
> Vnd bey der Herd herumb gesprungen/
> Thun jetzund stäts weinen vnd heulen/
> Vnd klagen vnsre Eyterbeulen/
> Die vnß der Spannier gschlagen hat/ . . .

The poor shepherds, who, in the French and Dutch, express themselves in an Arcadian vein, have their minds on politics in the German version, though it is perhaps a testimony to their literary status that they are distinguished from the peasants, who speak *Knittelvers*, by declaiming in quite well constructed *vers communs*, rhyming *a b a b* (both French and Dutch have Alexandrine couplets at this point). Where the original has:

> Nerée et ses Tritons ne tempestoyent les eaux
> Æole en ses poumons cachoit ses soupiraux.
> Les oiselets de l'air deguisoyent leur ramages,
> En faisant retentir les forests et Bocages,
> Le Rossignol plaisant d'un chant harmonieux
> Recreoit mes espirits me rendant amoureux.
> Et maintenant on n'oyt que cris, plaintes et larmes.
> Par ces Monstres Hibous, et malheureux Vacarmes,

the German reads:

> O weh/ o weh ich hab es wol gedacht/
> Das der Holländisch fried vnd tugentlich anstandt/
> Vns nutzet nichts/ . . .

and goes on, with a faint reminiscence of the literary scenery of the original:

> Da bleibt gar nichts in vnserm Hauß vergessen/
> Die Nachtigal hört man jetz nirgent singen/
> Von ach vnd weh sind voll all Berg vnd Thalen/
> O weh wie lang sollen Posaunen klingen?
> O weh wie lang sollen Carthaunen knallen?

There can have been no space for the epigrammatic quatrains and the song of the Pucelle de Hollande which are present in the French and Dutch versions. The German translator has worked very freely and kept clearly in mind a German public which would not be favorably impressed by the expression of the sufferings of the poor folk of Cleves in Arcadian terms. At such points he writes very independently; his version of the shepherds' complaint, which owes very little to his model, is an impressive piece of versification for its date. We must remember that in 1615 neither Weckherlin nor Opitz had published anything in German and that there were very few available models for the use of *vers communs* in German. Furthermore, he must have been under some sort of inducement to stick to the Alexandrine couplets with which his model provided him; he, nonetheless, felt free to neglect them when he wished.[17] All things considered, it is quite an achievement. What we see here is an anonymous German, in Holland, working freely and confidently—though not always successfully— for a wide and probably mainly nonliterary public in Germany, in a medium which, in Germany, is as yet experimental, the concern of a few isolated littérateurs. This is a very remarkable state of affairs.

In 1619 an old engraving, *Den slapende Leeuw*, from the workshop of the Wierix brothers, was revived, which bears the legend "Doemen 1567 schreef, wast schade dat den Leew soo lang slapende bleef." In the familiar Wierix style there are Dutch, French, German, and Latin verses engraved on the plate. The German verses, with their Brabantisms in vocabulary and orthography, conform to the pattern known from other products of the collaboration of the van Haechts and the Wierixes in the 1560's and 1570's:

> Der Louw sclaeft ietz ohn wachen
> Der Wolff sperret auff sijne rachen

[17] Balthasar Froe, the German translator of Jan van der Noot's *Theatre oft Toon-neel*, in 1573, also renders Alexandrines by *vers communs*. See my survey "Jan van der Noot und die deutsche Renaissancelyrik; Stand und Aufgaben der Forschung," in *Literatur und Geistesgeschichte: Festgabe für Heinz Otto Burger* (Berlin, 1968), pp. 70–84.

> Der Fuchs raubt al was er wil,
> Der Hont bloft vnd ist nicht stil
> 5 Der Esel lydet last uber al
> Das schaeffleyn ist in großer quael.

The new edition, entitled *Der Niederlandsche schlaffende Louw*
(fig. 3), has a printed text attached, with 105 German Alexandrine
couplets, dated 1619. We reprint the letterpress portion in Ap-
pendix E, below. Here, too, there are apocopated inflectional end-
ings; here, too, there are Hollandisms in vocabulary and orthog-
raphy, and there is a preference for masculine rhymes. The writer
was evidently less skilled than the translator of *Der Kram des
Romischen Papst*, five years earlier, but he does not shirk the task
of producing 210 Alexandrines. The German text is clearly based
on a Dutch original (cf. the rhyme *hals—falsch*), which unfor-
tunately seems to be lost. Though it is in Alexandrines, it does not
show much of the spirit of the new age; the repeated "Nun hort was
ich euch sag" and "Hort fleißig was ich sag" are more in the admon-
itory style of the sixteenth century than in the oratorical vein of the
seventeenth, and the handling of the caesura is clumsy in the ex-
treme. Here and there, however, lines stand out which are worthy
of Opitz's early experiments a year or two before, for example,
"Der Mensch kont auch was tun zu seiner seligkeyt," or "Jene ver-
stunden nicht das Fundament der Lehr."

The old plate was brought forth again to be used against Olden-
barnevelt and the Arminians. Despite the date it seems to have
come out before the execution of Oldenbarnevelt and to be de-
signed to discredit him and his associates and to maintain the reputa-
tion of the States-General as the bulwark of Protestantism against
Spain. This last was clearly the reason for producing a German ver-
sion. Four years later another broadsheet appeared, pointing out
that the danger Oldenbarnevelt presented to the Protestant cause
had been avoided. In this case we fortunately have the Dutch orig-
inal, *Clare Af-beeldinghe, ofte Effigien, der voornaemste Conspira-*

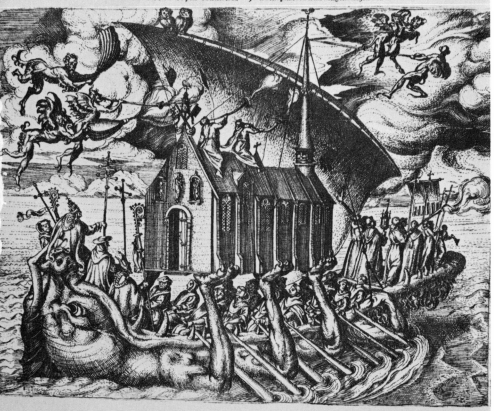

Die letzte fart der Bapstischen Galeien.

Anmerck in diese Bapsts Galeien wol, Mit dem pfennet seiner heiligen kirchen vol.

Wie wol fraute gluck uns ehre gunst anbeut
Dürch unsern Drach, dern leden thut erbarmen
Wir fürchten es kein schreckbublein für den todt
Es es nach deser frude unsr e led werde kommen
Der Frantzolisch vertreg dienet uns gar vest
Es sind noch gar zu viel geulen im leben,
Wol gelust und gerust widr unserm fest
Darum wir vor angst gantz unnutig beben.

Was sollen wir denn thun? und was fur raht?
Uns machen auff kein Hispanien zu rucken
Und stirbt den Drach, was zu geschehen staht
Ziugn von der haut uns ein galeie flicken
Mit dem sol unsre kirch werden gefurt
Unsr kauffmanschafft, Concilium zu Trenten,
Meile, und alls das uns weiter angegort
Auff das wir so da mugen aufs best bezenten.

Der Romisch Bapst soll der Schiffuhrer sein
Und furen Schiff nach in Compas seiner geletz
Die Auderleut sein der geistliche er scheur
Der pfaffen gar so in ehr bofgert mesten.
So faren wir zum land uns vhast befrimdt
Ins teuffels nam der uns wolle bewaren
Und geben den Schiff gluckhaff ig guten winde
Sonst mus es im grunde der heilen faren.

Courtesy Herzog-August-Bibliothek, Wolfenbüttel

Fig. 1. Die letzte fart der Bapstischen Galeien.

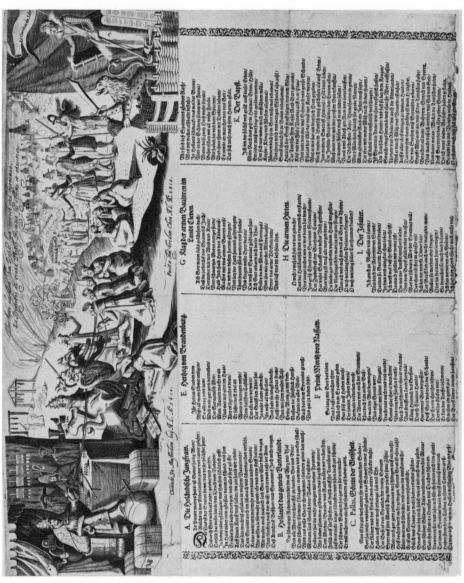

Courtesy Rijksmuseum, Amsterdam

Fig. 2. Der Kram des Romischen Papst, 1615.

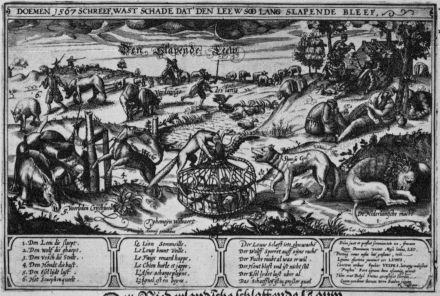

Der Niederlandsche schlaffende Louw.

Courtesy Rijksmuseum, Amsterdam

Fig. 3. Der Niederlandsche schlaffende Louw, 1619.

Fig. 4. Die enthauptete Arminianische Schlange, 1623.

teurs, staende op het lichaem van de Hoofdeloose Arminiaensche Slange. Waerin vertoont word hoe den Orangien Boom/ mitsgaders Religie ende Justitie (in spijt van't Bedrogh en den vervallen Boom) door de strael Gods/ beschermt word, dated 1623. The German version (fig. 4), rather more succinctly entitled *Die enthauptete Arminianische Schlange Sampt dero selben verfallnem Baum,* bears no date; but on the analogy of other cases it can be assigned with some certainty to the same year. Both versions (minus the two apostrophes to the readers, quoted below) have been reprinted in Appendixes F and G. The Dutch original is in Alexandrine couplets with the by now obligatory alternation of masculine and feminine rhymes. It has an oratorical movement which already suggests the baroque. The German translation follows the original closely and reproduces these features faithfully. It is technically much the most accomplished piece of German versification we have so far examined, and it is hard to believe that only four years separate it from *Der Niederlandsche schlaffende Louw.* This may be seen from the verses which conclude the broadsheet:

Aen den onpartydighen Leser.

Ghy Leser bid ick/ geeft een onpartijdich oordeel/
Of dit vertoog u dient/ tot schade/ of tot voordeel?
 Tot schade kan't niet sijn: vermits de reen getuygt
 De waerheyd van de saeck: en yeg'lic gaerne buygt
Onder de waerheyds reen: ten waer waen-wijse sotten
Die dicwils zijn gewent met waerheyt selfs te spotten.
 Den goeden scheld' ic niet/ en 't quaet verdient sijn straf/
 Dus yeder sy gerust/ en houd' sijn mont daer af:
Hem wachtend' van 't Serpent/ so is hy vry van sorgen:
Mits 't meeste des fenijns is in den staert verborgen.
 En elc blijft voort te vreen/ en siet dat hy't so maeckt
 Dat hy tot geender tijt/ wordt van d'slangs start geraect:
Op dat de liefd' end' Kerc met eendracht mach floreren/
Dat gun ons 'tware licht/ den Opper-heer der Heeren.

An den vnparteyischen Läser.

Jhr Läser / ich bitt / gebt ein vnparteyisch vrtheil
Ob diser truck euch dient zu schaden oder vortheil?
 Zum schaden kans nicht seyn: dieweil der grund bezeugt
 Die warheit der geschicht: ein jeder sich gern beugt
Vnder der warheit grund; nit vnder lose zotten /
Die mehrmals sind gewohnt / der warheit selbst zuspotten.
 Ich schilt den frommen nit: boßheit verdient solch lohn.
 Drumb jeder sey vermant / daß er jhm selber schon /
Sich hüte vor der schlang / so ist er frey ohn sorgen /
Dieweil das scherpste gifft ist in dem schwantz verborgen.
 Ein jeder bleib in ruhe / vnd sein sach so anstell /
 Damit jhn nit hernach der schlangen schwantz auch quell.
Daß Christlich Lieb / der **Glaub** / auch **Einigkeit** sich mehren /
Das geb vns allen Gott der Herr Herr aller Herren.

Though the German verses contain forms which Opitz would not
have countenanced, their rhythm is very close to Opitz's, not least
perhaps because the translator has kept very closely to the rhythm
of the Dutch original, which, after all, is the way Opitz himself
began. Some obvious dissonances can easily be removed by minimal
redrafting, as the first line of "An den vnparteyischen Läser," which
only requires changing "ich bitt" to "bitt ich" in accordance with
the original. The broadsheet is dated one year before the *Buch von
der deutschen Poeterey* appeared in Breslau. Who can have written
this very modern German text for this ephemeral sheet?

In Amsterdam, as in Antwerp, we see the same pattern: broad-
sheets with German verses, written in the Netherlands after a Dutch
model and in a style which is unusual in Germany. The Alexandrines
and *vers communs* are, by German standards, not merely unusual
but positively avant-garde stuff. If they had appeared in manuscript
or in privately printed works produced in limited editions for a
small circle of friends, it would not be surprising. They would fit
easily into one of the pigeonholes of literary history which con-

tain the various individual forerunners of Opitz, men like Melissus, or the translator of Jan van der Noot, or G. R. Weckherlin, or Tobias Hübner, who worked either privately or for a small coterie and who seem not to have been aware of one another's existence. But this case is quite different. Here we have verses intended for a wide public, verses which were presumably widely read. This public apparently knew, long before Opitz, how Alexandrines and *vers communs* were meant to be read. The anonymous translators in the Low Countries had already begun the process of assimilating Romance verse forms. And, moreover, they evidently knew that they could reckon with readers for whom the same held good—at least passively. As I pointed out at the beginning of this paper, there are indications that the *Buch von der deutschen Poeterey* did not fall on entirely virgin soil, that even minor spirits were already prepared for it. People were evidently already acquainted with the foreign verses; all that was needed was the practical instruction.

There is one question which must be asked, though I do not know how to answer it. Who were these anonymous Germans working in Holland? We do not have a single name. The identities of their Dutch associates take us, for the moment at any rate, no further. The men who worked for the van Haechts were almost certainly Lutherans, but there may well be some doubt whether all of them were Germans. The pamphlets emanating from Amsterdam are all Reformed, and we should therefore look for natives of those parts of the German-speaking world where the Reformed religion was strong. It is noticeable that nearly all these texts show certain South German traits; this suggests the Reformed territories of the Palatinate, Switzerland, perhaps Hesse-Cassel, and, less probably, Alsace. That there were German students with a good knowledge of Dutch, able to write pretty regular German (and Dutch!) Alexandrines, in the circle round Daniel Heinsius at Leiden as early as 1618, is apparent from the remarkable poem by the otherwise unknown Daniel Crombein from Wriezen in the Mark Branden-

burg written for the wedding of Opitz's friend, cousin, and patron, Caspar Kirchner, which was discovered long ago by Witkowski,[18] and which is reprinted in Appendix H.

It may well be in circles such as these that our German broadsheets originated. But this very case shows how uncertain the ground is. Crombein was not a South German, and the language of his poem shows no specific South German characteristics.[19] As a Brandenburger he was presumably a Lutheran, but by 1618 the Elector John Sigismund of Brandenburg had turned Calvinist to improve his position in the negotiations for the Jülich-Cleves succession. This had paid off in the Treaty of Xanten in 1614, whereby Brandenburg acquired Cleves and Mark. An ambitious young Brandenburger wishing perhaps to seek his fortune in these newly acquired territories might well have imitated his prince. The Brandenburg connection does suggest that he may have had a hand in *Der Kram des Romischen Papst*. But all this is pure theory. A careful analysis by a dialect geographer would throw much light on problems of this kind; one would then know rather better what one was looking for.

But even when this question is finally answered, it only raises a further one: What did these people, working in this technique in Holland, bring with them from home? Were they themselves in any way prepared for what they were called upon to do? This question cannot be profitably put until a great deal of further research has been done, but it gives rise to interesting speculation.

It also links up with another question I would like to ask. If

[18] Georg Witkowski, "Ein unbekannter Vorläufer Martin Opitzens," *Euphorion* 8 (1901): 350–351 and the supplement on p. 723.

[19] He does, however, use *han* as an auxiliary and occasionally South German apocope—*gebad, zusamm.* He is the Daniell Krumbein Writzensis Marchicus who matriculated at the University of Frankfurt on Oder in the summer of 1607; see Ernst Friedländer et al., eds., *Ältere Universitäts-Matrikeln I: Frankfurt a. O.* (Leipzig, 1887–1891; reprinted Osnabrück, 1965), vol. I, p. 514. Other members of the same family matriculated there in the early years of the century, including another Daniel in 1599. The name also occurs in the Leiden matriculation register.

people were already acquainted in some measure with Romance verse forms when Opitz's work appeared, how did they know about them? Regnart and his followers were tied to music; the same goes for Lobwasser and his psalms. The translations of van der Noot were forgotten; Melissus in Heidelberg was dead, and his German verses were known to only a small circle; Weckherlin in Stuttgart, Plavius in Danzig, and Hudemann in Holstein were local celebrities only; we know little about the effect on a wider public of the early work of the Fruchtbringende Gesellschaft. Where is there a body of writing sufficiently widespread to have paved the way for Opitz throughout Protestant Germany? I can see only one answer: the Dutch-German broadsheets, some of which I have considered. They are not great art; indeed, they hardly go beyond the level of decent craftsmanship—some of them not even so far. They were polemically Protestant; and at a time when the States-General were seen— and took good care to be seen—as the bulwark of Protestantism, they were probably read everywhere where people had the Protestant cause at heart. The early poetry of the baroque in Germany is uniformly Protestant. The Catholic areas resisted Opitzian metrics as they had resisted Luther's German. Moreover the broadsheets were produced by keen businessmen who knew their market. If the newfangled verses had had an adverse effect on sales, they would have been abandoned in short order. But they went on being used; so presumably the sales situation was good. We remember at this point that some of the broadsheets on the battle of Breitenfeld in 1631 are in *pre*-Opitzian Alexandrines (especially the *Confect* series). Here we have writers in Germany itself who appear not to have heard of Opitz, but who are prepared to turn out fifty or sixty Alexandrines to order at short notice. Perhaps the various forerunners of Opitz had a wider influence than we know. Opitz at any rate did not stand alone though he spoke the magic "Open Sesame."

APPENDIXES

The texts reprinted here are presented simply as specimens of metrical practice. I have made no attempt at complete bibliographical description or at elucidation of the various historical and other references, or of the linguistic or typographical peculiarities. The plates will give an idea of the appearance of some of the broadsheets. Three small points need to be made here. The broadsheet *Schampatas* is wrongly entered in the British Museum Catalogue as *Schampalas*; the German text of *Der Niederlandsche schlaffende Louw* is not printed on the same sheet as the engraving but is pasted on (all the other texts are on the same sheet as the engraving); finally the engraving in *Die Enthauptete Arminianische Schlange* is not identical with that in the Dutch version but has been redrawn.

APPENDIX A

Schampatas
Der liestigen Buhler Spießgeselle

[Engraving of three male figures with strange hats and slapsticks. One is making the horn sign against the evil eye, the second is carrying a round box, the third a key. Motto: 'Nos stulti sumus et mundum bene fallere nati.']

[col. 1] Der blinden Liebe Kunst/ den schlauen Grieff im Buhlen
 Die halbe Zauberey/ gelehrt in Amors Schulen/
 Vom Pöbel wol erlernt/ der Schönheit falschen
 Wahn/
 Sieh'/ O verliebtes Volck/ an *Schampatasen* an.

5 Sieh deiner Sinnen witz. Wer sich/ wie du tust/ übet
 Im Lieben mit Betrug/ vnd seine Lust ergiebet
 Der klugen Vnvernunfft/ muß so sein abgericht
 Als dieser *Schampatas*/ dem keine List gebricht.
 Ey/ Ey/ wie macht Ers doch wann Er will Närrisch scheinen/
10 Der arme *Schampatas*? Jetzt hebt Er an zu weinen/
 Hat aber doch kein Leid: Itzt lacht Er wider gut:
 Itzt springt Er in die höh'/ Itzt setzt Er auff den Hut/
 Den Hut sein Meisterstück/ den Er auff alle Seiten
 Kan wenden vmb vnd vmb/ bald kurz/ bald lang außbreiten:
15 Itzt schaut Er an sein Kleid/ daß ihm Einbildung macht/
 Als sey Er hoch gesehn in seiner newen Tracht.
 Itzt nimbt den Schlüssel er/ vnd zeiget seine Kisten/
 In der Geld vnd Betrug gleich wie beysammen nisten/
 In dem Er aber meynt Er sey der Man allein
20 Siht er mehr bey jhm stehn/ die jhm zugleichen sein.
 So gehts im Bulen auch. Ach wie viel tausend Tücken/
 Erdeucht das schlimme Volck/ die Hertzen zuberücken.
 Ein jeder ist bemüht/ stellt alle Vortheil an/
 Das Er bey seinem Schatz' ans Bret nur kommen kann.
25 Der Eine braucht den Hut/ erfindet kluge Rencken
 Auß dem sonst albern Kopff'/ ist embsig nachzudencken
 Auff das was Lieben macht/ schickt manchen Bothen auß/
 Forscht in der stille nach/ wer in der Liebsten Hauß
[col. 2] Zugehen sey gewohnt/ denckt heimlich zuvernichten
30 Die da in Gnaden sein/ wil sich dafür verpflichten/
 Gibt artig bey jhr vor/ wie jhrer Tugend Zier
 Sein Hertz' entzünde gantz/ den Leib in Banden führ.
 Der Ander braucht das Kleid: Dieweil Er seinen sachen
 Nicht besser weiß zuthun/ wil Er sich schöne machen/

35 Was bloß den Leib betrifft/ Pralt wolgeschmückt
 daher/
 Als kein Mensch auff der Welt nicht seines gleichen
 wer.
 Ist einig drauff bedacht mit Hoffart sich zu zieren
 Die doch wie Er vergeht/ vnd seinen Stand zu führen
 Viel höher als Er ist/ vnd wil mit solchem Schein
40 In seiner Liebsten Hertz' vnd Wohnung schleichen
 ein.
 Was braucht der Dritte dann? Der thut den Schlüssel
 weisen/
 Den Schlüssel/ mit dem man Ihn sol vor andern preisen/
 Er rühmet seinen Schatz/ die Kasten voller Gold
 Als einen Liebes-Freund/ vnd vrsach' aller Huld:
45 Da redt Er sonsten nichts als nur von Silberstücken/
 Da hat das Reichthumb selbst erbawet eine Brücken
 In sein Geldsüchtig Hauß/ da ist fast alles Sein/
 Was Er nur recht bekömbt in seinen Augenschein.
 Diß ist der meisten Grieff. Wann Sie sich dann verstiegen
50 In Hoffnung also hoch/ die Liebste wegzukriegen/
 Vnd sehen sich kaum vmb/ so steht an jhrer stat
 Ein Ander/ der was mehr/ als Sie/ gelernet hat.
 Drum jhr/ die jhr mit frucht vnd fortgang ewer Leben
 Der vngefärbten Pflicht gesint seyd zuergeben/
55 Last solche Vortheil sein/ vnd braucht der Tugend
 Kunst
 So habt jhr Heyl bey Gott/ vnd bey den Menschen
 Gunst.
 Gedruckt im Jahr 1629.

[BM 1750. b. 29 (118). All on one sheet, the engraving being
enclosed within a typographical border. The title (*Schampatas*,
etc.) is printed in letterpress.]

APPENDIX B

Die schandtliche flucht der wolfischen Papisten,
veriaght van den Schaffen Gottes.

Horzu ihr Bruder/ mercket hertzlich an/
Wie Gott der herr (ob er ein weil lesz zu/
Das sein volck mus in langr verachtung stan)
Der werlt boesheit endtlich wird muede nu.
5 Erstlich sehet ihr hie von Himmel abfaren
Das fewrig schwert welches zweischnidig sticht/
Der Gottes grimm/ vertreibet/ macht erschrocken/
Vnd macht zu schanden alls das ih[n] beficht.
 Vnd darzu hilfft als ein mittel beqwame
10 Gotts starcker Geist/ alls guten ein vrsaech/
Der ietzt erklart die warheit/ in Gotts name/
Vertrost die gueten/ ander forchtsam macht.
 Denn dafur fliehen so andern theten lauffen/
Der wolffen hauff/ gehaulet vnd gestabt/
15 Mit gantz ihrem kraem/ vnd alls das sie verkauffen/
vnd werdn selbr durch die Schaffe gesteubt.
 Die Tauben der [t]euren Geister figure[n]
Jagen h[i]e auch mit Tugenet/ Warheit/ Macht/
Dis boses geschums/ der pfaffischen thieren
20 So den dag schewen/ vnd suchen die Nacht.
 Welchs vnzifer nimpt sein zuflucht alleine/
Zum Antichrist ihrs heilgen vatte[r]s Rott
Dem Ro[m]schen Bapst/ vnd seine huren gemein[e]/
Sampt ihrem Drachn/ die sie finden halbtodt.
25 Darumb ist wee/ schweermut/ vnd gros ellende/
Bei diesem volck/ das sucht [vb]er all Rhat/
Der Teuffel bschawt das wasser/ vnd ist in henden
(wie dan [dann] sein) krafftlos/ vnd ir hertz vergaht.

So wird erfullt nu Christi wortes warheit/
30 Das alle pflantzen/ wenns der Minsch erticht/
Werdn ausgereut v[o]ns Vatte[r]s himlischer klarheit/
Denn nichtes bleibt/ ohn was er selber stifft.
 Bruder/ laszt uns Gott bitten/ vnd recht leben/
Vns buigen gantz vnter sein Maiestet/
35 Das er vns bald woll diese wolthett geben/
Zu sei[ner] ehrn/ vnd vnser seligkeit.

 [Herzog-August-Bibliothek, Wolfenbüttel, Cod. Guelf. 38.25
 Aug.2°, Bl. 263.]

APPENDIX C

Die letzte fart der Bapstischen Galeie[n].
Anmercket diese Bapsts Galeien wol/ Mit dem pfinnent seine heilgen
kirchen vol.

Wie wol fra[w]e gluck vns ehre gunst anbeut
Durch vnsern Drachn/ dern ieden thut erbimmen
Wir furchtn et leinn scheckbydlin fur den todt
Das nach deser frudt vnsr ellend werde kommen
5 Der Frantzoisisch vertrag drewt vns gar vest
Ees sind noch gar zu viel geusen im leben/
Wol gefast vnd gerust widr vnserm Nest
Darum wir vor anngst gantz vnmutig beben.
 Was sollen wir denn thun? vnd was fur raht?
10 Vns machen auff nein Hispanien zu rucken
Vnd stirbt den Drach/ was zu geschehen staht
Mugn von der haut vns ein galeie flicken.
 Mit dern sol vnsre kirch werden gefurt
Vnsr kauffmanschafft/ Concilium zu Trenten/
15 Messe/ vnd alls das vns weiter ange[h]ort

Auff das wirs da mugen auffs best berenten.
 Der Romisch Bapst soll der Schiffuhrer sein
Vnd furen Schiff nachm Compas seiner gesetzen
Die Ruderleut sein der geistlicher schein
20 Der pfaffen gar so in ehr bosheit mesten.
 So faren wir zum land vns vhast befrimdt
Ins teuffels nam der vns wolle bewaren
Vnd gebn den Schiff gluckhafftig guten windt
Sonst mus es im grundt der hellen faren.

[Herzog-August-Bibliothek, Wolfenbüttel, Cod. Guelf. 38.25
Aug. 2°, Bl. 289.]

APPENDIX D

Der Kram des Romischen Papst, sein werck vnd furnemen, 1615.

[Title engraved on the plate, the rest letterpress]

[col. 1] A. Die Holändische Jungfraw.

Das Panier meines heils/ ist Gottes heilig Wort/
Welchs in den Niderlanden paur vnd lauter gelehrt:
Das ist der Staden frewd/ vnd vnser höchster hort/
Dadurch Gott wirdt erkandt/ gelobet vnd geehrt.
5 Derselb hat vnsre feind/ den Drach von Babylon/
Zu boden nidergschlagen/ vnd jhm sein schädlich gifft
In Hals wider nein gstossen/ daran in schand vnd hon
Er selbs muß bald erworgen/ vnd alles so er gstifft/
Auff seinen Kopff muß fallen/ die zeit hand wir erlebt/
10 Das sein macht ist gefallen in vnserm Vatterlandt/
Dem Spanier auch die schmach vnd schandzeichen anklebt.
Keiner wird nimmermehr zertrennen vnsern Standt/
Wir wöllen ja fürwahr glaub/ ehr vnd trew steiff halten/
Wir wollen auch zugleich Leib Gut vnd Blut frisch wagen

15 Vnd künfftig nach der weiß/ vnd trewen raht der Alten
 Deß Antichrist Boßheit/ vnd Spanniers Joch nicht tragen.

B. Hollandt das gemein Vatterlandt.

Du schwartzer Rodomont/ der du all Berg vnd Thal
Vnd alle Meer durchlauffst/ zu rauben Gut vnd Blut/
Dein schiessen/ stürmen/ schlagen/ trommen vnd paucken
 schall/
Wird vns wills Gott nicht nemmen/ sondern geben den
 muth/
5 Marran/ faul Gotisch blut/ Vallaco Drahidor/
Hollandt solt du nicht zwingen mit deiner Tyranney/
Wir haben zsammen gschworen/ das sag ich dir zuuor/
Dein Morden/ Brandt/ vnd Raub wöllen wir rechen frey.
Frisch auff jhr Fürsten all/ frisch auff jhr Teutschen gut/
10 Last vns nicht lenger schlaffen/ vnd sehen doch zur schantz/
Der schwarze Sarazen hat gar ein stoltzen muht/
Er will nicht nur ein theil/ sondern alß haben gantz.

C. *Pallas*, Göttin der Weißheit.

Nun ist die zeit verhanden jhr wolllobreichen Ständt/
Gott hat nicht vmbsonst geben das Schwert in ewer Händt/
Der Römer vnd der Griech/ vnd andre Völcker mehr/
Haben auff ewer weiß erlanget Lob vnd Ehr.
5 Der Busiris von Spanien/ der trotzig Sarazen
Spert auff sein Morisch Aug/ vnd plecket seine Zähn/
Wolt euch gar gern zusammen verschlingen auff ein mahl/
Hoff doch es werd nicht gelingen. Gottes Gnad ist ohne
 zahl/
Allein wolt euch fürsechn/ vnd trawt im minsten nicht/
10 Er ist ein Scorpion/ der vnversehens sticht.
Gülch vnd Cleven zu mahl haben es leider gsehen/
Bedenck nun bey euch selbst/ wie es mit euch mag gehen.
Sein schöner Güldner Adler verblendet manchen Mann/
Solt jhn für einen Greiffen vnd Drachen sehen an.
15 Trawret nicht/ vnd seht euch für/ sie halten euch kein
 glaub/

Der einem Spannier trawt/ der ist sinnloß vnd taub.
Haben sie nicht zu Costnitz in jhrem Conuent groß/
Da man deß frommen Hussen vnschuldig Blut vergoß/
[.]

[col.] E. Hertzog von Brandenburg.

Ihr Herren Staden trew
Wißt all mein schwer anligen/
So alle tag wird new/
Mich wolt gar gern vertreiben/
5 Der Sarazenisch Mor:
Mein Vettern macht er an
Vnd wer mir gern im Haar/
Aber es ligt nichts dran/
Er fahrt noch vbel an
10 Wann er betrogen wirdt/
Vom falschen Castillan/
Der alle welt verwirrt/
Der Greiff den Adler hat
In vnser Landt gebraucht:
15 Ihr wißt all diese that/
Vnd habt sie lengst bedacht.
Helfft mir jhr Helden from/
Vnd mit seim weisen Raht
Printz Moritz zu mir kom.
20 Nassaw du Fürstlich Hauß/
Bekandt in aller Welt/
Mach das dem Spannier grauß/
Vnd gar zu boden fehlt.

 F. Printz Moritz von Nassaw.

So lang mir Gott das leben
Vnd krafft verleichen thut/
Will ich dem Spannier geben
Gut stöß auß Helden muth/
5 Der faulen Juden samen/

Dermaln verderben muß/
Die Wurtz vnd auch der Stammen/
Thut doch kein ander Buß/
Er wolt die Welt bezwingen/
10 Vnd tilget Gottes wort/
Brauiert mit seiner Klingen/
Tracht nur nach raub vnd mordt/
Gottes gsatz thut er verachten/
Vnd trotz die Fürsten fromb/
15 Nach Teutschland thut er trachten/
Vnd streifft im Landt herumb/
König Heinrich des Grossen/
Durch Esauiter Handt/
Hat tewres Blut vergossen/
20 Hilff Gott/ vnd recht die Schandt/
Der Coton thut jhn lehren/
Der bösen stücken viel/
Er kan den Teuffel bschweren/
Gibt jhm ein gutes ziel/
25 Der Bapst sampt seinem hauffen/
[.]

[col. 3] G. Klag der armen Bauwren im Landt Cleven.

Ach Gott wann solls geschehen doch/
Daß du zerbrichst das Spanniscch Joch/
Darunder mir mit Weib vnd Kindt/
Von schwartzen Moren trenget sindt/
5 Halb Jud/ halb Heyd von Andelauß/
Machts mit vns armen Bauren auß/
Die wir vor diesem hatten gsungen/
Vnd bey der Herd herumb gesprungen/
Thun jetzund stäts weinen vnd heulen/
10 Vnd klagen vnsre Eyter beulen/
Die vnß der Spannier gschlagen hat/
Ach Gott erbarm dich dieser That/
Stürtz du den Morn auß Portugal/

Vnd jhn mit gleicher Müntz bezahl/
15 Errett das arme Völcklein dein/
Vnd laß vns dir befohlen seyn.

H. Die armen Hirten.

O weh/ o weh ich hab es wol gedacht/
Das der Holländisch fried vnd [t]ugentlich anstandt/
Vns nutzet nichts/ wie er vns dann hat bracht/
Ins größ[t] Ellend vnd Spannier Sclavenstandt/
5 Der Zwibelfraß/ der Bluthund Catalan/
Hat vnsre Schaaf vnd bestes Vieh gefressen/
Was vbrig ist muß alle morgen dran/
Da bleibt gar nichts in vnserm Hauß vergessen/
Die Nachtigal hört man jetz nirgent singen/
10 Von ach vnd weh sind voll all Berg vnd Thalen/
O weh wie lang sollen Posaunen klingen?
O weh wie lang sollen Carthaunen knallen?

I. Der Jesuiter

Ich zeuch zu Wasser vnd zu Landt/
Vnd brich der Reformirten Stand/
Darinn sie Gott im Himmel droben/
In fried vnd einigkeit thun loben/
5 Ich weiß wol daß jhr Glaub recht ist/
Dannoch gfallen mir meine list/
Die mir der Teuffel eyn thut blasen/
Vnd dem Bapst gfallen vber dmassen/
Was der schwartz Mor der Spannier will/
10 Das thun ich flux in grosser eyl/
Ich bin der trewste Diener sein/
Der Bapst kan auch nicht manglen mein/
Wollen sie morden oder kriegen/
Oder die frommen Leut betriegen/
15 So brauchen sie mich beed behendt/
Ich kan verwirren alle Ständt/

Ich halt kein glaub/förcht mich nicht viel/
[.]

[col. 4] Wir sind deß Spanniers gheime Rath/
Was wir wollen alßbaldt bestaht/
In Holland schmackt vns wol der Butter/
Vnd in der Schweitz finden wir Futter/
Wann diese zwey Orth vnser seyndt/
Beherrschen wir all vnser Feindt.
Wir haben hie vnd dort Spionen/
Vnd thun jhnen mit Dublon lohnen/
Es nimbt an mancher von vns Gelt/
Der sich nicht nach seim Hertzen gstelt.

K. Der Bapst.

Ich bin der höchst vnd gröst auff dieser Erden/
Mein Reich das geht in Himmel/ Erden/ Hölle/
Ein jeder muß verfolgt vnd getödtet werden/
Der sich nur wider mich aufflähnen wölle/
5 Keyser/ König vnd Fürsten allzumal/
Fürnemblich so in Gott nicht wol erbawen/
Verehren mich vnd bringen Gschenck ohn zahl/
Sonst thet ich sie zu Boden niderhawen/
Heinrich der Groß must folgen meinem Gsatz/
10 Der Teutsche Fritz Keyser Roth Bart genandt/
Küst mir die Füß zVenedig auff dem Platz/
Vnd leidt von mir viel Schmach vnd grosse Schandt/
Phocas der Mörder must mir Keyser werden/
Weil er mir hat ein dreyfach Cron gegeben/
15 Nach meinem Wunsch muß geschehen als auff Erden/
Inn meinem Gwalt ist Himmel/ Höll/ vnnd Leben/
Die Infuln/ Scepter/ sampt den Cronen allen/
Muß man von mir mit grossem Gelt erkauffen/
Zu meinen Füssen muß man niderfallen/
20 Vnnd vmb Ablaß gen Rom vnd Loret lauffen/
Die Bischoffen/ Aept/ Thumbherren in gmein/
Wie dMönchen halt ich für grobe Narren/

Mein gheimbster Rath ein Jesuit muß seyn/
Der thut mir weder Müh noch Arbeit sparen/
25 Er ist subtil/ vnd teuffelisch verschlagen/
Ist Spannien Trew/ vnd thut vnsäglich hassen/
Die Teutschen Hundt/ vnd fast sie bey dem Kragen/
Streicht rings herumb/ vnd thut jhr Wort aufffassen/
Thonaw vnd Rhein/ wie auch die Niderlanden/
30 Will er durch Müh vnd Vnuerdrossenheit/
Auffs aller ehest bringen zu meinen Handen/
Darumb jhm dann gnädig ist mein Heiligkeit.
Der von Sophoy auß Saxenblut geboren/
Greifft Meylandt an/ vnd ist den Teutschen holdt/
35 Verachtet all mein Wahrnen/ Streich vnd Sporen.
Vnd macht daß ich verliehr viel Gelt vnd Golt/
Nun dann wolan: Wollen die Teutschen holen/
Auff Saxenpferden jhre gelben Gulden/
Die ich vnd meine Vorfahrn haben gestolen.
40 So bleibt bey mir Venedig nicht in Hulden.
O ach vnd weh/wie soll ichs greiffen an/
[.]

[Amsterdam, Rijksprentenkabinet FM 1309 Bc. The five dots
between square brackets indicate loss of text]

APPENDIX E

[Engraving, Alvin, *Catalogue raisonné*, No. 1518]

Der Niederlandsche schlaffende Louw

EIn spiegel eins verderfs des freyen Niederlands
Hierin du klar dich sihst mit augen eins verstands.
Was hat gantz Niederlant von Spaenschen frech erfahrn
Wie manch betrubtes leidt innerhalb funffzig jarn?
5 Sie gdachten all diß Volck/ das landt mit grosser macht

Mit zähnen stracks zerreißen/ das wahr ihr Spanscher
 pracht/
Aber Gott sey gedanckt/ es ist ihn nicht gerathen
Der Louw von Niederlandt kam stracks vnd röch den bradn/
Er sperret auff sein mundt vnd riß dar von ein stück
10 Das schmacks ihm wunder wol/ er acht es für ein glück/
Das septer vnd die kroon der Spanschen in gemein
Die Geistlichkeyt darzu förchten den Louw allein:
Dann sie sahen gewiß/ mit seinen klauwen krumb
Was er gefasset hatt/ das hielt er vest kurtzumb/
15 Sie hetten gern gefangen den Leuwen vngeheuwr
Sie wusten niet wahin auß/ gut Rhat war bey ihn theuwr/
Es war niemandt so starck der ihn kont binden fest
Er war ihm viel zu groß/ vnnd thät er auch sein best/
Niemand war auch so klug/ der ihn kont hindergehn
20 Sein augen waren klaar/ sein hals kont er wol drehn.
Endlich da kam ein Fuchs/ der hatt ein Monchs-kot an
Ist lachens werd vorwahr das wer ein wunder han/
Er macht sich bey den Louw vnd streichelt ihm sein ruck
Vnnd sang ein Leid Treviß/ das war ein fal[s]cher tuck/
25 Das kitzelen sehr sanfft/ das that dem Leuwn so woll
Das singen auch dabey macht ihm die ohrn so voll/
Daß er kriegt einem schlaaf vnnd legt sich auff die Erdt/
Der Fuchs lacht in sein sinn/ Er dacht die kunst ist bwerdt/
Leuw legt sein tapfers Haupt zwischen die vorder fuß
30 Er thut sein augen zu vnd felt im schlaf sehr süß/
Wo hat so manches Mensch beklaget diesem fundt
Dann wie langer er schlief/ ie arger daß es stundt/
Es waren etliche bestrichen mit dem Stock
Die holffen daß der Louw blieb schlafen als ein plock/
35 Es kam ein arger Wolf vnder des Leuwen schlaf
Der stal/ der raubt vnd moordt die vnschuldige schaf/
Die Burger wurden arm/ die Bauren lieden noot
Vnder den schein des Frieds geschah manch heimlich moort/
Ja das noch arger war die hoch seyn in dem Raht
40 Der warn etliche selbst bedachtn ein bose that/

In dem der Leuw so schlief / da warn sie drauf bedacht
Sie gingen darmit vmb / daß sie die weltlich macht
Gantz an sich brechten selbst / vnd die Herren getrauw
Setzen auß ihrer macht / das thun sie ohne schauw /
45 Nun hort was ich euch sag / die sach ist wunderbahr
Gebt achtung auf mein wordt / sie sindt warafftig wahr /
Hier zu lest sich gebrauchen ein ganz verschlagner kopf
Das war der Fuchs merck recht / er gieng mit ledigen kropf /
Da stond ein schoner korb mitt sieben Gänsen fett
50 Diß seyndt die sieben Landn / gleich als mit einer Kett
Zusamen vest geschmidt mit einem stercken bandt
Eben als wann sie wern zusamen all ein landt /
Zwey Schafen warn dar bey mit in den korb gebracht
Seindt orter auß Brabandt vnd Flandern vnveracht /
55 Die der Hollandsche Louw hatte mit groser macht
Vnder Hollandsch gebiet gantz dapferlich gebracht /
Der Fuchß lauwrt auff den Korb / er gdacht die Gänsen fein
Zu wurgen alle gantz oder auffs wenigst ein /
Er konts allein nicht thun / es war ihm viel zu schwer /
60 Von klugheyt vnd verstant nimbt andre bey sich mehr.
Da war ein starcke wacht dem Vatterland getrauw
Nicht ferr vom Gansen-korb / bewarde den genauw /
Ein wacker Hundt am post mit Treueß seil gebondn
Der gab drauff fleisig acht / gleich pflegen all die Hondn
65 Zu thun / die manchen brock von ihers Herren tisch
[col. 2] Entfangen in ihr Maul / dar zu manch guten visch.
Der Fuchs bedacht sich weit vnd breit / er furcht den Hundt
Hort fleissig was ich sag / er bkam ein argen fundt /
Er bstelt heimlich den Wolff / das war die Spansche macht
70 Der solt von fern still kommn zu dieser fetten jacht /
Wann er zu schwach wierdt sein die Gänse zu ergreiffen
So solt er gryffen zu / vnd sie hinweg stracks schleiffen
Schliech heimlich zu dem krob gleich alle Fuchse thoen
Im schein der heligkeyt vnd besser Religioen /
75 Lehrer vnd Professorn die krieg er an die handt
Die stelten in vnruh mit lehrn das gantze Landt.

Sie gaben vor man must die lehr so hoch nicht tr[e]ibn
Man musts fein moderirn vnd in der einfalt bleibn/
Der Mensch kont auch was thun zu seiner seligkeyt
80 Dardurch wurd er getrieben zu grosser heiligkeyt.
Dem einfaltigen Volck stund diß spiel sehr wol an
Vnnd die dem Bapstumb noch sehr waren zugethan/
Jene verstunden nicht das fundament der Lehr
Dese suchten ihr heil in eign verdiensten sehr/
85 Als nun das gantze Land in affruhr war gestelt/
Der Wolf macht sich herbey/ das hatt de Fuchs bestelt/
Als er anfing zu schleichen zu diesen Gänsen fein
Da gryfft er wacker zu vnder ein frembden schein/
An Landen vnd an statten an Dorfern in gemein
90 Was er nur kunt erschnappen/ das war flox alles sein/
Ach manchen haes er krieg dem zaust er seinen beltz
Auch manch kuniglein friß zwischen dem steineren fels/
Ein Wiselein sehr schon grieff er auff einer brugk
Zerreist ihm seinen hals vnnd bricht ihm auch sein ruck/
95 Der Hundt hort diß von fern/ er hielt getrauwe wacht
Auff seine Ganßlein zart gab er wol fleissig acht/
Er hort ein groß geschrey/ fieng an zu bellen sehr
Er wer gern loß gewesen/ hett gern gethan gut wehr/
Aber er hatt das seil treveß vmb seinen hals
100 Das hatt der Fuchs gesponn mitt sein gesellen falsch/
Gleichwol als er nun sah des Wolfs solch tyranney
Springt er gewaltig zu/ vnd reist das seil ent zwey/
Vnd laufft den Wolff entgegn/ daß er nicht weiter **kunt**
Drumb blieb er stracks zu ruik/ raest nicht mehr na der
 stunt/
105 Die gute wacht getrauw wirdt widerumb gebonden.
Mit Treves seil/ ein knob wirdt nun daran gfonden/
Ach daß getrauw wacht zwen tag wer ehr gekommen
Das *Weisel*ein wer ihm in seine klauw nicht kommen/
Diß ist nun so geschehen/ man muß es mit gedult
110 Ertragen/ den es ist vnsr eigen sunden schult/
Der in dem Himmel wohnt Got kan es besseren balt

Last ihn anruffen sehr/ steht all in syn gewalt.
Aber Gott sey gedanckt/ Wolff kam nicht in Holland
Die Ganß blieben gesunt in ihrem Korb bekant.
115 Das that dem Fuchs sehr leidt/ er dacht ein andern Raht
Er hette so gern gefressn von einem Gansen bradt/
Ihn daucht es wer ihm nutz/ er wirdt ein Remonstrant
Es war ihn nicht die lehr/ es war ihn vmb den Landt/
Er wer gewesen gern ein Graf von Holland gantz
120 Daß er hett mogn seyn Meister des gantzen Lants/
So hett er dann leichtlich die sieben Gansen all
Die bey ein ander sasen in einem fetten stall/
Dem Wolff gantz preiß gemacht/ dieselbe kal zu plicken
Zu bradn vnd zu sieden/ zu theiln in gute stucken.
125 Merck auff was ich nun sag/ die sach ist nicht gering
Will auch ein Kriegsman seyn/ wars nicht ein wunder ding/
Er nimbt ein grosen Esel/ darauff packt er gewehr
Er reist nach *W trecht* zu/ vnd anderen statten mehr/
Brengt viel auff seine seit/ er kunts allein nicht thun
130 Sie thun sich vest verbindn/ and werden stracks so kün/
[col. 3] Sie nemen an Soldaten in einen falschen schein/
Die musten schweren all nur solchem Herrn allein
Vnd nicht sein *Excellentz* dem Vatterland getrauw
Dem Princen von Oranjen dem Helden von Nassauw.
135 Vnd daß mans ja nicht merckt/ haben sie vorgewent
Es gschaeh zum fried das Lands vnd zu kein andern ent/
Dieweil so grosser streit in Kirchen ein gerissen
So must man mit Kriegvolck bey zeit kommen darzwischen/
Daß nicht den stand des Lands verging vnder der hand
140 Vnnd daß nicht blutvergiessen erreget würd im Land.
Er meindt es wer nun zeit/ als ein verahter falsch.
Lieff schnellich zu dem krob vnnd grieff ein Gans beim hals/
Zu ruffen fingen an die ander Gänse all
Sie wern gewaltig bang fur ihren eigen fall.
145 Das hort getrauwe wacht der Hund/ der sie verwart
Er macht ein groß geraaß mit seinen bellen hart/
Der Louw druff wacker wirdt/ es stund ihm nicht wol an

Er thut sein augen auff/ er schauwt den handel an.

Er grief gleich nach den Esel auß zorn in seinen hertz
150 Daß der wolt Wafen tragn/ das bracht ihn grosem schmertz/
Als solchs der Esel sah/ wolt er springen auff seit
Vnd dweil er schwer geladen/ sich da im treck er leit.

Ehr sies hatten gehofft/ setzt den Fuchs vnd noch drey
In einem vesten stall/ vnd kurtz noch ein darbey/
155 Dar essn sie Gänse gnug/ darnach sie habn getracht
Sie mogen endlich sehn/ was ihn das hab gebracht.

Es ist nicht lang geschehn/ daß eim ein Ganß darvon
In seinen hals blieb stecken/ das war sein rechter lon/
Kunt sie nicht schlingen ein/ kunts auch nicht ziehen auß
160 Er must daran ersteckn vnd sterben als ein Mauß.

Als die Lehrer das hoorden de Remonstranterey
Von diesem Raht auch wusten/ welchs war ein meuterey/
Die liefen al darvon/ sie mochten der Gänse nicht.

Der *Stier* dar von ist todt/ der *Iager* lehrt fransös
165 Der dritte ist auß den *Bongard*, vnd gibt den andrn die lös/
Zu vor die in dem spiel warn groß *Harminianen*
Seind nun bey iederman verachte arme Hanen.

Gleich sie haben verdient/ zu ihrem eigen hohn
So wirdt sie Godt gwiß findn/ vnd geben ihrem lohn.
170 Mit groß verwunderung lieb Leser so du wilt
Kanst sehn den gantzen handl figurlich abgebilt.

1. Diß ist der Leuw der schläfft/ die Niederlansche macht
Welcher durchs sanffte streichlen war in den schlaff
 gebracht/
Aber zu rechter zeit erwacht durch grossen lermn
175 Vmb das vereinigt Land tapferlich zu beschermn.

2. Wolff is die fressigkeyt der Spangers vngemach
Die auffs vereinigt Landt thut lauwren vor vnd nach/
Vnd siehet einem Raub/ den er nicht kan bekommen
Er geynt aber kriegt nichts/ zu vnser aller fromen.

180 3. Der Fuchs is Barnevelt/ der Wtrecht zu sein theill
Greifft auß dem Gansen korb. holff nicht viel zu sein heill/
Die andern Ganße sechs ein groß geschrey thun machn
Daß iederman der schlieff must stracks darvon erwachn.

4. Der Hundt/ getrauwe wacht/ steht an den post gebundn
185 Horent der Gänß geschrey/ gleich pflegen alle Hundn/
Macht ein schrecklich gebell/ darvon der starcke Louw
Wirdt wacker springet auff vnd fast sein schwerd getreuw.
5. Felt vnder seiner last der Esel schwer geladen
Werden schnel abgedanck die Krieger von den Staden.
190 6. Dieß sind des Lands verderber/ die machen manche beut
Die fromme menschen plagen verwusten Land vnd Leut.
7. Mit groser froligkeyt den Weinkauff hier man trinckt
Ein wunder kauffmanschafft/ man klingt darbey vnd singt/
Sie hatten schon verkaufft das Land zu allen stundten
195 Aber Gott sey gedanckt/ daß sies nicht liebern kunten.
8. Die Hirter solten hier ihr Schafen fleisig weiden
Aber sie schlafen ein vnd lasen sie verleiden/
Dar zwischen komt der Wolff gantz frossig vnd sehr gram
Verstreuwt sie/ vnd zerreist das vnschuldige Lam.

Im Iaer 1619.

[Amsterdam, Rijksprentenkabinet 524 b; Castle Library, Český
Šternberk, ČSSR]

APPENDIX F

Clare Af-beeldinghe, ofte Effigien, der voornaemste Conspirateurs,
staende op het Lichaem vande Hoofdeloose Arminiaensche Slange.
Waerin vertoont word hoe den Orangien Boom/ mitsgaders Religie ende
Justitie (in spijt van't Bedrogh/ en den vervallen Boom) door de strael
Gods beschermt word.

[Engraving showing the snake with the portrait heads of thirteen prominent
conspirators in medallions bearing their names, the stricken Arminian tree,
and the flourishing orange tree.]

O! wonderlijc vergift: O! listich vuyl *Serpent*
Die dees verraderij/ dit Nederland toe-sent.
Waer blijft nu uwen roem/ van trouwe *Batavieren*,

Die dicwils (so gy segt) den *Prins* selfs gingt bestieren
In sijne jonge Jeugt/ in sijne Kintsche tijd:
Waer door d'inlandsche sijn/ van slavernij bevrijd.
Wat wast dat u verleyd? wast dees vergift'ge *Slange*,
Die u dus Goddeloos/ nae staet-sucht deed' verlange?
Of was u lucx gheboort/ het Huys van *Barnevelt*
Na uwen wensch en wil/ niet hoogh genoegh ghestelt?
Voorwaer u luck was groot/ dus hoogh in staet vercoren/
Gemerckt ghy wt gheen bloet/ van *Princen* waert gheboren.
Of waent ghy trotsaert stagh/ dat die van slechten bloet/
So veel met reen verdient/ als eenigh *Prince* doet?
Waer door u yd'le waen/ dus weeldich is gheresen/
Dat ghy alleen de grootst'/ en boven al woud wesen:
Hier ist te recht ghetreft: en 't Goddeloos bestaen/
Was met een schijn becleet/ van den *Arminiaen*.
De groote *Slangh* die langh een Logenaer verstreckte/
V oock tot desen waen/ en hoop'loosheyt verwreckte;
Doch so vertreden is/ het heyloose *Serpent*,
So wierdt ghy Hoofdeloos/ en wt-geroyt in't ent:
Want siet recht nae verdienst/ so wierd 't *Hooft* eerst
 v[er]treden
Benemende de macht van al de and're *Leden*:
Die doch al even-wel gehetst sijn tot een wraeck/
Noch meer tot ondergangh/ van haer vervloeckte saeck:
Hier comt verraderij/ door wraeck-lust inne woelen/
Om 't Bloet van haeren *Prins* verraed'lijck wt te spoelen.
Wat zijt ghy *Groenevelt*, of ghy o *Stoutenborgh*,
In u *Bataefsche* hart/ dus sorg'loos sonder sorgh/
Dat ghy u *Prins* en *Heer*, soeckt lijf en ziel te scheyden/
Wiens genereus gemoet/ vaeck Vyands strick ontleyden!
Ay groot ondancbaerheyd: en wats u aenhangh doch!
Ist *Adriaen* van *Dijck*? of eenen and'ren drogh
Als *Coren-winder*, die was Berckels Secretaris!
't Zijn die: en 'tgeen noch onwtsprekelijcke swaer is:
't Zijn *Predicanten* die in plaets van goede leer/
Gaen brouwen Moorderij aen haeren *Vorst* en *Heer*,
't Zijn *Proponenten* die in plaets van goede stichten

Malcand'ren in't beleyd der Moorden onderrichten:
't Is eenen *Slatius*, en *Velsen* Predicant:
't Zijn *Blanckaerts* twee ghebroers en noch een and'ren quant
Zijn naem my onbekent: en meer hier in ghetekent/
Bepaelt in dese *Slangh*, van hooft tot staert gherekent.

[col. 2] Ay boose aen-hangh snood/ die 'tsamen rot/ en mort
So langh 'tfenijn by een/ dat ghy een *Slange* wort:
*Dus gantsch verwerpelijck/ moet cruypen langs der aerde/
Vermits 'tingeven quaet/ van u eerst openbaerde:
In *Eva* ist ghesien/ in *Adam* ist volbrocht/
**Die hebben na u raet de sond' en dood ghewrocht.
So oock in desen tijd/ de sect der *Arminjanen*,
Het is *Serpents* vergift/ het is maer ydel wanen:
Doch siet eens hoe het quaet/ brengt voort zijn eygen straf/
Een geessel voor u loon: in plaets van uwe graf
Een eeuwighe schandael: en om niet meer te bouwen
V quade vrughten/ werd u *struyck* gantsch wt-ghehouwen/
Op dat ghy niet meer bloeyt: den *Vyg'boom* ghelijck zijt/
Daer *Christus* dus van spreeckt: *Ghy sult nae desen tijd*
***Voortaen gheen vrughten dragen tot inder eeuwicheyd*
Hieromme syt vervloeckt: want siet 't *Bedrogh* dat leyt
Recht nevens desen *struyck*, en soeckt steeds te vervolgen
Iustity en *Geloof*: seer woedende verbolghen
Met thooren om de wraeck: maer siet u bitter end/
De *Roede* slaet de *struyck*, den *Boom* is vol ellend:
V vrughten snood' die staen/ op gallich en op raden:
Iustitia die comt haer straf op 't onrecht laden:
Vergeldingh' brenghend' meed'/ haer Schale nimmer mist
In 't weghen 't goet van 't quaet: daer voor bedrogh en list
Moet wijcken schandelijck: te meer als s' is verbonden
Met waer op-recht gheloof/ so sijn 't bedrochs doot-wonden:
Want so veel als den dach van duysterheyd verscheelt
So veel verscheelt het goet, van 'tgeen dat quaet voort teelt.
Siet nu d'*Orangien* stam in dese lente bloeyen/

* Genes. 3 cap.
** *Pena delicta Sequntur.*
*** Math. 21. capittel.

Met *eendracht* wel becleet/ in 't midden van het groeyen.
De *pylen seven* zijn aen dees *eendracht* ghehecht:
Dees *Boom* 't *Geloof* beschermt/ als oock het *goede recht*
Een *Sons-strael* om den *Boom*, een flick'ring van hier boven
Beschermt dees altesaem: dies dancbaerlijck wy loven/
Den gever van dit licht: en wensschen dat den *Prins*
Langh bly regieren mach na zijnen wil en wins.
Orangie gelauw'riert/ wiens lof blijft in gedachten:
Waer zijn de Moorders nu die na sijn leven trachten?
Voorwaer sy sijn te niet: haer staet-sucht is verneert/
In spijt van *Barnevelt*, ons *Prince* glorieert.

****Hy die hovaerdich was/ en *Haman* nae woud' stappen
In op-geblasentheyd/ viel selfs van staets-trappen.
Sy die de doot des *Prins* nu lang hadd'n voor-bereyt/
Zijn selfs als *Haman* oock ter galgen geleyt.
O Leser dit ghedenckt/ en wilt de hovaerd mijden/

[col. 3] Op dat ghy niet als dees' geraect in droevich lijden:
Maer doet een ander so/ als ghy wilt u geschiet:
In staet die u God geeft/ blijft/ en wild hooger niet:
So haelt ghy prijs en eer/ by alle goede lieden/
So ghy een ander doet/ sal selfs u geschieden.

(Here follows the fourteen-line poem quoted on p. 33.)

[Explanation in prose of features designated by letters in the engraving.]

Tot Amsterdam, Gedruct by Ian Adriaenssz, Voor *Ian
Amelissz*, Boeck-vercoper /tot/*V trecht*, Anno 1623.
[Amsterdam, Rijksprentenkabinet 1479]

**** Esth. 5. cap. *Et crucem quam fecit alteri ipsos ferat. Esth. 7.*

APPENDIX G

Die enthauptete Arminianische Schlange Sampt dero selben
verfallnem Baum.

[col. 1] ES ist nun mehr bekandt der welt/
 Was practick haben angestelt/
 Etlich die sich verbanden/
 Jüngst in den Niderlanden:
 5 Zu mörden mit verwegnem mut
 Printz Moritzen das Helden blut:
 Die Staden vmbzukehren:
 Sich machen selbst zu Herren.

[col. 2] Welches jedoch Gott hat entdeckt/
 10 Durch leut die er hierzu erweckt:
 Hiemit gemacht zu schanden/
 Die sich so kün verbanden.
 Wer nun diser verrätherey
 Vnd anschlags ein vrsacher sey/
 15 Darzu die Redlinsführer/
 Vnd fürnemste Auffrührer:

[col. 3] Die werden/ nach jhrs lebens bildt/
 Eigentlich alhie fürgebildt/
 Deßgleichen allzusamen
 20 Benennt mit jhren namen:
 Darnach jhr straff auch für gestelt/
 Vnd wie dargege Gott erhelt
 Den Printzen vnd die Staden/
 Für solcher gfahr vnd schaden.

[col. 4] 25 Der selbig durch sein starcken gwalt
 Sie gnediglich noch lang erhalt/
 Zu ehren seinem namen/
 Durch Christum Jesum/ Amen.

Ein jede Boßheit führt jhr eigne straff mit sich: Darumb für vbelthat ein
jeder hüte sich.

[engraving]

[col. 1] O! wunderliches gifft: O! listig faule schlang
 Die mit betrug die Landt wolt bringen vndern zwang.
 Wo bleibt jetz euwer rûhm/ als wern jhr recht auffrichtig/
 Die/ als der Printz war jung/ gewesen sind so tüchtig/
 5 Daß jhr (noch euwer sag) jhn habt geleit so frey/
 Daß er hierdurch die Land befreyt von schlaverey?
 Was wars/ daß euch verführt? warens vergiffte
 Schlangen?
 Die euch zur herrschens sucht machten gottloß verlangen?
 Ald war die glücksgeburt/ das gschlecht von Barnefeldt/
10 Nach euwerm wunsch vd will nit gnug hochangestellt?
 Gwüß euwer glück war groß/ sehr hoch im stand erkoren/
 Bedacht/ jhr nit auß blut der Fürsten seit geboren!
 Villeicht euch hochmût stach/ weil der von schlechtem blût
 Mit reden so vil gwann/ als kaum ein Fürst noch thût!
15 Daher euwerm sinn so eytler wohn entstanden/
 Daß ihr zu werden hofft die Grösten in den Landen!
 Das war der rechte zweck! vnd der gottloß anschlag
 Vnder des Armyans mantel verborgen lag!
 Die groß schlang/ die man lang ein lügner seyn
 vermerckte/
20 Zu disem losen wohn und hoffnung euch auch sterckte.
 Doch/ weil vertretten ist der schlangen haupt vnd schlund/
 So werdet außgereut auch jhr jetz gantz im grund:
 Dann secht! recht nach verdienst fallt shaupt zu erst
 darnider/
 Dardurch warden gemacht krafftloß die andre glider:
25 Die gleichwol all verhitzt warn zu verwegner rach/
 Doch mehr zu vndergang jhrer selbst eignen sach:
 Da meint verrätherey der rachgier zu geniessen/
 Wann sie das Heldenblut jhrs Fürsten köndt vergiessen.
 War bistu Grünenfeld/ vnd du O Stoltzenborg/
30 In euwerm faulen gmüt so sorgloß ohn all sorg/

Die jhrem Herren selbst sucht leib vnd seel zu trennen/
Der doch die feindes strick großmütig kan abrennen?

[col. 2] Doch laßt jetz hören an/ wer ist in jhrer rott?
Ersts/ Adrian von Dyckh vnd sonst ein fauler zott/
35 Als Kornwinder der zu Berckel ist schreiber gwesen:
Darnach haben sie auch (merckts!) ferner außerlesen/
Etliche Lehrer/ die an statt gesunder lehr/
Bestelten wie ermördt werd jhr recht eigner Heer:
Auch Proponenten die/ für Christlichs vnderrichten/
40 Nur wie man mörden sol einandern thun abrichten:
Dann Slatius vnd Vels geweßne Lehrer beid/
Zwen bruder gnant Blansart vergessen ehr vnd eyd:
Vnd andre/ die alhie/ zierlich nach jhrem adel/
Brangen auff diser schlang vom kopff an biß zum wadel.
45 Pfuy du gottlose rott/ die zsamen rott vnd mördt/
Behalt das gifft beysam biß jhr zur schlangen werdt/
Müßt so ellendiglich jetz kriechen in die erden:
Weil solche arge stück von euch ersts kundtbar werden.
In Eva fieng en an/ vnd Adam hats außgführt/
50 Welche/ gleich euwerm raht/ dsünd vnd den tod eingfürt:
So auch in diser zeit die sect der *Armiaenen*/
Ist ein recht böses gifft vnd nur ein eytels wähnen.
Doch secht! wie die boßheit jhr eigne straff führt eyn/
Ein rût für euwern lohn/ fürs grab den Rabenstein!
55 Vnd/ welchs ja ist ein schand/ daß man nit mehr könn
 bauwen
Sölch schnöde frucht/ so wirt der baum gantz außge-
 hauwen:
Auff daß jhr nit mehr grûnt: dem Feygenbaum gleich seyt/
Von welchem Christus sprach: damit er nach der zeit
Fortan in ewigkeit kein frücht ja nit mehr trage/
60 Daß er sol seyn verflücht: Weil dann betrug auch lage
Rechts nebet euwerm strauch/ vnd zu verfolgen suchte
Das Recht vnd Gottes Wort/ die er rasend verfluchte/
Mit zorn vnd auß rachgier: So secht jetz euwer end/
Die rûte steupt den strauch/ der baum ist voll ellend:

[col. 3] 65 Euwer verdienst/ secht! ist der Galgen vnd das Rade/
 Gott kompt daß er die straaff selbst auf die boßheit lade!
 Es kompt die Grechtigkeit/ die mit der waag abwiegt
 Böses vnd gůts/ jhr gwicht gewůß niemandt betriegt/
 Betrug jhr weichen můß: dieweil sie ist verbunden
 70 Mit wahrem Glauben: die sind betrugs tödtlich wunden.
 Dann als groß vnderscheid bey tag vnd nacht sich hellt/
 Solch vnderscheid ist/ wer böses ald gůts anstellt.
 Secht den Vranyen stamm bey disen leuten blühen/
 Mit einigkeit bekleidt/ in jhrem mittel trühen:
 75 Siben pfeil sind gehefft an dise einigkeit/
 Den Baum beschirmt der Glaub vnd die Gerechtigkeit:
 Ein Sonnstral vmb den Baum vnd Gottes Regenbogen
 Beschirmt das allzumal: deß danckbarlich wir loben
 Den geber dises Liechts/ vnd wünschen mit begier
 80 Daß der Vranyen stamm glücklich noch lang regier.
 Vranyen bleib geziert/ sein lob můß man erheben!
 Wo sind die mördersdieb die jhm stelten auffs leben?
 Fürwar sie sind zů nichts: Jhr ehrsucht hat sie gfelt/
 Vnser Fürst gloriert/ zum spott dem Barnefeldt:
 85 Der so hoch tragen war wie Haman sich erhůbe
 Jn aufgeblasenheit/ vom Tron fiel in die grůbe:
 Der/ welchen nach dem tod deß Printzen hat verlangt/
 Gleich wie Haman/ jetzund auch an dem Galgen hangt.
 Jhr läser diß betracht/ vnd thůt den hochmůt meiden/
 90 Damit jhr nit zůgleich komet in solches leiden/
 Jeder dem andern thüe/ als er jhm selbst begert:
 Vnd bleibt gern in dem stand/ welchen euch Gott
 beschert.
 Wann jhr einandern thůt/ wie jhr wünscht euch zů-
 gschehen/
 So werdt jhr preiß vnd ehr selbst von einandern sehen.

 (Here follows the fourteen-line poem quoted on p. 34.)
 [Amsterdam, Rijksprentenkabinet 1479A]

HAT nu *Amor* ein mal den rechten Pfeil gefunden,
Vnd dir ins Hertz gemacht ein solche Wunden,
　　Das er dich zu dem stand bezwungen vnd bewegt,
　　Darin man, wie man sagt, geflickte Hosen tregt.
5 War das nu deine Braut, von der du offt gesungen,
So manche schöne Nacht, das Berg vnd Thal erklungen,
　　Der Rhein vor vnser Thür zu Leiden hats gehört,
　　Wie manche stunde wier mit solcher Lust verzehrt.
So offt wir sind zusamm nach LeiderDorp gefahren
10 En daer getroncken han beym goudenen oyvaren
　　So oft wir vnsern lauff nach Catwick han gewand,
　　Vnd vnsre Leib gebad ans wilden Mehres strand,
Haben wir vnsre Lieb gestelt in kein vergessen,
Wie offt ging *à la sante de vosste matresse*,
15　　Ein grosse Flöte rumb, vom besten Frantzen Wein,
　　Wie offt sprang man auff jr gesund ins Mehr hinein
Hoe dyckwils uyt den Haag de Meyskens angekommen,
En Haeren Paß naer die dry Regenboeg genommen,
　　Off well getrocken ynn by onsen Jonker Stuel,
20　　Blibstu allzeit zu Hauß vnd dachst an deinen Bul.
Wie manchmal hastu wol bey *Heinsio* gesessen,
Vnd bey seiner *Ermgard* bey dir selbst ausgemessen,
　　Wie deine mit der zeit wol solte sein gestalt,
　　Vnd hast Jhr *Contrafect* in dein gemüt gemahlt.
25 Nu hastu was du vor so viel vnd offt begehret,
Nu hat der kleine Gott dir deinen Wuntsch gewehret,
　　Vnd wie Ich bin bericht, hastu nicht weit gefehlt,
　　Weil du dein lieb in ein solch Mägdlein hast gestelt,
Derer mit frömigkeit vnd liebreichen geberden
30 Niemand in ewrer Stadt wol mag verglichen werden,
　　Die aufferzogen ist in einem solchen Hauß,

Da nichts als Erbarkeit zu gehn pflegt ein vnd auß.
Doch sagt man sie sey Arm, da ist nichts angelegen,
Armut mit Frömigkeit hat vmb sich Gottes Segen.
35 Wo eine Reiche Fraw in ein Arm Hauß kehrt ein,
Da muß die Fraw sein Mann, der Mann muß Frawe sein.
Was wars das man sich so verstig in dem Studiren,
Wenn man nicht köndt bey sich ein Weib *alimentiren?*
Wir nicht gelernt das er sich vnd ein Weib ernert
40 Ohn seines Weibes Geld, der ist nicht ehren werth.
Das vbrig ist nichts nütz: al die soo bijster draven
Naer Ryckdoom en gewin, en acht ick niet dan slaven,
In vreden met het myn, ben rycker, dan die leeft,
Besitter van veel goets, en niet genoech en heefft.
45 Den ryckdom en licht niet in Landen ende Steden,
Maer die nit veel en heeft, en iß nochtans te vreden,
Trotst al dat wat er leeft, de kroonen en't gewelt,
De scepters en het goet iß onder hem gestelt.
So hastu auch genug, weil dein Lieb in der Jugend,
50 Gewehnet ist zu Zucht, zu Ehrbarkeit, zu Tugend,
Vnd liebet Gott vnd dich von hertzen, glaube mir,
Da darffstu keinen Hund vor deine Hinderthier.

Suo quondam lectissimo
commensali Scrib. VratisL.
Daniel Crombein
Wrizâ-Marchicus.

[*Euphorion* 8 (1901): 351–352]

THE MIRROR AND ITS IMAGE IN SEVENTEENTH-CENTURY GERMAN LITERATURE

BY BLAKE LEE SPAHR

The University of California at Berkeley

Georg Philipp Harsdörffer epitomizes the mirror as "Der Warheit Schein."[1] No better phrase could be found to typify, both in its own form (an oxymoron), and in its import (the combination rather than the juxtaposition of appearance and reality), the essence of baroque perception. The phrase suggests as well the dual nature of the mirror image, for it is not only the active reflection (the *Schein*), which presupposes an eye to witness it, but also the passive entity of Truth or Reality, existing independently and separately from its reflection or the implied interpretation of the viewer. Hence, static truth is transformed into a dynamic projection in terms of the frame of existence conditioned by appearance. The mirror is both active and passive,[2] masculine and feminine, a truly hermaphroditic symbol of the *Schein* it emanates and the *Warheit* it embodies.

[1] Georg Philipp Harsdörffer, *Deliciae Mathematicae et Physicae: Der Mathematischen vnd Philosophischen Erquickstunden Zweyter Theil* (Nuremberg, 1677), p. 240.

[2] The question of the active as opposed to the passive function of the mirror is discussed in Harsdörffer's *Frauenzimmer Gesprächspiele*, IV, 332, where it takes the following form: "Es waltet der Zweiffel; ob die Augen der Jungfrauen die Bildung in des Spiegels Grund bemahlen/ oder ob der Spiegel eine so helleuchtende Tafel sey/ welche der Jungfrauen Augen ausbilde?" The argument is then refined as follows: "Es ruhet aber im Ende die Frage darauf: Ob die Sehung geschehe/ indem die Stralen aus dem Auge/ oder in des Auge schiesen" and is finally resolved: "Die Stralen hab ich jederzeit mit den Feuersflammen

Harsdörffer is referring, of course, to the mirror image and not
to the mirror itself, but the phenomenon which he describes is im-
plicit in the use of mirror imagery. Such subtlety is thoroughly in
keeping with the baroque age, so congruent, in fact, that it is taken
for granted and felt without the necessity for analytic dissection.
Hence, when a lady is characterized, in what I should like to term
the *prototype image*, as "ein Spiegel der Tugend," or "Spiegel weib-
licher vollkommenheit,"[3] the mirror image, as well as the mirror
itself, is understood. In other words, the lady herself is the mirror;
and the image, either external or internal, which she casts is the
quality she embodies passively and reflects actively. It is as though
Virtue or Perfection stood before the phenomenal form of the lady-
mirror or mirror-lady, and she, in her *Erscheinungsform*, reflects
the essence of the quality regarded. *She* is not Virtue, she is the
reflection of virtue; she acts as a visual distillate yielding the abstract
qualities, not in appearance, but in idea, in the Platonic sense. She
becomes the prototype of Virtue.

It is taken for granted in the application of this conceit that the
viewer is outside the frame of reflection, in another dimension, for
he cannot see himself in this mirror figure, he "sees," that is, con-
ceptualizes, the abstract quality of the lady (virtue, perfection, etc.)
within the framework of her acting as the mirror instrument of the
personification, still in an abstract sense, of the virtue reflected. It
is as though the poet, describing his lady in these terms, is standing
at the side of a little act in which the abstract quality holds up the
mirror of the lady and sees itself reflected in her actions which are

vergleichen hören/ deren Mittelpunkt in dem Aug/ und ihre Grundbreite [mar-
ginal gloss: *Basis*] auf dem gesehenen Dinge hafftet. Man reibe die Augen in
der Finsteren/ so wird man sehen/ daß gleichsam etliche Fünklein herausglent-
zen." See also the excellent discussion from a different perspective by Frederick
Goldin, *The Mirror of Narcissus in the Courtly Love Lyric* (Ithaca, 1967), p. 4
and passim.

[3] For the sake of convenience, a modern edition, anthology, or reprint will
always be cited rather than the original edition. Martin Opitz, *Teutsche Poemata*,
ed. G. Witkowski, Neudrucke deutscher Literaturwerke des XVI. und XVII.
Jahrhunderts, no. 189–192 (Halle, 1902), "An die Teutsche Nation," p. 15.

manifestations of the quality which views itself. The poet is able to see the lady and the reflection she casts, but he does not mar the mirror image by standing in such a position that he too is reflected. The conceit of the abstract mirror becomes stereotyped in these terms, which, although seemingly complex, are completely in keeping with an age in which *catoptrica*, the "science" of reflection, is a legitimate branch of optics. Athanasius Kircher devotes a large section of his *Ars Magna Lucis et Umbrae*[4] to complicated discussions of the mirror and its reflections.

The application of this image is, of course, not restricted to the lady, but is transferred to any number of other agents of reflection, always with the same basis understood. A poet involved in the description of abstract or concrete qualities may regard his book as a mirror which he is holding up to that which he is describing, and such titles as *Spiegel der Ehren des . . . Erzhauses Oesterreich* result. This conceit is by no means restricted to the seventeenth century; it can be traced to classical antiquity and perhaps beyond,[5] but in the baroque age, with its predilection for introspection, the mirror reflection of abstract qualities is particularly appropriate. Jacob Böhme, in his *De Signatura Rerum*[6] describes his book as follows: "Als wil ich den Leser trewlich gewarnet vnd jhme für Augen gestellet haben/ was mir der Herr aller Wesen gegeben hat/ Er mag sich von jnnen vnd von aussen in diesem Spiegel besehen/ so wird er finden/ wer er sey." Grimmelshausen postulates the baroque conviction well: "daß die meisten Menschen verdampt werden/ ist die Ursach/ daß sie nicht gewust haben/ was sie gewesen/ und was

[4] Athanasius Kircher, *Ars Magna Lucis et Umbrae in Decem Libros Digesta* (Rome, 1646); see especially "Pars tertia: magia catoptrica, sive de prodigiosa rerum exhibitione per specula."

[5] See Sister Ritamary Bradley, "Backgrounds of the Title *Speculum* in Mediaeval Literature," *Speculum* 29 (1954): 100–115.

[6] Jacob Böhme, in *Die deutsche Literatur: Texte und Zeugnisse*, 2nd ed., 6 vols., ed. W. Killy; vol. III, *Das Zeitalter des Barock*, ed. A. Schöne (Munich, 1968), p. 81. Hereafter cited as Schöne. This anthology, the most extensive as well as the most readily available, will be cited whenever possible.

sie werden können/ oder werden müssen,"[7] and the dynamism implied in "daß du dich je länger je mehr selbst erkennen sollest,"[8] is in keeping with both the mobile nature of the mirror image and the reflection of inner qualities described above.

Harsdörffer deepens and allegorizes the concept by proposing: "daß das Aug unsers Verstandes nichts zierlichers betrachten könne als sich selbsten/ den Spiegel unsers Hertzen/ in welchem gleichsam nach dem verjüngten Maßstab alle Bewegungen desselben erhellen."[9] Our understanding, our reason, the rational interpreter of our inner self should regard itself, and the reflection will yield the image of the heart, seat of the essence of our emotional and spiritual being. By this introspective process we can then judge our spiritual being through the eye of understanding. By this refraction our essence is diffused into its component parts and we can judge our moral being by our thought. For Harsdörffer this rational process is paramount. "Ein Thier bespiegelt sich auch in dem hellen Wasser/ aber ohne allen Verstand; Der Mensch aber allein erkennet sich in dem Spiegel/ und nimmet daher Ursach sich zu verwundern/ in dem er augenscheinlich betrachtet/ daß er auch an sich hat/ was er nicht weiß/ und ohne Spiegel in seinem Angesicht nicht sehen kan: deßwegen auch der Spiegel für die Erkanntnuß sein selbst gebildet wird/ und ist die Demut der Silbergrund/ zu solcher Erkanntniß zu gelangen."[10] Thus the mirror is elevated through un-

[7] Grimmelshausen, *Der Abentheurliche Simplicissimus Teutsch und Continuatio,* ed. R. Tarot (Tübingen, 1967), bk. 1, ch. 12, p. 35.

[8] Ibid.

[9] Harsdörffer, *Deliciae Mathematicae,* p. 233.

[10] Ibid, pp. 233–234. On the other hand, the gallant poets or those who employ the mirror symbol as a moralistic vanity motif stress the surface nature of the reflection. Cf. Logau: "Der Spiegel kan zwar weisen; doch kan er reden nicht; | Sonst hätt er manche Stoltze im Irrthum unterricht." (*Friedrich von Logaus Sämmtliche Sinngedichte,* ed. G. Eitner, Bibliothek des Lit. Vereins Stuttgart [BLVS], no. 113 [Tübingen, 1872], p. 547); or Sigmund von Birken: "Ich mag einem Glas nit trauen | u. was soll der ausen-Schein? wahre Zier muß innen seyn" (in the unpublished work "Amaranten Garten," leaf 176ᵛ). Angelus Silesius, who uses the mirror in its other sense, also maintains: Der Spiegel zeiget dir dein äußres Angesicht. | Ach, daß er dir doch auch das innre zeiget

derstanding to a mystic level, on which man is shown aspects of his being of which he is unaware. But humility, in the sense of Christian objectivity, serves as a counterpart to vanity and must temper man's understanding so that he will not view himself according to his external appearance, but rather according to the truth behind it made visible by the mystic mirror.

In another place, Harsdörffer revises his viewpoint and lets one of the characters in the *Frauenzimmer Gesprächspiele* dispute the question. Vespasian maintains: "Ich gestehe gerne/ daß der Mensch allein seine Gestalt in dem Spiegel erkennet/ aber nicht seine Schwachheit/ und dieser Mangel kommet nicht von seinem Verstand/ sondern von seinem verderbten Willen her."[11] Understanding is a servant of the will. The will, in turn, must be rooted in the knowledge that man is God's image, not the external mirror image, which is transitory and ever-changing. The inner image is visible only through the eye of understanding motivated by divine will. The entire gist of the discussion is summed up by the proverb "Was soll dem Blinden der Spiegel?"—both the blind man and the mirror are to be understood in a concrete and in an abstract sense.

The mirror in its function of depicting reality has another quality that is lacking in pictorial art. It is the one instrument which can inject movement into its image. As such it captures a baroque ideal so evident in the architecture of the age. The mirror vaunts itself as an artist superior even to Alexander's portraitist:

> Apelles mahlte zwar die bilder nach dem leben.
> Doch kont' er ihrer zier nicht die bewegung geben.
> Ich aber thu, was kein Apelles je gethan.
> Ich mahl ein Contrafait, daß sich bewegen kan.[12]

Yet the movement of the mirror image is more than dynamism; it

nicht! Angelus Silesius, *Sämtliche Poetische Werke*, ed. H. L. Held, vol. III, *Cherubinischer Wandersmann* . . . (Munich, 1949), p. 158: "Cherub. Wan.," IV, 118.

[11] Harsdörffer, *Frauenzimmer Gesprächspiele*, IV, 337.

[12] Nicolaus Ludwig Eßmarsch, *Helicon*, Glückstadt and Leipzig, 1707, p. 143.

is also symbolic of the quality which causes constant lament in the
Baroque Age—inconstancy. The image is ever-changing, never
still, hence it typifies the lady's affection: Und daß ihr hertz sich
spiegeln gleicht/ Wo iedes bild sich/ doch nicht stetig/ zeigt.[13] And
even Simplicissimus identifies himself as "ein Spiegel der Unbestän-
digkeit deß Menschlichen Wesens."[14] The figure combines the
prototype image with the object that symbolizes inconstancy in its
own right and thus constitutes an example of the amalgamation of
form and content.[15]

An additional baroque extension of the mirror conceit is to pro-
ject the whole underlying manner of thinking into a personalized
environment which further complicates its complexity. The physio-
logical equivalent of the mirror is the eye—that part of the body
which reflects in human terms the mechanical characteristics of the
mirror. The eye, also, is capable of taking into itself the image from
without and of extending that image inward in terms meaningful
to human understanding. Hence it shares the dual function of the
mirror. But, beyond this, the eye projects the sentiments of the heart
and in this respect has an active function. This complicated conceit
is widely employed. Paul Fleming apostrophizes the eyes of his
beloved:

> Ihr seid es, die ihr mir die meinen machet blind
> ihr lichten Spiegel ihr, da ich die ganzen Schmerzen
> leibhaftig kan besehn von mein und ihrem Herzen.[16]

[13] *Benjamin Neukirchs Anthologie Herrn von Hoffmannswaldau und andrer
Deutschen auserlesener und bißher ungedruckter Gedichte erster (anderer) Theil,*
ed. A. G. de Capua and E. A. Philippson, NDL, n.s. nos. 1 and 16 (Tübingen,
1961 and 1965), anonymous poem, pt. 1, p. 431. Hereafter cited as Neukirch,
I or II.

[14] Grimmelshausen, *Simplicissimus,* bk. 6, ch. 15, p. 536.

[15] On the other hand, a gallant conceit lets the mirror image become a constant
which is taken away by the stream that reflects it. See Hans Aßmann Freiherr
von Abschatz, *Anemons und Adonis Blumen,* ed. G. Müller, NDL, no. 274–277
(Halle, 1929), p. 28.

[16] Paul Fleming, *Deutsche Gedichte,* J. M. Lappenberg (BLVS), no. 82
(Tübingen, 1865; reprinted Darmstadt, 1965), I, pp. 496–497.

Here the eyes of his mistress reflect not only her own pain, in their active function as mirror of the heart, but also the pain of her lover, combined in her eyes to so great a degree that the image causes the exclusion of itself in blindness, perhaps occasioned by tears. The image is echoed more simply by Birken, who calls his eyes "seiner Schmerzen Spiegel."[17] The active function of the eye-mirror is stressed in a baroquely mixed metaphor by Johann Christoph Göring as he writes:

> Der Augen helleSpiegel-Glantz
> kann bald die Jung-Gesellen gantz
> mit Liebe stekken ahn/
> Wenn sie die güldne Strahlen-Saat
> außstreuen so durch Venus Raht
> auff unsern Hertzens-Plahn.[18]

And, in an uncertainly identified poem—perhaps by Lohenstein— the prototype conceit is combined with that of the eye as mirror in an example also notable for an extreme instance of tmesis:

> Auff schöne Augen
> Ihr/ die ihr doppelt vor- der liebe spiegel -stellt/[19]

Here, the eyes are the mirror of love, just as the lady may be the mirror of virtue (prototype image), yet, as a mirror image, they doubly represent this same function.

C. Eltester also combines the eye-and-mirror image with a motif borrowed from the Narcissus myth when he addresses his lady's mirror and tells it:

> Wirff ihren glantz zurück/ der durch die augen blitzt/
> Und laß dieselbe glut/ die mich und dich erhitzt/

[17] Sigmund von Birken, "Pegniz-Abschied des verzweifelten Silvano," "Amaranten Garten," leaf 159[r].

[18] *Barocklyrik*, ed. H. Cysarz, Deutsche Literatur in Entwicklungsreihen, 3 vols. (Leipzig, 1937; reprinted Hildesheim, 1964), I, 206. Hereafter cited as Cysarz, I, II, or III.

[19] Neukirch, II, 26.

Ihr aug und hertze selbst durch eigne krafft verletzen.[20]

Finally, Harsdörffer reverses the image in his mirror riddle and lets the mirror act as the eye, rather than the eye as a mirror:

> der ich ohn Augen bin mach' aller Augen schauen.
> Was ich gesehen hab/ das bild ich treulich vor/[21]

The mirror, by virtue of its function, is connected also with a favorite baroque vice, vanity, and especially in connection with the feminine sex. At the same time this vice may serve as the basis for the gallant compliment paid to the lady's beauty, most gracefully phrased by Hofmannswaldau:

> Und du/ Berinne/ kanst in einem spiegel weisen/
> Wie gold und lieb allein im feuer dauren kan.[22]

But the gallant compliment may be turned around and the mirror's truth be used in satiric fashion. Erdmann Neumeister insults his Laura by reversing the Narcissus myth:

> Hier ist es umgekehrt/
> Wenn Laura sich im spiegel will beschauen/
> So fängt ihr an zu grauen/
> Und laufft zum hause naus/
> Als wenn der teuffel selbst zum spiegel seh' heraus.[23]

The insult reflects the old superstition embodied in the saying; "Wer nachts in den Spiegel sieht, hinter dem wird der Teufel sichtbar."[24]

Opitz extends the gallant compliment to a conceit when he presents his beloved with a mirror:

[20] Neukirch, I, 57–58.
[21] Cysarz, II, 140.
[22] Neukirch, I, 34, "Cupido an Berinne," lines 27 and 28.
[23] Neukirch, II, 120.
[24] See H. Bächtold-Stäubli et al., *Handwörterbuch des deutschen Aberglaubens*, vol. IX, "Nachträge" (Berlin, 1941), cols. 546–577. G. F. Hartlaub in his book *Zauber des Spiegels* (Munich, 1951), discusses this motif (pp. 154 ff.) and illustrates his discussion with several paintings.

> Den Spiegel send' ich euch, jhr Spiegel aller Frawen,
> Daß jhr die Göttligkeit an euch recht möget schawen,
> Ob gleich kein Spiegel ist zutreffen jrgendt an,
> Der euch, jhr schönes Bild, schnurrecht entwerffen kan.[25]

The implication, continued in the remainder of the poem, is that the mirror is able only to reflect the visual image, but not its effect on the viewer, a conceit which may be found in other gallant poems.[26]

In the gallant poetry of the age, the mirror serves as a bearer for virtually all the themes and motifs customary to these courteous compliments. It is a favorite present to the beloved,[27] especially with the connotation that it will reflect her beauty; the theme of envy of the lady's mirror because she gazes upon it is as common as the envy of her lapdog;[28] it combines with Petrarchistic descriptions of the lady's anatomy, sometimes with grotesque effect, for example when Johann Christian Günther compares the breasts of his lady with a magic mirror because they are always in motion.[29] In short, it functions as an instrument of gallantry with its own range of connotative association.

However, a main area in which the mirror functions as a significant symbol is that of religious verse. In its heritage from the mysticism of the late Middle Ages, the mirror is associated with man's

[25] Opitz, *Teutsche Poemata*, p. 79.

[26] See, for example, Opitz, *Buch von der Deutschen Poeterey*, ed. R. Alewyn, NDL, n.s. no. 8 (Tübingen, 1963), pp. 43–44:

> Du sagst/ es sey der Spiegel voller list/
> Vnd zeige dich dir schöner als du bist:
> Komm/ wilt du sehn das er nicht lügen kan/
> Vnd schawe dich mit meinen augen an.

[27] For example, Gryphius, "An Eugenien" (Andreas Gryphius, *Gesemtausgabe der deutschsprachigen Werke*, ed. M. Szyrocki and H. Powell, vol. II, *Oden und Epigramme*, NDL, n.s. no. 10 [Tübingen, 1964], p. 190) discussed below; or Opitz, *Teutsche Poemata*, p. 79, in which the same motif is used in the first line of either poem.

[28] See, for example, the poem by Fleming (*Deutsche Gedichte*, I, 497).

[29] Johann Christian Günther, *Sämtliche Werke*, ed. W. Krämer, BLVS, no. 275 (Stuttgart, 1930; reprinted Darmstadt, 1964), p. 30.

soul "als 'stiller' und ungetrübter Spiegel, der bei rein leidendem
Verhalten das Bild Gottes in der unio mystica in sich aufnimmt und
zurückstrahlt."[30] Harsdörffer, suggesting the emblem for this con-
text, proposes a mirror turned toward the sun with the superscript
"Zu dir allein," and with the interpretation "eine Gottergebene
Seele . . ./die sich von der Welt Eitelkeit zu der Ewigkeit ge-
wendet."[31] The same emblem is used by Johann Arndt with the
superscript "Mit aufgedecktem Angesicht," derived from 2 Cor.
3:18,[32] and by Abraham a Sancta Clara,[33] who extends the basic
image also to the Holy Ghost.

But the mystic mirror has its foundation in the seventeenth cen-
tury in the works of Jacob Böhme, for whom the concept of the mir-
ror forms a basic image in the development of creation from the
Ungrund. I shall not attempt to discuss the implications of Böhme's
complex imagery which plays relatively little part in the literary
application of the mirror image, and which would merit an investi-
gation of its own. I may mention, however, that in Böhme's first
ideal scheme of creation (which is followed by a later *substantial*
scheme), wisdom is depicted as the one will of the *Ungrund* and is
likened to an empty mirror. This image represents ideally for
Böhme his elusive concept of an essence which in itself is nothing,
yet which conceals "alle Gestalt der Natur darinne, . . . gleich als

[30] August Langen, "Zur Geschichte des Spiegelsymbols in der deutschen Dich-
tung," *Germanisch-Romanische Monatschrift* (*GRM*), 28 (1940): 270. Langen
underestimates the importance of the mirror as a symbol in the seventeenth cen-
tury when he maintains: "Auch die weltliche Dichtung der Barockzeit ver-
wendet das Motiv oft genug, aber selten oder nie als Träger eines wesenhaft
geistigen Gehalts."
[31] Harsdörffer, *Deliciae Mathematicae*, pp. 265 ff. Of all the baroque poets,
Harsdörffer is the poet most fascinated with the mirror. He admits: "wir [beken-
nen] schließlich/ daß wir von Jugend auf in diesem Stucke gleich dem Narcisso
gewesen/ der sich in dem kalten Krystallbrunnen/ ich will sagen diese Spiegel-
kunst/ verliebet/ . . ." (ibid., p. 235).
[32] Johann Arndt, *Sechs Bücher Vom Wahren Christentum* (Erfurt, 1735),
sig. a2[r].
[33] Abraham a Sancta Clara, *Abrahamisches Gehab dich wohl!* (Vienna and
Nuremberg, 1738), p. 189.

ein Nichts, und ist doch wahrhaftig, aber nicht essentialisch."[34]
The emblem for the *Sex Puncta Theosophica* illustrates this basic
concept by a *Spiegel der Weisheit*. Angelus Silesius combines the
same figure with the prototype image:

> Die Weisheit schauet sich in ihrem Spiegel an.
> Wer ist's? Sie selber und wer Weisheit werden kann.[35]

The prototype image is frequently applied to man in a general way
as well as in a specific way. His soul should stand before the mirror
of God's commandments;[36] he should reflect God's image;[37] and his
heart should be a mirror capable of showing the glory of God.[38]

But the prototype image is carried further by Rompler von
Löwenhalt to the extent that the heart is not only in a figurative
sense the mirror of God, but its purification is taken step by step
through the actual fabrication of a mirror, clarified by faith, pol-
ished by adversity. God's word is its silver face, glued fast by Love.
The frame is from the wood of the cross, and God's grace provides
the gilding. The whole is decorated with deeds of virtue. The bril-
liance of God's reflection in his heart-mirror will blind evil de-
sires. A truly baroque construct in which, as Cysarz puts it: "Mys-
terium und Mechanismus in Wechselbeziehung [treten]."[39] Not
only is the heart symbolized, but the symbols inherent in the manu-

[34] Jacob Böhme, *Sex Puncta Theosophica, oder Von sechs Theosophischen
Puncten hohe und tiefe Gründung, Facsimile Neudruck*, ed. W.-E. Peukert
(Stuttgart, 1957), vol. IV, pt. 6, p. 5. See also the discussion of Böhme's mirror
symbol by Howard Haines Brinton, *The Mystic Will* (New York, 1930), pp.
185 ff.

[35] Angelius Silesius, *Sämtliche Poetische Werke*, p. 25: "Cherub. Wan.," I,
166.

[36] Daniel von Czepko, *Weltliche Dichtungen*, ed. W. Milch, Einzelschriften
zur Schlesischen Geschichte, vol. 8 (Breslau, 1932; reprinted Darmstadt, 1963),
"Geistliche Gedichte unsicherer Verfasserschaft," "Bußlied," p. 439.

[37] Angelius Silesius, *Sämtliche Poetische Werke*, p. 18: "Cherub. Wan.," I,
105; Catharina Regina von Greiffenberg, "Das beglückende Unglück," Cysarz, II,
194–195.

[38] Rompler von Löwenhalt, Cysarz, I, 188–189.

[39] Cysarz, I, 35, "Barocke Lyrik und barocke Lyriker."

facture of the mirror receive a separate spiritual symbol for them-
selves. And the total image acts as man's defense against evil.

This same theme is also formalized in a similar construct by Mor-
hof in which a true friend is compared to the various parts of a mir-
ror according to their respective characteristics. Thus, a mirror's
glass is clear and pure as a true friend should be, whereas its re-
flector is of lead symbolizing a true friend's firmness and con-
stancy.[40] This technique is, in turn, employed for a man as a mirror
of God by Catharina Regina von Greiffenberg who would see man
"zugericht . . . durch Creutzes-Stahl,"[41] if he is to mirror God
truly. The same image is to be found in Arndt's devotional book
Vom Wahren Christentum, where God's glance as He regards Him-
self in the mirror of the true Christian penetrates man's being:

> . . . und gibt sich dir
> Mit sehnlicher Begier
> Zu schmecken und geniessen.[42]

Man is more than a mirror of God's image, for he reflects also the
"Gleichniß des unsichtbaren Gottes, und seiner überaus schönen
innerlich verborgenen Gestalt."[43]

In its broadest application the mirror image and its reflection be-
come the basic, underlying principle of the universe and transcend it
to represent a microcosm parallel to man himself. All of creation is
a mirror "in welchem da leuchtet des höchsten Werckmeisters/
Meisterstück."[44] The light of the planets illumines the earth only
because they are mirrors, and the great *Weltaug*, which sees every-
thing, is itself seen only in the mirror by man's weaker eyes.[45]
Like man himself, the mirror forms a little world, for in it the

[40] Daniel Georg Morhof, "Wahrer Freundschafft Spiegel," Cysarz, III, 29–30.
[41] Cysarz, II, 195.
[42] Arndt, *Sechs Bücher*, sig. a2ᵛ.
[43] Cf. also Abraham a Sancta Clara, *Abrahamisches Gehab dich wohl!* pp. 189
ff., where the clergy is compared to a mirror.
[44] Johann Arndt, selection from bk. 4, ch. 2 in Schöne, p. 70.
[45] Harsdörffer, *Deliciae Mathematicae*, p. 234.

macrocosm may be observed. It conquers both time and space, since "das Ferne ist nahe/ und wird ohne Bewegung Flügelgeschwind ereilet."[46] Its effect is "Geistschnell und pfeilet in einem Augenblick."[47] It is indeed capable of all things. It is man's true guide as well as his faithful friend, for it laughs when he laughs and weeps when he is sad. It bears true witness, untainted by hearsay. It is a touchstone of the years, the privy adviser of beauty's toilet, the high judge of cosmetics, and the soothsayer of woman. Man is a reflection of the universe as his countenance is a mirror of his thoughts, his speech a mirror of his deeds, and his form a mirror of his character. The mirror is "diese beleuchte Erden"[48] which reflects the glory of the heavens, indeed, the mirror unites mystically heaven and earth. Brockes expresses this thought in the most sensitive terms when he observes a fishpond in the garden:

> Das glatte Wasser scheint ein Glas
> Von einem rein polirten Spiegel,
> Der, an der Seiten, uns der Erden grüne Zier,
> Und, in der Mitte, gar den himmlischen Sapphir,
> Des Tages voller Glantz, des Nachts voll Sterne, zeiget,
> Und so die schöne Pracht des Himmels und der Welt
> Verdoppelt uns vor Augen stellt . . .
> Man kann, wenn man's erweget, finden,
> Wie, voller Licht und Klarheit, hier
> Des Himmels und der Erden Zier,
> Auf einer Stelle, sich verbinden.[49]

As the embodiment of reality, tangible only in appearance, it is the perfect symbol of man's inability to attain the essence of being. He may witness it and be assured of its presence, but it flees be-

[46] Ibid.
[47] Ibid.
[48] Ibid.
[49] Barthold Heinrich Brockes, *Auszug der vornehmsten Gedichte aus dem . . . Irdischen Vergnügen in Gott* (Hamburg, 1738; reprinted Stuttgart, 1965), "Der Fisch-Teich," p. 211. I am indebted to my former student Professor Barton Browning (Pennsylvania State University), for this reference.

fore him and disappears in an instant. Like all phenomenal signs
of man's earthly existence, the mirror image is transitory and vain,
and how better symbolized than by the accouterment of vanity?
Yet the truth of its appearance is not to be denied; the fact of its
image is not to be questioned. Only the passing permanence of
that image, the fleeting reality of the appearance, will fade and dis-
appear. Man has been a witness to his earthly existence, he has seen
the unsubstantial substance of his life, a reflection in the mirror of
time. But as that reflection is unreal, yet present; is true, yet chang-
ing and inconstant; is self-evident, yet incorporeal; so also is man's
life on earth. Hofmannswaldau, who will transcend even this image
by denying our existence totally, asks: "Was ist das grosse Nichts/
so Welt und Erde heisset/ . . . ?" and answers appropriately by
destroying the mirror image by which it is represented: "Ein Spiegel
ohne Grund/ ein Saal von schlechtem Lichte/ . . ."[50]

In this age the mirror image has a tremendous fascination. It per-
meates the science, the art, the philosophy, and the mysticism of the
day. Not only Versailles may boast a hall of mirrors; mirrors are
present in every baroque palace from Pommersfelden to Persia.
Adam Olearius describes the mirror rooms of the king of Persia
with great admiration, where the lower walls "mit vielen grossen/
vnd etlichen hundert kleinen Spiegeln/ so alle in den Wänden or-
dentlich eingemauret/ und künstliche gestellet/ gezieret. Daß/ wer
in der mitten stund/ seine gestalt vielfältig auff einmal sehen
kunte." Or another room, where "an den Wänden vnd Decke nicht
eine Handbreit etwas anders als Spiegel gesetzet."[51] The constant
interchange of reality and reflection, the active projection and the
passive receptivity, are so ingrained in baroque thought that one
may speak of *Spiegeldenken*. The short mirror vignette, motionless
only for an infinitesimal instant of time, is the perfect visual rep-
resentation of baroque thought. And the duality of the phenomenon

[50] Hofmannswaldau, "Verachtung der Welt," Schöne, pp. 923–924.
[51] Olearius, "Offt begehrte Beschreibung Der Newen ORIENTALischen
REISE," Schöne, p. 790.

is a formal representation of both style and content in baroque literature: the reality, which cannot be viewed by itself, and the appearance of the image, which has no real existence. These are two separate forms of existential condition in which no identity may be established. Here is a symbol of flesh and the spirit, of *Sein* and *Schein*, of substance and form, which is endowed with another dimension, that of the viewer outside of the image and its reflection. The dualistic manner of projecting reality is a commonplace of baroque literature, but in the mirror image it finds not only a symbol but also an amalgam of content and style. Let us use a short example from the poems of Gryphius, chosen not only because it employs the mirror-image technique, but because it illustrates it by means of the mirror itself. It is the short strophe to his Eugenie:

> Den Spigel schenck ich euch/ O Spigel höchster Zucht/
> In dem ihr schawen mögt was ich bißher gesucht.
> Kan iemand euch was mehr Wohl-Edle Jungfrau geben/
> Als diß in dem ihr euch seht gehn und stehn und leben?
> Doch könnt ihr/ wenn ihr gebt/ was ich so hoch begehrt
> Mir geben/ was in euch mir doppelt mich gewehrt.[52]

In each line we find a reflection, on the level either of abstraction or of worldly appearance, sometimes reflected back upon itself. In the first verse, for example: "Den Spigel schenck ich euch/ O Spigel höchster Zucht/" the word *Spigel* is reflected back upon itself quite literally, but in the first instance its referent is a literal mirror, whereas in the repetition, it is used in a figurative sense, in the abstract prototype image. But, in addition, the appellative "O Spigel höchster Zucht" is the glorified image of "euch," the Eugenie to whom the poem is addressed.

The second verse repeats the technique: "In dem ihr schawen mögt was ich bißher gesucht." The whole clause, "was ich bißher gesucht," is indeed that which she may see in the mirror, or, in other word, the reflection of the first half-line, the nearer characteriza-

[52] See footnote 27.

tion of what she will see, but with the personal connection to the poet. Simultaneously, both halves of the line reflect also both halves of the preceding line, each respectively. We could put each half-line together with itself equally well as reflection; that is "Den Spigel schenck ich euch/ In dem ihr schawen mögt" as opposed to "O Spigel höchster Zucht/ was ich bißher gesucht."

In the third line: "Kan iemand euch was mehr Wohl-Edle Jungfrau geben," the appellation "Wohl-Edle Jungfrau" is the expanded, "visualized" image, reflected by the colorless, neutral "euch" of the first half-line, as well as the further reflection, in yet another dimension, of the preceding half-lines above it.

The fourth line, "Als diß in dem ihr euch seht gehen und stehn und leben?" has the balanced reflection "ihr : euch" connected by the visualization "seht" to the three formally similar verbs "gehn, stehn," and "leben," whose similarity is as a single original, reflected in three slightly different mirrors.

The fifth line: "Doch könnt ihr/ wenn ihr gebt/ was ich so hoch begehrt" (the clause parallels exactly "was ich bißher gesucht"), has a rhythmic reflection in the first half-line ('könnt ihr/ wénn ihr), while the second half-line is again, as in the first three verses, the characterization of Eugenie in terms of the poet's desire, the repeated "ihr" of the first three feet. The final line, "Mir geben/ was in euch mir doppelt mich gewehrt" gives the impression that all the mirrors of the preceding lines were combined to reflect, refract, and diffuse the image, not only in form but also in meaning. "Mir geben" parallels "mir gewehrt," though the latter two are significantly separated by "doppelt mich." Moreover, the "mich" is a different identity from the "mir," being the combined image of Eugenie ("in euch") with the poet, as well as the true inner "mich," as opposed to the surface "mir." The whole dependent clause is again a reflection of the preceding second half-line.

Hence the poem is not only the dedicatory poem to accompany the gift of a mirror, but in effect it is a mirror in itself. The mirror gift is symbolic of Eugenie, who would, in giving herself to the poet, as

a mirror reflects the image of the viewer (in this context, giver), also give him doubly to himself (since he is a part of her in the mirror) and, moreover, through this joining of appearance and reality, will combine the two parts of his "self" to a true identity. The poem is an example in several senses of the mirror structure.

Hence, formally, structurally, and in content, the poem illustrates what I should like to call *Spiegeldenken*. The mirror image, as mentioned above, represents the favorite baroque theme of *Sein* and *Schein*, but with the added interpretative aspect, implied by the viewer outside the mirror image. The poet presents a neutral essence, devoid of characteristics, identified only by name or pronoun, then amplifies this entity in terms of its role, its appearance, its worldly attributes or the accouterments which give it its contextual place in the social, political, or religious surroundings, or its relationship to the subjective attitude of the poet. These contextual attributes endow the neutral *ontos* with its relative significance to the phenomenological world about it. And only in the image, the reflection which orients it to its place in reality, does it quite literally play a role in existence.

The Alexandrine line lends itself admirably to the mirror structure. The caesura is frequently the gap between neutral reality and contextual appearance, in which it is most characteristic that the statement of reality assumes the baroque form of a question, while the appearance is the answer, or the clause which modifies the key word of the question: "Was sind wir Menschen doch?" asks Gryphius, and the neutral "Mensch" is reflected in the mirror of existence in terms of its relationship to the context of the answer: "ein Wohnhauß grimmer Schmertzen . . ."[53] The word *Schmertzen* connects the reflection subjectively to the poet's interpretation.

"Was ist die Schönheit wohl? Ein Gifft das Hertzen zwinget/" is Zesen's question with the reflection-answer echoed a few lines later in the description: "ein Spiegel voller List."[54]

[53] Cysarz, II, 185.
[54] Cysarz, II, 88.

The mirror image in the poetic line is often reflected verbally in its characterization:

> Erhöre meine Noth/ du aller Noth Erhörer/
> Hilff Helffer aller Welt/ hilff mir auch/ der ich mir
> selb-selbst nicht helffen kan.[55]

It may take the form, as above, of a chiasmic construction reflecting the mirror's enantiomorphic property, that is, of showing the right on the left side and vice versa.

> Ich weiß nicht was ich bin/ ich bin nicht was ich weiß[56]

and

> Nicht du bist in dem Ort, der Ort, der ist in dir;[57]

and

> Zeit ist wie Ewigkeit und Ewigkeit wie Zeit[58]

are examples from Angelus Silesius, who is especially fond of this construction. Just as a defective mirror sometimes reflects imperfectly, we find such examples as "Ruh ist das höchste Gut, und wäre Gott nicht Ruh,"[59] where "Ruh" reflects itself enantiomorphically at the beginning and end of the line, whereas "Gut" is reflected imperfectly in the mirror and appears as "Gott."

I am not suggesting that the mirror structure takes the place of the rhetorical devices of which it is also an example, but I would propose that the predilection of the baroque age for certain types of rhetorical devices is conditioned by the duality which I have characterized as *Spiegeldenken*. And mirror structure may be regarded as the bearer of these devices, just as the mirror motif is the bearer for other baroque themes. Such structure is not, of course, restricted to

55 Paul Fleming, "An meinen Erlöser," Cysarz, II, 9.
56 Angelus Silesius, *Sämtl. Poet. Werke*, III, p. 7: "Cherub. Wan.," I, 5.
57 Ibid., p. 27: "Cherub. Wan.," I, 185.
58 Ibid., p. 12: "Cherub. Wan.," I, 47.
59 Ibid., "Cherub. Wan.," I, 49.

the poetic line, which is only a particular unit of it. Examples are given above of mirror words, and certainly various manneristic devices, such as the sonnets of the Nuremberg poets which are repeated in reverse order, may be regarded as mirror structures as well.

Spiegeldenken, moreover, goes beyond the usual baroque *Schein*-and-*Sein* topos, for the mirror does not show an unreal or apparent appearance. As pointed out above, the mirror permits us to view ourselves as others see us, but with the important distinction that the view with which we are faced is altered and deepened by the self-knowledge we possess outside our image. We may see the costume of the court, the handsomeness of physical attributes, the characteristics of our role, but in this process of introspection we may, by virtue of our own self-knowledge, see beneath the mask which faces us. Hence, a tinge of irony may pervade the view. Sigmund von Birken, the very model of a literary servant of princes, sees himself not as the courtly poet, but as the court dog, living on the scraps from ducal dishes.[60] Not only is the surface role reflected, but the deeper significance beneath its appearance, as well. The double triangular structure of *Simplicissimus* has long been noted, in that as Simplex's materialistic fortunes improve and rise to a high point, his moral fiber is corrupted and he sinks lower and lower as an ethical being. But after the high point of his worldly fortunes is reached, when his lot begins to decline, he regains his sense of moral values relatively in the same proportion until he ends as he began, separated from the world and its values. I would add that the concept of *Spiegeldenken* provides the dynamism in this structural development by regarding the image as in a mirror which moves ever farther from the object, until the high point is reached at which the separation of moral and material is greatest; then the mirror is brought ever closer until the image and the reality coalesce, and Simplex's true identity is established.

[60] Sigmund von Birken, "Lob- vnd Leichschrift eines Hof-Lewhundes, Namens Männchen," in *Guelfis oder NiderSächsischer Lorbeerhayn* (Nuremberg, 1669).

So the mirror is a truly baroque instrument, in which the prevailing duality of existence is incorporated and projected. It is a genuine symbol, of which the symbolic import gains a reality of its own by extending itself into style, content, and even a manner of thinking. It is the means of self-knowledge and the reflection of the role. It shows us the "real" image beneath the mask of reality. It is indeed "Der Warheit Schein."

THE GERMAN BAROQUE OPERA
LIBRETTO: *A Forgotten Genre*

BY JOHN D. LINDBERG

University of Nevada, Las Vegas

INTRODUCTION

Of all the branches of German literature none is receiving so little attention from scholars as the opera libretto, particularly the libretto of the baroque opera. This neglect is surprising if we take into account that opera was unquestionably the most vigorously flourishing dramatic form of its day, as can easily be ascertained from Gottsched's *Nöthiger Vorrath*, where, until about 1725, the listings of operas greatly outnumber those of spoken plays. Perhaps the main reason for this neglect is that opera is in general no longer felt to fall within the domain of the literary critic. Since the beginning of the nineteenth century this field has largely been preempted by musicologists and, with few exceptions,[1] these scholars have tended to lay stress on the scores and composers rather than on the libretti and authors.

[1] Notably Friedrich Chrysander, who, in his articles in the *Allgemeine Musikalische Zeitung*, 1877–1880, briefly reviewed a series of libretti of the Hamburg opera, and Hellmuth Christian Wolff, *Die Barockoper in Hamburg* (Wolfenbüttel, 1957). In that portion of his work dedicated to the libretti, Wolff appears to be primarily interested in providing a motif analysis in a "horizontal" manner rather than in giving a "vertical" interpretation of individual texts or in examining the characteristic style and purpose of particular authors. There are numerous comments on such matters as meter and versification, and the chapter on comic elements in opera is especially exhaustive.

Whenever, during the last hundred years, literary historians have
dealt with baroque opera, they almost invariably started with the as-
sumption that the libretti were beneath critical notice and limited
themselves to chronicling the campaign against opera waged by Gott-
sched.[2] These writers, however, largely ignored the voluminous
research on the historical development of the genre that had in the
meantime been carried out by musicologists—whose findings, it is
true, are published in a forbidding array of monographs and in
journals not usually perused by scholars in the field of literature—
with the result that they almost uniformly overrated the effects of
Gottsched's opera criticism and even went so far so to claim that he
was largely responsible for the disappearance of German baroque
opera.[3] In the same way a number of other misunderstandings have
arisen among literary historians, evidenced by such statements as
"Practically all opera, aside from the notable stage at Hamburg . . .
was in Italian."[4] Another example of this lack of coordination of
research effort is afforded by the 1965 edition of Merker-Stammler's
Reallexikon, where we read, regarding the German baroque opera

[2] The notable exception here is Willi Flemming, who in his introduction to
Die Oper (Deutsche Literatur in Entwicklungsreihen, Reihe Barock, vol. V)
gives not only an excellent picture of baroque opera in general but also some
valuable comments on the libretto as a literary genre. These have not been super-
seded in importance by more recent scholarship and must still be considered the
starting point of research in this field. In recent years three dissertations have been
written on the libretto of the German baroque opera: S. Edgar Schmidt, "Ger-
man Librettos and Librettists from Postel's Psyche (1701) to Schikaneder's
Zauberflöte (1794)" (diss., University of California, Berkeley, 1950), Arthur
Scherle, *Das deutsche Opernlibretto von Opitz bis Hofmannsthal* (diss., Munich,
1954), and Wolfgang Huber, *Das Textbuch der frühdeutschen Oper* (diss., Mu-
nich, 1957). None of these dissertations, however, makes an attempt to deal ex-
haustively with the works of any particular librettist or to analyze and interpret
individual libretti.

[3] See Gustav Waniek, *Gottsched und die deutsche Litterature seiner Zeit* (Leip-
zig, 1897), p. 306; Eugen Reichel, "Gottsched und das deutsche Musikdrama,"
Beilage zur Norddeutschen Allgemeinen Zeitung, no. 150 (June 29, 1901). See
also Jakob Minor, *Christian Felix Weiße und seine Beziehungen zur deutschen
Literatur des achtzehnten Jahrhunderts* (Innsbruck, 1880), p. 130: "Gottscheds
Vernichtungskrieg hatte sie [die Oper] ausgetilgt."

[4] Alfred R. Neumann, "Gottsched versus the Opera," *Monatshefte* 45 (1953):
302.

at Hamburg, "Der kirchliche Zug der führenden Bürgerschicht hatte einen bemerkenswerten Anteil biblischer Stoffe an den hamburgischen Operntexten zur Folge. . . . Mit der Schließung des hamburgischen Opernhauses 1738 war die erste kurze Blütezeit der deutschen Oper zu Ende."[5] These two sentences are quite misleading, since they contain three different misunderstandings. First of all, of the 246 operas staged in Hamburg between 1678 and 1738 according to Mattheson's records,[6] only eight dealt with biblical topics. Furthermore, the Hamburg opera house was not closed in 1738, but, on the contrary, in the 1740's it entered into its period of greatest prosperity. As for the commonly held misconception that German-language opera came to an end in 1738 when the Hamburg opera house was taken over by companies playing in Italian, it is necessary to bear in mind that a flourishing German opera continued to function in Braunschweig until 1749, when it, too, was taken over by the Italians.

In view of these widely held misunderstandings it may not be amiss to start this discussion of German baroque opera with an old-fashioned account of its historical evolution at the principal centers, Hamburg, Braunschweig, Leipzig, and Weissenfels, with the double purpose of (1) once and for all dispelling the myth that Gottsched's campaign against opera brought about the decline of the genre and (2) showing the large extent to which German-language opera was practiced at the time, in the hope that this presentation will stimulate others to join the discussion. Opera, that most baroque of all art forms, played a key role in the cultural life of the times. The foremost German librettists, like the leaders of the Second Silesian School, were lawyers who had traveled widely and were in the literary forefront of their day. Some, like Christian Friedrich Bressand in Braunschweig, were influential in transplanting to Germany the ideas and practices of French neoclassicism.

[5] Paul Merker-Wolfgang Stammler, *Reallexikon der deutschen Literaturgeschichte*, II (1965), 769–770.

[6] Johann Mattheson, *Der Musicalische Patriot* (Hamburg, 1728), p. 179 ff.

Others, of the next generation, like Barthold Feind in Hamburg, not only were among the first to reject the stylistic extravagances of the baroque but even, as we shall see, went so far as to advocate turning away from French neoclassicism and following the example of Shakespeare. It is true that many of the German libretti were translations from the Italian and the French, but this does not mean that they are undeserving of our attention. Much to the contrary; this extensive labor of rendering in German the melodious verses of Romance librettists helped not only to propagate foreign techniques and ideas but also to make the German language the supple instrument it became in the hands of such a writer as Brockes, one of the patrons of the Hamburg opera. We must bear in mind that precisely because opera was the most widely practiced dramatic form at that time, its influence in all areas of literature was great.

THE MAIN CENTERS OF GERMAN BAROQUE OPERA

Hamburg

During the first decades after the Thirty Years War, by which it was scarcely touched, Hamburg enjoyed a period of remarkable prosperity, largely due to the maritime trade the city had succeeded in attracting.[7] The ranks of its wealthy burghers were swelled by foreign merchants who found security behind its virtually impregnable wall, by the residents maintained in the city by the major states of the empire and the major foreign powers, and by the members of the German and Scandinavian nobility who had found asylum there or simply preferred life in this northern metropolis to residence in their own lands. This wealthy, internationally oriented society of Hamburg was fully abreast of the cultural developments that had taken place in Italy, in Paris, and in some of the South German capitals where opera houses had been built.[8] It was actually

[7] See H. Reincke, *Hamburg, ein Abriß der Stadtgeschichte von den Anfängen bis zur Gegenwart* (Bremen, 1926), pp. 81–89.

[8] Venice, 1637; Munich, 1657; Vienna, 1667; Dresden, 1667.

only five years after Lully had introduced regular opera perform-
ances in the French capital that it was decided to follow all these
examples and to bring opera to Hamburg as well. The actual found-
ing of the Hamburg opera is attributed to the lawyers Gerhard
Schott and Lütgens and to the organist Johann Reinike,[9] who in
1677 obtained approval from the city council for establishing an
opera house, which was inaugurated the following year. Behind
these men, however, stood wealthy, aristocratic patrons, who en-
thusiastically backed the venture. Perhaps the foremost of these was
Duke Christian Albrecht von Holstein-Gottorp, who had settled in
Hamburg in 1676 after being driven from his duchy.[10] Another
nobleman of the highest rank who patronized the Hamburg opera
was Count Friedrich Guldenlöw, natural son of King Frederick III
of Denmark, who had been intended by his father to occupy the
throne of Norway, but who preferred the life of a gentleman of
leisure at Hamburg, where he resided from 1676 until his death in
1704.[11] Beekman Cannon, in his excellent biography of Mattheson,
has already drawn attention to the fact that the continued existence
of the Hamburg opera depended no less on the patronage of these
foreign noblemen than on the wealth and taste of the scarcely less
aristocratic patricians of the city itself.[12] As a result of the resolute
support given to the opera venture by these wealthy patrons, there
can be little doubt that during its initial years the Hamburg opera
house stood comparison with the best in Europe.[13]

[9] Ernst Otto Lindner, *Die erste stehende deutsche Oper* (Berlin, 1855), p. 3.

[10] It was Duke Christian Albrecht's *Kapellmeister*, Johann Theile, who wrote
the music for some of the first operas performed at Hamburg. See Liselotte Krüger,
Die Hamburgische Musikorganisation im XVII. Jahrhundert (Leipzig, 1933),
pp. 254–255.

[11] Ludwig Meinardus, *Johann Mattheson und seine Verdienste um die deutsche
Tonkunst* (Leipzig, 1879), p. 230.

[12] Beekman C. Cannon, *Johann Mattheson, Spectator in Music* (New Haven,
1947), p. 14.

[13] This is attested by the French writer Regnard, who passed through Ham-
burg in 1681 and recorded: "Les Opéra n'y sont pas mal représentés; j'y ai
trouvé celui d'Alceste très beau." See Jean François Regnard, *Voyage de Flandres
et de Hollande* in *Oeuvres* (Paris, 1790), I, 32.

A few years after the founding of the opera, however, conditions in Hamburg began to deteriorate. Commerce was disrupted by violent civic strife and Denmark assumed a more and more menacing attitude. In 1686 Denmark attempted to occupy the city, and her freedom was preserved only by the intervention of Brandenburg and Celle. At the same time the rise of Sweden as a major power imperiled Hamburg's maritime trade. This situation was aggravated by the Northern War (1699–1721) between Sweden on the one hand and Russia, Denmark, Poland, and Saxony on the other; by a plague epidemic in 1713, to which at least one-eighth of the population is said to have succumbed;[14] and by the aggressive mercantilistic economic policies of King Frederick I of Prussia, which severely weakened Hamburg's economy.[15] Because of these adverse circumstances there was a substantial decline in the prosperity of the community and many businesses were forced into bankruptcy.[16] Naturally, these hard times also affected opera revenues, which decreased at the very time operating expenses were increasing as a result of the higher salaries the singers demanded and could get— owing to the competition offered by the many opera houses flourishing elsewhere.[17] As a result, almost every one of the fourteen opera administrations that succeeded each other between 1678 and 1726 ended in financial disaster.[18] Finally, operations were drastically curtailed, costs were cut wherever possible, and the better singers began to leave.[19] In 1726 the end of the German opera in Hamburg

[14] Ernst Finder, *Hamburgisches Bürgertum in der Vergangenheit* (Hamburg, 1930), pp. 179–182.

[15] Adolf Wohlwill, *Aus drei Jahrhunderten der Hamburgischen Geschichte* (Hamburg, 1897), p. 70.

[16] Christian Ludwig von Griesheim, *Die Stadt Hamburg in ihrem politischen, öconomischen und sittlichen Zustande* (Hamburg, 1760), p. 92.

[17] By 1722 salaries of 1,000 thalers per annum were not uncommon at Hamburg. See Lindner, *Die erste stehende deutsche Oper*, p. 117.

[18] See Mattheson, *Der Musicalische Patriot*, pp. 179 ff.

[19] See Lindner, *Die erste stehende deutsche Oper*, p. 138: "Schon nach 1726 fingen die guten und besseren Sänger der Oper an sich zu entfernen. . . . So kann man den eigentlichen Untergang der Oper schon um 1728 ansetzen; trotz des mehrjährigen Fortvegetierens."

was clearly in sight. It was staved off temporarily by the intervention of some of its more affluent patrons, one hundred of whom were persuaded by the English Resident, Cyrill von Wich, a man with a veritable passion for opera,[20] to come to the aid of the moribund enterprise.[21] Losses, however, continued to exceed expectations, and von Wich's associates were unwilling to continue their subsidies over the full four-year period to which they had committed themselves. In April, 1728, we hear of a new lessee, von Ravens,[22] who fared no better than his predecessors and went out of business a year later.[23] From April, 1729, to October, 1729, the opera remained closed. Finally another lessee was found, the singer Madame Margarethe Susanna Kayser.[24] Before long she, too, ran into difficulties, and in 1731 the opera house again remained closed for several months, "aus Mangel einer dem Eigner des Hauses zu stellenden Bürgschaft."[25] Madame Kayser continued to struggle on bravely for a few more years, but on a very reduced scale. Only two or three new operas were staged each year and these seem to have been very inferior productions.[26] Finally, in 1737, in a last change of administration, the lease of the opera house was assumed by an Italian tailor, one Bartholomäus Monza, and his daughter Maria, a

[20] Meinardus, *Mattheson und seine Verdienste*, p. 234.

[21] Mattheson, *Der Musicalische Patriot*, p. 194: "[1727] hörte . . . das Regiment des Herrn Hoffraths auf und fanden sich 100. *Subscribenten*, welche die Oper gleichsam auf vier Jahre pachteten, mittelst Erlegung 25. Reichsthaler jährlichen Zuschusses die Person. Die Ober-Auffsicht führten Ihro *Excellence*, der Herr Envoyé von Wich."

[22] Paul A. Merbach, "Das Repertoire der Hamburger Oper von 1718 bis 1750," *Archiv für Musikwissenschaft*, VI (1924), 362.

[23] Ibid., p. 363: "April 5 [1729] hat Ravens den Opern contract durch 2 Notaren aufsagen lassen."

[24] Mattheson remarked: "[Ab März 1729] lagen die Opern stille. Der Pächter von Ravens trat ab und fand seine Rechnung gar nicht dabey. . . . Zuletzt übernahm Madame Kayser, die Sängerin, das Werk und machte am 10. October [1729] wieder den Anfang mit einem Prologe, genannt *Die aus der Einsamkeit in die Welt zurück gekehrte Oper*." See Friedrich Chrysander, "Mattheson's Verzeichniss Hamburgischer Opern," in *Allgemeine Musikalische Zeitung* 12 (1877): 262–263.

[25] Ibid., p. 262.

[26] Ibid., pp. 262–264.

singer. When they went out of business in January, 1738,[27] the
opera house was taken over for a short time by the Neuber troupe,
to the great satisfaction of the enemies of opera.[28] It must be empha-
sized, however, that this by no means marked the end of opera in
Hamburg, as has so often been stated erroneously.[29] It is well known
that the Hamburg public did not take kindly to Neuber's *Hoch-
teutsche Comoedianten*,[30] and after they departed in 1740, opera
staged a triumphant return at the Hamburg opera house, but on an
entirely different financial basis, and in the Italian language.[31] In-
stead of local companies, trying to eke out a pitiful existence during
the entire year by staging mediocre productions with second-rate
singers, now internationally famous opera ensembles came to Ham-
burg, where they performed only part of the year—in Italian, of
course—and then moved on to other cities. The first of these troupes
to visit Hamburg was that of Angelo Mingotti, in 1740.[32] His en-
semble included some of the most famous singers of the internation-
al opera stage, the renowned Francesca Cuzzoni, who some years
previously had been the main attraction of Handel's opera in Lon-
don, the great Marianne Pircker, who in 1749 became the star of the
Stuttgart opera, and many others. Whereas the public had largely

[27] Ibid., p. 265.

[28] Mattheson commented regarding this event: " 'Auf, stärket euren Muth!
zum Fall der Opera; | Und schlagt die Augen auf, dieweil ihr Ende nah!' so
schrieb damals ein Professor Opern Feind [Gottsched?]." Ibid., p. 264.

[29] In Kurt Stephenson's relatively recent article "Hamburg" in *Die Musik in
Geschichte und Gegenwart*, V (1956), 1398, we find the misleading statement
"[In 1738] verödete der Opernhof."

[30] Their first performance of Gottsched's *Cato* in May, 1738, yielded a revenue
of only thirty-six thalers, and, when the tragedy was repeated a few days later,
there were but twelve persons in the audience. See Merbach, "Das Repertoire,"
p. 368.

[31] Wolff states that Mingotti's troupe performed largely in German. See *Die
Barockoper in Hamburg*, I, 345. This I believe to be a misunderstanding probably
based on the fact that Mattheson reported that some of Mingotti's libretti were
translated into German. (See Chrysander, "Mattheson's Verzeichniss," pp. 266
and 280–281.) The fact that German translations were made of some of the li-
bretti does not mean, however, that these operas were performed in that language.

[32] Erich Hermann Müller, *Angelo und Pietro Mingotti; ein Beitrag zur
Geschichte der Oper im XVIII. Jahrhundert* (Dresden, 1917), p. 15.

ignored the performances staged by the Hamburg opera under Madame Kayser,[33] they now flocked enthusiastically to applaud these star performers. Revenues, which, during the last years of Madame Kayser's regime had averaged a paltry seventy thalers a performance,[34] now soared to as much as 1,000 thalers.[35] In 1743, 1744, 1746, and 1748 Hamburg was included in the itinerary of Pietro Mingotti's ensemble,[36] whose performances appear to have been received with even more enthusiasm.[37] After the old opera house was condemned as unsafe in 1749, Pietro Mingotti performed in the *Reithaus* in 1751, 1752, 1753, and 1754. In 1754 and 1755 Locatelli's ensemble also played at Hamburg.[38]

During the sixty-year period, 1678–1738, when the Hamburg opera was playing almost exclusively in German, at least 246 different music drama productions were staged there. About half of these were briefly—and superficially—surveyed by Friedrich Chrysander in his articles in the *Allgemeine Musikalische Zeitung*.[39] On a much higher level is Wolff's more recent *Die Barockoper in Hamburg*.[40] No attempt was made by either of these musicologists, however, to deal exhaustively with the libretti of individual writers or to study these works within the larger framework of German literature of their time.

[33] In 1736 one of Gottsched's correspondents in Hamburg reported: "Es sieht . . . so leer und wüste in der Oper aus, daß oft nicht 10 Personen zugegen sind." See Friedrich Johann von Reden-Esbeck, *Caroline Neuber und ihre Zeitgenossen* (Leipzig, 1881), p. 198.

[34] Merbach, "Das Repertoire," pp. 365–367.

[35] The first performance staged by Angelo Mingotti in 1740, *Ipermestra*, reportedly yielded a revenue of a thousand thalers. See Chrysander, "Mattheson's Verzeichniss," p. 265.

[36] Müller, *Angelo und Pietro Mingotti*, pp. 27–87.

[37] The first performance put on by Pietro Mingotti in 1743 is reported to have yielded two thousand thalers. See Merbach, "Das Repertoire," p. 370. Of the opera *Il tempio di Melpomene*, staged in 1747, Mattheson recorded: "Diese Opera von 2 Acten hat Mr. Mingotti bei die 2000 Thaler eingebracht in 2 Aufführungen." See Chrysander, "Mattheson's Verzeichniss," p. 281.

[38] Joseph Sittard, *Geschichte der Musik und des Conzertwesens in Hamburg vom 14. Jahrhundert bis auf die Gegenwart* (Altona, 1890), p. 80.

[39] Chrysander, in *Allgemeine Musikalische Zeitung* 12–15 (1877–1880).

[40] See footnote 1, above.

Braunschweig

The Braunschweig opera, founded by Duke Anton Ulrich in 1690, occupies a unique position in the history of German baroque opera, since it was the only major *commercial* opera house founded by a ruling prince. At the same time it is the only opera house of this period of which some financial records have come down to us. We may presume that Anton Ulrich entered into this venture because he believed that the presentation of opera would draw more visitors to the two annual fairs held at Braunschweig. That he also expected to reap a direct profit from the enterprise, however, is evident from his cost and revenue calculations, which amounted to 3,700 thalers and 8,000 thalers, respectively.[41]

These optimistic estimates very quickly had to be revised, however, when it became apparent that for the construction of the opera house a capital of 24,000 thalers had to be raised, on which interest had to be paid. A second operating budget was drawn up which forecast expenses of 4,600 thalers versus revenues of only 4,000 thalers. In other words, instead of a profit of 4,300 thalers, Duke Anton Ulrich now expected a deficit of 600 thalers per annum.

In practice even these figures turned out to have been too optimistic, for the duke had both underestimated operating expenses and overestimated revenues, as becomes evident when we examine the figures for the winter fair of 1692. Instead of the ten performances envisioned for each fair, only six were actually given;[42] and instead of the originally expected revenue of 200 thalers per performance, the average gross was only 165 thalers. Total revenue for these six performances amounted to less than 1,000 thalers, while

[41] Friedrich Chrysander, "Geschichte der Braunschweig-Wolfenbüttelschen Capelle und Oper vom 16. bis zum 18. Jahrh.," *Jahrbücher für Musikalische Wissenschaft* 1 (1863): 185.
[42] February 5, *Ariadne*; February 8, *Ariadne*; February 10, *Andromeda*; February 11, *Ariadne*; February 12, *Andromeda*; February 15, *Ariadne*.

expenses reached 2,770 thalers.[43] In order to cover the operating deficit and pay off the capital loan outstanding, the Braunschweig opera house had to be subsidized by revenues from other sources to the extent of about 2,800 thalers annually. Even so, it took thirteen years before all the debts were finally paid off, and it was only in 1703 that Duke Anton Ulrich could write with a sigh of relief: "Gott sei gedanket, an Niemand mehr an Capitalien noch an Interessen nichts zu bezahlen laut Hauptbuchs."[44]

Under the rule of the sons of Duke Anton Ulrich, Duke August William (1714–1731), and Duke Louis Rudolph (1731–1735), opera performances at Braunschweig continued regularly, and two or three different operas were staged during each fair. At the death of Duke Louis Rudolph, however, the duchy passed to Duke Ferdinand Albrecht of the Bevern line, a determined foe of opera, who immediately announced his intention of closing down the Braunschweig opera house. Before he was able to carry out this plan, however, he succumbed to a stroke, on September 3, 1735, and the duchy passed to his son Charles. This development saved the Braunschweig opera, since Duke Charles I was married to Princess Philippine Charlotte of Prussia, a sister of Frederick the Great, who shared her brother's love for opera. She apparently communicated her taste to her husband, for Duke Charles not only did not close down the Braunschweig opera house, but on the contrary, he enlarged the scope of its operations and inaugurated its most splendid period—at the very time Gottsched was celebrating the demise of the German opera. When Duke Charles moved the court from Wolfenbüttel to Braunschweig, in 1753, the Braunschweig opera acquired even greater splendor, and this city became one of Germany's foremost operatic centers.[45] In fact, Duke Charles lavished

[43] Chrysander, *Jahrbücher*, 1:197.
[44] Ibid., p. 187.
[45] Erich Rosendahl, *Geschichte der Hoftheater in Hannover und Braunschweig* (Hanover, 1927), p. 17.

money on his opera on an even greater scale than had his brother-in-law, Frederick II, and so much indulged his passion for display that at his death in 1780 he left a debt of seven million thalers.[46]

These developments are frequently misunderstood. Chrysander carried his history of the Braunschweig opera only to the year 1735, to the point when Duke Ferdinand Albrecht announced his intention of discontinuing the opera. This circumstance has apparently caused some confusion and has led astray such eminent musicologists as Kretzschmar,[47] Moser,[48] and Haas.[49] Even such very recent writers as Huber[50] and Kindermann[51] hold to the mistaken belief that opera in Braunschweig actually came to an end in 1735.

There have also been some misunderstandings regarding the date at which operas in Braunschweig ceased to be performed *in German*. According to Erich Rosendahl, German opera ended in 1735 with the accession of Duke Charles I.[52] This was not the case. In fact, as long as the opera was directed by the German Georg Caspar Schürmann, who held sway at Braunschweig for almost half a century (from 1697 to 1701 and from 1707 to 1749), it was predominantly German. The greatest concession Schürmann was willing to make to the changing times was to agree that some of the arias in libretti translated from the Italian could be left in the original lan-

[46] Gustav Friedrich Schmidt, *Die frühdeutsche Oper und die musikdramatische Kunst Georg Caspar Schürmanns* (Regensburg, 1933–1934), I, 76.

[47] Hermann Kretzschmar, *Geschichte der Oper* (Leipzig, 1919), p. 139: "Im Jahre 1735 löst der neue Herzog Ferdinand Albrecht Oper und Kapelle auf."

[48] Hans Joachim Moser, "Die frühdeutsche Oper," in *Geschichte der deutschen Musik vom Beginn des Dreißigjährigen Krieges bis zum Tode Joseph Haydns* (Stuttgart, 1928–1929), II, 192: ". . . ungefähr gleichzeitig [1733] endete sie [die Oper] in Braunschweig. . ."

[49] Robert Haas, "Die Oper in Deutschland bis 1750," in *Handbuch der Musikgeschichte*, ed. Guido Adler, 2nd ed. (Berlin, 1930), II, 679, "1735 stellte plötzlich der Hof die [Opern-]Aufführungen ein."

[50] Huber, *Textbuch*, p. 16: "Unter den deutschen Residenzen widmete sich Braunschweig-Wolfenbüttel fast hundert Jahre, von 1639 bis 1735, der Pflege der Nationaloper."

[51] Heinz Kindermann, *Theatergeschichte Europa*, III (Salzburg, 1959), 534: "1735 löste Anton Ulrichs Nachfolger Ferdinand Albrecht Oper und Kapelle auf."

[52] Rosendahl, *Geschichte der Hoftheater*, p. 10.

guage. He resolutely opposed the practice current at Hamburg of introducing Italian arias even into original German libretti.[53] Thus the Braunschweig opera continued to perform almost exclusively in German until the retirement of Schürmann in 1749. It was only under Schürmann's successor, Ignazio Fiorillo, appointed in 1750, that the Braunschweig opera finally became purely Italian.

More than 150 different opera productions were staged at Braunschweig during the years 1690 to 1749. As far as the literary aspects of the Braunschweig opera are concerned, we may distinguish three clearly defined periods: a period of great original creativity, 1691 to 1699; a period of decline, in which relatively few original libretti were written, 1700 to 1735; and lastly, a period of almost complete dependence on translations of Italian texts, 1736 to 1749. Thus, although from 1700 on the Braunschweig opera quickly began to surpass the Hamburg opera in importance, from the point of view of the literary historian its significance declined. The court at Wolfenbüttel, like all other major courts, preferred Italian music to German, and in order to keep the original music, commissioned translations of Italian texts rather than new ones. The tendency increased markedly after 1735, when the Braunschweig opera was under the influence of Princess Philippine Charlotte, who, like her brother Frederick the Great, was completely under the spell of Italian opera.

A brief survey of the libretti of the operas performed at Braunschweig was presented by Chrysander in his "Geschichte der Braunschweig-Wolfenbüttelschen Capelle und Oper."[54] Subsequent to this a more complete list of opera performances staged at Braunschweig was given by Gustav Friedrich Schmidt.[55] Here again,

[53] In 1726 Schürmann wrote to Johann Friedrich von Uffenbach: "Die Oper anlangend, so machen wir die teutschen Opern pur teutsch, wann wir aber etliche mahl italienische Opern ins teutsche übersetzet, so haben wir wohl die Arien mehrentheils italienisch gelassen" (G. F. Schmidt, *Schürmann*, I, 43).

[54] *Jahrbücher für Musikalische Wissenschaft* 1 (1863):147–286.

[55] Gustav Friedrich Schmidt, *Neue Beiträge zur Geschichte der Musik und des Theaters am Herzoglichen Hofe zu Braunschweig-Wolfenbüttel*, Erste Folge (Munich, 1929).

neither musicologist attempted a thorough study of the texts from a literary point of view.

Leipzig

If Hamburg was the most important commercial center of North Germany, Leipzig without a doubt could lay claim to a similar distinction in East Germany. Like Hamburg, Leipzig had weathered the storms of the Thirty Years War without major damage and during the decades immediately following that conflict had enjoyed great prosperity. Although the city was less populous than Hamburg, the ranks of its wealthy burghers were swelled three times each year by the influx of visitors who came to its important trade fairs, which made up at least to some extent for this disadvantage. In view of these circumstances it was not illogical that Nicolaus Adam Strungk, *Kapellmeister* at the court of Dresden, felt that Leipzig offered a climate in which a commercial opera house might be expected to flourish. Strungk had known the Hamburg opera during the halcyon days of its initial splendor—he had acted as one of its musical directors during the period 1678–1683—and could therefore consider himself well qualified to undertake such a venture. It is possible that the opening in 1691 of the second important commercial opera house in Germany, in his native city of Braunschweig, decided him to establish a similar enterprise in Leipzig. On the other hand, the accession of Elector John George IV, in September, 1691, may have provided the final impetus. While the previous Elector of Saxony, John George III, had been a great patron of German drama, his successor was mainly interested in opera and forthwith dismissed from his service Magister Johannes Velten,[56] whose "Chur-Saechsische Komoedianten Gesellschaft" had regularly played at Leipzig during the fairs. Strungk lost no

[56] See Carl Heine, *Johannes Velten* (Halle, 1887), p. 15: "Im Beginn des Jahres 1692 entliess der neue Kurfürst Johann Georg IV., der keinen Geschmack am deutschen Schauspiel fand und die 2000 Thaler, die dasselbe bisher gekostet hatte, lieber der Oper oder fremdländischen Schauspielen zuwenden wollte, die deutschen Hofkomödianten . . . und Velten verliess im Februar 1692 Dresden." Velten died shortly thereafter.

time in trying to fill the void created by Velten's dismissal. Velten left Saxony sometime during the first half of 1692, never to return, and in June, 1692, Strungk obtained from Elector John George IV the license to stage operas during the Leipzig fairs instead of legitimate plays. The construction of an opera house was begun in January, 1693, and, although it seems scarcely credible, performances started during the Easter fair of that year. Obviously, the edifice was of the cheapest and flimsiest construction.

If Strungk had expected to reap profits from this venture, he was sadly disappointed. In fact, when economic conditions in Leipzig deteriorated during the last decade of the seventeenth century because of the increasing success of Halle as a rival commercial center,[57] the Leipzig opera soon found itself in even worse financial difficulties than its Hanseatic counterpart.[58] It must be remembered in this connection that while Schott in Hamburg was a wealthy patrician who could afford to subsidize his opera when revenues began to decline, this was not possible for Strungk, the relatively impecunious musician. Furthermore, Leipzig lacked the many foreign ambassadors and aristocratic émigrés who were always ready to come to the aid of the Hamburg opera. As a result, the history of the Leipzig opera, as chronicled by Opel, Berend, and Reuter, consists of little more than an enumeration of the interminable lawsuits which creditors brought against Strungk and his associates from the very inception of their activities.[59] By 1694 Strungk was obliged to pe-

[57] For an excellent analysis of the causes of the decline of Leipzig's prosperity at that time see Hermann Heller, "Die Handelswege Inner-Deutschlands im 16., 17., und 18. Jahrhundert und ihre Beziehungen zu Leipzig," *Neues Archiv für Sächsische Geschichte und Alterthumskunde* 5 (1884): 1–72.

[58] Even before the Leipzig opera opened its doors, a neighbor of Strungk's gloomily expressed his expectations, "[daß] dieses operen Haus mit der Zeit wohl wieder eingehen [werde] wegen der schlechten und sehr kümmerlichen Zeiten, da die Leute ihre Geldmittel wohl zu Noth wendigeren ausgaben anzuwenden haben" (March, 1693). See Fritz Berend, *Nicolaus Adam Strungk* (Hanover, 1915), p. 94.

[59] J. O. Opel, "Die ersten Jahrzehnte der Oper zu Leipzig," *Neues Archiv für Sächsische Geschichte* 5 (1884): 116–141; Fritz Berend, *Nicolaus Adam Strungk,* passim; Fritz Reuter, *Die Geschichte der deutschen Oper in Leipzig am Ende des 17. und Anfang des 18. Jahrhunderts,* (diss., Leipzig, 1926).

tition Elector Frederick August I to grant subsidies to the Leipzig opera, but even these could only mitigate to some extent the pecuniary distress that perennially afflicted this enterprise.[60] During the winter fair of 1695 Strungk's plight was aggravated by the performance of *Comoedien* by a troupe of strolling players, and he had to appeal to the Elector to stop this competition which, he exclaimed in despair, threatened to ruin him: "Ich und mein Consorte [sind] in sehr großen Schaden gesetzet und wann damit bey künfftiger Oster-Messe solte continuiret werden, uns in den äußersten Ruin gesetzet sehen."[61] In 1697, when Elector Frederick August stopped his subsidies to the Leipzig opera, and Strungk lost his position of *Kapellmeister* in Dresden, the fortunes of the Leipzig opera took a further turn for the worse. In a most pathetic tone Strungk once more appealed to the Elector for help, describing himself as "armen Diener, . . . der alss das meinige in dem operen Hausse zu Leipzig zugesetzet."[62] But to no avail. The Elector, who spent fortunes in maintaining the Italian court opera at Dresden, was no longer willing to support the German opera at Leipzig. Nevertheless, Strungk gallantly struggled on for three more years. When he died, in 1700, worn out by all these cares, he left a crushing burden of debts.[63] The Leipzig opera continued on a hand-to-mouth basis under the direction of Strungk's heirs, who eked out a meager living by performing some of the leading roles. In 1720, when no one could be found to finance the extensive repairs which the old and badly constructed building required,[64] the Leipzig opera

[60] Reuter, *Die Geschichte der deutschen Oper*, p. 12: "Die Leipziger Oper litt von Anfang bis zu ihrem Ende an Geldmangel."

[61] Berend, *Strungk*, p. 97.

[62] Moritz Fürstenau, *Zur Geschichte der Musik und des Theaters am Hofe zu Dresden* (Dresden, 1861), 315.

[63] Berend, *Strungk*, p. 109.

[64] Hardly six months after the opera had opened its doors, the neighbors complained that it was about to collapse because it had been "vom Winde geschoben" (Berend, *Strungk*, p. 88). Little wonder, therefore, that in his comparison of the Hamburg, Braunschweig, Hannover, and Leipzig opera houses Feind called the Leipzig theater "das pauvreste" (Barthold Feind, *Deutsche Gedichte* [Stade, 1708], p. 89).

ceased to function, while litigation of its creditors continued for another five years.[65]

As far as the literary aspects of the German baroque opera at Leipzig are concerned, perhaps the most salient characteristic of the texts is their lack of originality. Gustav Schmidt has compiled a list of 104 opera presentations for the period 1693–1720.[66] On the average, four different operas a year were presented. A preliminary and very cursory survey of these libretti was subsequently made by Reuter,[67] but this has not been followed by a detailed, comprehensive study of the texts.

Halle-Weissenfels

In 1656, at the death of Elector John George I of Saxony, the Albertine lands were divided among his four sons, a procedure which resulted in the creation of the duchies of Sachse-Merseburg, Sachse-Weissenfels, and Sachse-Zeitz, beside Electoral Saxony. Sachse-Weissenfels fell to Duke Augustus, who resided at Halle. This duke was a member of the Fruchtbringende Gesellschaft, or Palmenorden, and as such he was very much interested in promoting the use of the German language.[68] Since court opera was practically mandatory, the preferences of Duke Augustus caused a tradition of German opera to start at Halle at the very time when almost all other courts of Germany were falling completely under the spell of Italian opera. When, at the death of Duke Augustus in 1680, Halle had to be ceded to Brandenburg, and his son Duke John Adolph took up residence at Weissenfels, opera performances at Halle came to an end. The tradition of German opera started by Duke Augustus was continued, however, at the new residence of

[65] Opel, "Die ersten Jahrzehnte der Oper zu Leipzig," p. 122.

[66] Gustav Friedrich Schmidt, "Die älteste deutsche Oper in Leipzig am Ende des 17. und Anfang des 18. Jahrhunderts," *Sandberger Festschrift* (Munich, 1919), pp. 209–257.

[67] Reuter, *Die Geschichte der deutschen Oper in Leipzig*, pp. 125–156.

[68] Arno Werner, *Städtische und fürstliche Musikpflege in Weißenfels bis zum Ende des 18. Jahrhunderts* (Leipzig, 1911), p. 103.

the Dukes of Sachse-Weissenfels, with the result that the small city
of Weissenfels soon became a foremost center of German opera.
Under the rule of Duke John Adolph's sons, John George and
Christian, performances of German operas continued on an ever
more lavish scale and, in fact, the expenditures which Duke Chris-
tian incurred in connection with his opera contributed no little to
the eventual bankruptcy of his entire realm. After an imperial com-
mission was appointed in 1727 to take over the fiscal administration
of the bankrupt duchy, Duke Christian had to curtail his operatic
activities to some extent. He would not consent to discontinue them
altogether, however, and opera performances at Weissenfels con-
tinued until his death. His brother, John Adolph II, who succeeded
him in 1736, was a man of an entirely different kind. He had been
a soldier most of his life and had risen to the rank of field marshal
in the Imperial army. In his Spartan disposition he very much re-
sembled Frederick William I of Prussia, and, like the latter, he
immediately disbanded the opera when he succeeded to the duchy.[69]

More than one hundred different operas were staged at Halle and
Weissenfels, according to a list compiled by Arno Werner.[70] The
titles of many of these works are the same as those performed at
Hamburg, Braunschweig, and Leipzig, but Werner makes no at-
tempt to identify these texts or to analyze them from a literary point
of view.

The End of German Baroque Opera

We are now in a position to examine the view widely held by
literary historians that Gottsched contributed in a large measure to
the decline of German-language opera. Waniek asserts:

Daß die Opern, über deren Niedergang sich Gottsched schon 1729
freute, in den dreißiger Jahren fast ganz verschwanden, wird in der II.
Auflage der Dichtkunst getreu registriert. Außer dem Leipziger und

[69] Ibid., p. 56.
[70] Ibid., pp. 112–120.

Hamburger Operntheater waren nun auch die zu Halle, Braunschweig, Weißenfels und an anderen kleinen fürstlichen Höfen bestehenden eingegangen. . . . Ohne Zweifel war hiebei sein Einfluß maßgebend gewesen.[71]

Such a statement is simply not in accordance with the facts. As we have seen, the Halle opera ceased in 1680, when the court moved to Weissenfels; the Leipzig opera closed its doors in 1720; the Hamburg opera was already moribund in 1726; all well before Gottsched initiated his attacks on opera. If the Weissenfels opera came to an abrupt end in 1736, it was not because of Gottsched's onslaught, but because Duke John Adolph was an austere soldier who felt that opera was an outrageous extravaganza he could well dispense with. The German opera at Braunschweig, on the other hand, not only did not come to an end in the thirties, but, after 1735, under the patronage of Duke Charles I, greatly increased the scope of its operations.

Waniek at least holds Gottsched responsible only for the disappearance of *German* opera. Reichel goes one step further and asserts that Gottsched brought about the decline of opera in Germany in general when he states: "[Gottsched] sorgt schließlich dafür, daß der prunkvollen undeutschen Oper mehr und mehr der Boden abgegraben . . . wird."[72] Such extravagant claims betray an ignorance of German opera history. Much to the contrary, at the very time when the commercial opera houses—which played in German—had to close, the operas at the important courts—which played in Italian—entered their most flourishing period. Thus the opera at Vienna reached its peak with the appointment of Metastasio as court poet in 1729. The Dresden court opera attained its greatest splendor in 1731 with the appointment of the celebrated composer Hasse and his wife, the singer Faustina Bordoni, at an

[71] Waniek, *Gottsched*, p. 306.
[72] Eugen Reichel, *Gottsched* (Berlin, 1908–1912), II, 932. Obviously, by the word *undeutsch* Reichel does not mean simply opera "not in German," but all baroque opera.

annual salary of 3,000 thalers each.[73] By 1736 the expenses of the
Dresden opera had risen to 42,625 thalers per annum;[74] by 1756
they mounted to 101,639 thalers.[75] In Berlin, where there had been
no opera during the reign of the austere Frederick William, Fred-
erick II started the construction of a magnificent opera house im-
mediately after his accession, in 1740, where performances con-
tinued uninterruptedly until 1806, when the disaster of Jena
brought them temporarily to a halt.[76] The cost of the sets and cos-
tumes for the first two operas staged under Frederick amounted to
150,000 and 60,000 thalers respectively.[77] In Munich the amounts
expended on opera during the reign of Elector Max Emmanuel rose
to such astronomical heights that, in 1724, to be able to pay for
them, this profligate prince imposed a special tax on his unfortunate
subjects.[78] In Württemberg, Duke Charles Eugene resolved only a
few months after he was declared of age in 1744 that he would
have an opera second to none. He engaged the services of the fam-
ous Francesca Cuzzoni at a salary of 1,000 thalers per annum[79] and
a few years later built a splendid opera house.[80] New opera houses
also mushroomed at other courts, for example, in Mannheim in
1737, and in Bayreuth in 1747. Evidently the enthusiasm of the
German princes for their opera had in no way been dampened by
Gottsched's crusade against the genre.

The fact that these court operas flourished as they did indicates
that opera still enjoyed the favor of the public,[81] so long as the pro-

[73] Fürstenau, *Zur Geschichte der Musik*, II, 174.
[74] Ibid., II, 219.
[75] Ibid., II, 296.
[76] Louis Schneider, *Geschichte der Oper und des königlichen Opernhauses in Berlin* (Berlin, 1852), p. 308.
[77] Ibid., p. 90.
[78] Fr. M. Rudhart, *Geschichte der Oper am Hofe zu München. Erster Theil: Die italiänische Oper von 1654–1787* (Freising, 1865), I, 110.
[79] Joseph Sittard, *Zur Geschichte der Musik und des Theaters am Württembergischen Hofe* (Stuttgart, 1890–1891), II, 31.
[80] Ibid., II, 44.
[81] In this connection it must be remembered that admission to the court operas was not necessarily restricted to the members of the court. Thus, at the Berlin opera,

ductions were lavish and expertly sung—and so long as admission was not prohibitively expensive. Thus the arguments of those who advance the theory that German opera declined because audiences had lost their taste for it are clearly invalid.[82] This is a misunderstanding to which Gottsched himself contributed. After recording the disappearance of the German-language opera houses at Hamburg, Leipzig, and other places, he had added complacently, "wären Liebhaber genug vorhanden gewesen, die einer solchen Lustbarkeit hätten beywohnen wollen: so würde man das Ende dieser Schaubühnen noch nicht gesehen haben. Dagegen sieht man, daß die Comödien und Tragödien täglich mehr und mehr Beyfall finden . . ."[83] This line of reasoning had already been rebutted by Gottsched's contemporary, the musician Lorenz Mizler, when he pointed out: "An Liebhabern der Oper fehlt es in Deutschland nicht, an Liebhabern aber, die es bezahlen können, fehlet es sehr, und deswegen sind an verschiedenen Orten die Opernbühnen eingegangen, hingegen an andern Orten, da man die Unkosten nicht gescheuet, auch aufgerichtet worden . . ."[84] He suggested that if more people attended spoken plays than attended operas, this was not because they preferred the former, but because they could not afford to go to the commercial opera houses, where admission was considerably more expensive. We might add here that if people no longer frequented the Hamburg opera in the thirties, their reason for staying away was that they simply refused to pay dearly for the mediocre spectacles which were the only ones this chronically bankrupt enterprise was able to stage. The citizens of Hamburg were not tired of opera, they were merely tired of second-rate opera. Con-

the officers had access to the pit, while the loges of the first and second floor were reserved for government officials and those of the third floor for prominent burghers. See Julius Kapp, *Das Berliner Opernhaus im Wandel der Zeit* (n.p., n.d.), p. 6. Consequently, the audience in the main represented a cross section of people similar to those in the audience at the Hamburg opera.

[82] Lindner, *Die erste stehende deutsche Oper*, p. 117.

[83] Johann Christoph Gottsched, *Versuch einer Critischen Dichtkunst*, 2nd ed. (Leipzig, 1737), p. 727.

[84] Lorenz Mizler, *Musikalische Bibliothek* 2 (1742): 35.

clusive evidence of this is afforded by the financial success of the Mingottis, who were able to attract capacity audiences because they presented first-rate spectacles.

It is clear, therefore, that the Hamburg opera did not have to close because it succumbed to the attacks of Gottsched or to the competition of the Neuber troupe (as has also been claimed).[85] The contention that Gottsched was largely responsible—directly or indirectly—for the decline of German-language opera cannot be maintained.

What then were the real causes of the disappearance of German opera? At the most important courts of Germany, Italian opera had become firmly entrenched before German opera had had a chance to develop. Princes, like the Electors of Saxony and the Electors of Hanover, took delight in spending the carnival months in Venice, and for them it was an accepted feature of international courtly society that the language of opera was Italian—just as the language of literature was French. Even in the duchy of Braunschweig, the court opera at Wolfenbüttel played in Italian, and it was only the commercial opera in Braunschweig which performed in German. Thus, at the major courts of Germany, German opera never really had a chance to get started. If Italian opera finally gained the upper hand even in the commercial centers of Germany, this was mainly due to economic factors. At a time when commercial opera was a financially unsound proposition even in as important a metropolis as London—witness the repeated bankruptcy of Handel's operatic ventures—*standing* opera companies could not be expected to survive in the much smaller communities of Hamburg and Leipzig, particularly since both these commercial centers at that juncture were passing through a period of economic decline. The Hamburg opera fell victim to an economic vicious circle like the one which had brought about the fall of the Leipzig opera eighteen years before: as its revenues decreased, on account of adverse economic con-

[85] Alfons Peucer, "Die Hamburger Oper von 1678 bis 1728," Allgemeine *Theater-Revue* 2 (1836): 16.

ditions, the quality of its productions deteriorated; and as the qual-
ity of its productions deteriorated, fewer and fewer people patron-
ized its spectacles, and revenues decreased even further. In the view
of an eighteenth-century audience, an opera was as good as the
singers who performed in it, and the interest it aroused was in direct
proportion to the magnificence of its stage scenery and costumes.
While the court operas produced their performances almost with-
out regard to cost, standing commercial opera companies headed
by such musicians as Strungk's heirs and Madame Kayser could not
raise the capital required to stage performances that would attract
large audiences. A contemporary account, written in 1736, describes
the wretched condition of the Hamburg opera at that time, which,
it pointed out, played to empty houses.[86] We are informed that
everything was in disarray, that the stage settings were old and di-
lapidated and that the spectators often had to wait for half an hour
until a machine would work properly, entertained meanwhile only
by "ein paar elende Griffe auf dem Clavier."[87] It was this artistic
decay of the standing commercial opera houses, brought about by
economic factors, which was the real cause for the disappearance
of German opera. If Mingotti only a few years later succeeded
where Madame Kayser had failed, it was because his singers, cos-
tumes, and stage settings were better, not because Hamburg audi-
ences preferred Italian opera or because Italian libretti were su-
perior, as has been claimed by Reuter.[88] The reason for Mingotti's
success lay in the fact that his was not a standing opera company,
restricted to a limited radius of action. His troupe played not only
at both Leipzig and Hamburg, but also at the court of Copenhagen

[86] [Lamprecht], *Schreiben eines Schwaben an einen deutschen Freund in Peters-
burg von dem gegenwärtigen Zustand der Opern in Hamburg* (Quoted in Lindner,
Die erste stehende deutsche Oper, pp. 148–149).

[87] And this in spite of the fact that at that time the Hamburg opera was still
supported by such wealthy patricians of the city as Ludwig Andreas von Bostel,
who was reportedly sacrificing his entire fortune in a vain attempt to prop up the
opera and who was forced into bankruptcy shortly afterward. Lindner, ibid.,
p. 149.

[88] Reuter, *Die Geschichte der deutschen Oper in Leipzig*, pp. 154–155.

and elsewhere. Thus his operations had a much broader economic base than the local opera companies in Hamburg and Leipzig. As a result, he was able to engage the services of first-rate singers of international fame and to stage spectacles which were sufficiently elaborate to attract the idly curious, who, after all, made up the bulk of opera audiences. To attribute the failure of the Hamburg opera to the bad quality of its libretti is to credit the Hamburg public with far better taste than it could muster even thirty years later, as Lessing had to discover.

THE GERMAN BAROQUE OPERA LIBRETTO AS A LITERARY GENRE

Let it be said first of all that although in their overwhelming majority the German libretti follow the conventional pattern of Italian baroque opera, in which stereotyped love intrigues dominate the action, they are not as devoid of interest as is generally supposed. Kretzschmar gives a good description of the general scheme of the Venetian opera libretto when he says:

Der ganze Aufwand an Geist . . . lässt sich auf die Formel ziehen: 2, 4 oder 6 Liebhaber gegen 1, 3 oder 5 Prinzessinen, einer geht leer aus. Verwicklungen in dieser einfachen mathematischen Aufgabe entstehen dadurch, dass Dame B, welche vom Prinzen A geliebt wird, ihre Neigung dem General C schenkt, der wieder sein Auge auf die Fürstin D geworfen hat.[89]

It is this kind of generalization that has undoubtedly deterred many literary historians from dedicating their attention to the German baroque opera libretto. And yet, once we succeed in divesting ourselves of our prejudices, we find that although the German libretti do by and large conform to the pattern of the Venetian libretti, they are nevertheless well worth studying. To claim that their authors had drunk liberally at the Castalian spring and that these works are great literary masterpieces would, of course, be absurd. We must

[89] Hermann Kretzschmar, "Die Venetianische Oper," *Vierteljahresschrift für Musikwissenschaft*, VIII (1892), 17.

bear in mind, however, that the time in which the German baroque opera libretto flourished, the period 1678–1739, was one in which great works of art were not abundant in any literary genre. It was a period of transition from baroque extravagance to enlightened sobriety, a period characterized by philosophical speculation rather than by true artistic creativity. An age which could not boast a greater dramatist than the clever but poetically uninspired Christian Weise was certainly one in which the muses had deserted Germany. It is interesting to note here that contemporaries did not delude themselves about this. Thus Feind, the most talented librettist of the Hamburg opera, called his age "das sterbende Seculum der Poeten."[90] However, if we cannot hope to discover artistic treasures in our investigations, which thus are bound to disappoint fastidious literary *critics*, there is no doubt that a study of German baroque opera libretti is rewarding from the point of view of the literary *historian*, who is concerned with the characteristics of works of literature of every period irrespective of their relative artistic merit. A primary consideration here is that merely because of the sheer quantity of production, we can ill afford to ignore this genre. As we have seen, at the four major centers of German baroque opera alone, we are dealing with a corpus of more than six hundred dramas which paint a vast panoramic canvas of seventeenth-century society. Let us not forget that although the setting of most of these works is ancient Greece, or Rome, or Persia, they are totally unclassical in spirit, and if their heroes and heroines bear names taken from classical antiquity, this means little. They are really very much a product of their own time, and just as they were garbed in seventeenth-century costumes, so their attitudes and ideas are contemporary rather than historically accurate. As a result, these libretti are an invaluable source of information regarding the attitudes and ideas prevalent in Germany at that time, and it is all the more important to tap this source, since relatively few plays were written during the period and even fewer have survived. With the excep-

[90] Feind, *Dt. Gedichte*, p. 333.

tion of the proliferous Weise, there were no dramatists the quantity of whose output could be compared to that of the masters of the German baroque opera libretto, Christian Heinrich Postel and Barthold Feind. Both these men were respected lawyers who prided themselves on their erudition. Their prefaces and footnotes manifest the same encyclopedic knowledge as those of Gryphius and Lohenstein. In this respect their work rises far above that of the majority of their Italian contemporaries, and Kretzschmar's complaint about a lack of "Geist" certainly does not apply to their work. Both Postel and Feind, quite like their German contemporaries writing for the regular stage, felt it to be their obligation not merely to entertain but also to instruct, and their libretti are often quite plainly didactic, illustrating what Gottsched called "eine moralische Fabel." An exhaustive discussion of their work is, of course, impossible within the limited framework of this paper. We must therefore content ourselves with a brief glimpse of just one example each from Postel's and Feind's voluminous production.

One of Postel's best and most popular libretti was *Gensericus*,[91] first performed in 1693 and thereafter produced repeatedly both in Hamburg and in Braunschweig.[92] The plot involves four pairs of lovers and is thus even more complex than usual. Its most remarkable feature, however, is not the incredible fickleness that causes these lovers to change partners, but the completely anachronistic philosophy of enlightened absolutism preached by the Vandal king. Thus, when his son Honorius expresses reluctance to marry the Roman princess Pulcheria, Gensericus sternly lectures him that a king must learn to subordinate his personal desires to the welfare of his people and be prepared to lay down his life for his country, thereby (to use a later phrase) converting himself into the first servant of his state:

[91] Der | Grosse König | Der *Africani*schen Wenden | GENSERICUS, | Als | Rom- und Karthagens | Uberwinder/ | In einem | Singe-Spiel | Auff | Dem Hamburgischen Schau-Platz | vorgestellet/ | Jm Jahr 1693.
[92] In 1725, 1728, and 1732. See Schmidt, *Neue Beiträge*, pp. 16–19.

Honorius: Mich deucht/ es ist nicht nöthig sehr zu eilen/
 Weil schnelle Lieb' auch schnell vergehen kan.
Gensericus: Diß gehet bey geringern Leuten an/
 Allein ein Fürst der muß sein Glück
 Nicht allzeit suchen im Vergnügen.
 Wann Reich und Staat dadurch kan Vorthel kriegen/
 Muß er den ersten Augenblick
 Zur Eh' / ja wol zum Tode/ seyn bereit.[93]

Similar views are expressed by Placidia, who urges her mother to marry the Vandal king for the good of the state.[94] Furthermore, there are several passages in which the opinion is expressed that it is the duty of a sovereign to mete out rewards and punishment justly and to observe the law. That Postel considered this philosophical message an important feature of the libretto is evidenced by the long scholarly preface in which he not only traces the history of the Vandals but ascribes their fall to the arbitrary despotism of their rulers:

Dieses mächtige Reich nun der Wenden in *Africa*, welches zwar mit grosser Tapfferkeit erobert und angerichtet war/ hat doch nicht länger als 95. Jahr . . . gewähret/ vermuthlich wol meistentheils aus der Ursach/ weil es mit nichtes als Grausamkeit und Tiranney/ unter seinen meisten Königen beherrschet ward/ was aber nur gewaltsam ist/ währet selten lange/ und ein Fürst der keine Güte kennet/ hat bald ausregieret. Denn wie *Antonio de Sousa*, ein sehr gelahrter Portugiese in seiner *Armonia politica part. 3. paragr. 3.* . . . saget: *Devese aver o Principe como pay, como mestre, ou como Capitam; o pay aspero não faz os filhos obedientes, mas desesperados; o mestre rigoroso não faz os discipulos sabios, mas timidos; o Capitam cruel não faz os soldados quietos, mas fugitivos;* das ist: Ein Regent muß seyn wie ein Vater/ wie ein Lehrmeister/ oder wie ein Capitain; ein harter Vater machet seine Kinder nicht gehorsam/ sondern hartnäckigt: Ein strenger Lehrmeister machet keine gelahrte/ sondern furchtsame Schüler/ und ein grausamer Capitain machet die

[93] Christian Heinrich Postel, *Gensericus*, Act. II, scene xviii.
[94] Ibid., Act I, scene xi.

Soldaten eher flüchtig als ruhig. Daher auch *Seneca de Clementia* saget: *Excogitare nemo quicquam poterit, quod magis decorum regenti sit quam Clementia*: *quocunque modo et quocunque jure praepositus ceteris erit. lib. 1. cap. 19.* Woselbst er diese *materie* durch das Gleichniß eines Bienen-Königs dem der Stachel fehlet/ vortrefflich ausführet. Weil nun dieser Haupt-Stütze des Reiches/ nemlich die Güte/ denen Barbarischen Wenden gefehlet/ hat ihre Herrschafft auch nicht lange bestehen können/ sondern durch die Tapfferkeit des *Belisarii* unter dem Keyser *Justiniano,* nachdem er ihrem letzten König *Gilimer* gefangen genommen/ ein Ende nehmen müssen.[95]

Unfortunately, the conventions of opera prevented Postel from developing these ideas in the libretto. As a result of this restriction, the preface stands in complete contrast to the text itself: While in the former we hear of the downfall of the Vandals because of the despotism of their kings, fit subject for a tragedy, in the libretto which, according to the prevailing conventions had to have a happy end, we find Gensericus voicing the very principles which the Vandal kings did not have and winning the acclaim of the conquered Romans, whose city he magnanimously—and quite unhistorically— spares!

Several of Feind's libretti are even more obviously didactic. His *Masaniello* libretto is a good example.[96] In this script the usual amorous intrigues are supplemented by a secondary political plot in which the author, who was at that very time himself deeply embroiled in the civic strife that pitted the ruling oligarchy of Hamburg against its lower classes, held up the Neapolitan revolt as a warning example for the population of Hamburg. Proceeding from the same source as had Christian Weise twenty years earlier, Schleder's *Theatrum Europaeum*, Feind comes up with an entirely differ-

[95] This most interesting preface unfortunately was omitted in Flemming's edition in *Die Oper* (DLE, Reihe Barock, vol. V).

[96] *Masagniello Furioso, Oder: Die Neapolitanische Fischer-Empörung.* First performed in Hamburg in 1706. This libretto was reprinted in Feind, *Dt. Gedichte,* pp. 252–320. Feind spells the name of the hero *Masagniello.* For simplicity's sake Weise's spelling will be used throughout this paper.

ent work than Weise's, which showed considerably more sympathy for the titular hero and his cause. The respective attitudes of these two writers are clearly evidenced by the fact that Weise, following the development of events as narrated in the *Theatrum Europaeum*, has Masaniello take a resolute stand *against* the robbers who were called to Naples by the aristocracy in order to embarrass Masaniello, while Feind pictures him as allying himself *with* the robbers. Thus, in Feind's libretto, the robbers appear as equal partners in the rebellion, alongside the people of Naples, to whom Feind characteristically everywhere alludes as *Gesindel* or *canaille*. It is precisely Masaniello's entirely fictitious alliance with the robbers that enables Feind to speak of the fisherman's "wohlverdientem Ende,"[97] while Weise (whose sympathies basically of course were also on the side of the ruling classes) suggests that his sudden madness and death were due to the intervention of an inscrutable "göttliche Providentz."[98] Moreover, while Weise, again following his source, dutifully reports Masaniello's execution of the robber captain Perrone and his own assassination by *four members of the nobility*, Feind has Masaniello killed *by the robber captain Perrone and four unidentified masked figures, who appear to be part of the robber band.* That this change was an intentional distortion of the incidents reported by the *Theatrum Europaeum* is evidenced by Feind's remarks in the preface: "Bey der vollständigen Wahrheit der Geschichte/ insonderheit der Auffführung des Perrone/ ist man/ gewisser Umstände halber/ nicht verblieben . . ."[99] There can be little doubt that Feind desired to impress upon his audience the fact that popular rebellion against the established order leads to unholy alliances with forces operating beyond the pale of the law and that such alliances in turn lead to destruction.

In this connection it is also important to note that Weise, again closely following his source, portrays Masaniello as essentially hum-

[97] Feind, *Dt. Gedichte*, p. 255.
[98] Christian Weise, *Sämtliche Werke*, ed. John D. Lindberg (Berlin, 1971), I, 367.
[99] Feind, *Dt. Gedichte*, pp. 255–256.

ble. Thus, in the scene where the fisherman appears in almost regal attire, Weise has one of the bystanders comment: "Es geschach auff hohes Gutbefinden des Hofes. Denn es war einem Vice-Roy schimpf-lich/ wenn er mit einem übelbekleideten Buben hätte tractiren sollen."[100] Then, several scenes later, he has Masaniello himself explain: "Verwundert sich iemand über diesen prächtigen Habit? Er ist mir wieder meinen Willen angeleget worden."[101] Weise also faithfully recounts Masaniello's repeated assertions that he wanted to remain a fisherman and that he had rejected the viceroy's offer to confer a title of nobility on him. All these sympathetic traits are omitted by Feind.

Thus Feind, like Weise, follows the *Theatrum Europaeum* in showing that the rebellion itself was justified; but by his character portrayal of Masaniello he clearly demonstrates that he has little sympathy for the popular leader. Feind's Masaniello is an ambitious and arbitrary autocrat who comes to grief because of his tragic flaws. He dies, not because his cause is unjust, but because by taking the law into his own hands he transgresses against the established order; and he is finally laid low by the very forces of anarchy unchained by his personal ambition. It is unfortunate that Feind did not deal with this subject in a spoken drama rather than in a libretto. The terse, vigorous language of some of the better scenes contrasts favorably with the rambling discourses of Weise's *Masaniello*; and if Feind had concentrated on the political action, the result might have been an absorbing tragedy. As it is, his attempt to combine it with the love intrigues considered indispensable in baroque opera was bound to result in a dramatic production devoid of unity.

Yet in many respects Feind's work represents a definite advance when we compare it to Postel's. First of all, Postel's libretti by and large are considerably more conventional than Feind's. With mo-notonous regularity the favorite devices of Italian opera appear in Postel's texts—women disguised as men, misunderstandings arising

[100] Christian Weise, *Sämtliche Werke*, I, 291.
[101] Ibid., p. 320.

from ambiguous statements, wrongly delivered letters, and so on.
Feind eschewed such hackneyed devices. Furthermore, while both
Postel and Feind make abundant use of poison and dagger, the
standard paraphernalia of Venetian opera, here too there is a dif-
ference: Whereas Postel's heroes merely threaten to commit suicide,
in Feind's *Masaniello* Antonio really stabs himself and Masaniello
goes mad and is shot. Similar events occur in Feind's other works.
As a result of such doings, his libretti are considerably more dra-
matic than Postel's. Feind quite intentionally departs here from
the precedents set by Italian opera. He discusses the question at
length in his treatise "Gedancken von der Opera," where, inter-
estingly enough, he dissociates himself from the dramatic theories
of French neoclassicism and advocates following the English
models, notably Shakespeare. He is thus the first German theore-
tician to set up Shakespeare as an example for German dramatists:

. . . wo keine *Actiones* sind/ da wird es auf dem *Theatro* sehr frieren. . . .
Aus dieser Uhrsache bin ich mit den Frantzösischen *Tragicis*, die darinnen
die alten Griechen und Lateiner *imitir*en/ nicht einerley Meynung/
daß sie in den *Tragedies* die fürnehmsten Thaten nur erzehlen lassen/
so/ daß die fürnehmste *Action* des *Acteurs* in einer wehmühtigen
Erzehlung allein besteht/ hauptsächlich wenn es den Untergang einer
Person betrifft/ worinnen die Engelländer abermahl von ihnen gantz
different. . . . Die Erzehlung macht mir kaum eine halbe so gute *Idée*,
als die ware Vorstellung eines Dinges. . . . Das heist nun natürlich
darstellen/ wenn der Leser oder Zuschauer bey der Durchlesung oder
Præsentation gerühret wird. . . . *Mr. le Chevalier Temple* in seinem
mehrmahls angeführten *Essai de la Poësie* erzehlet p. 374. daß etliche/
wenn sie des *renommirten* Englischen *Tragici Shakespear* Trauer-Spiele
vorlesen hören/ offt lautes Halses an zu schreyen gefangen/ und häuffige
Thränen vergossen.[102]

I have not yet been able to establish that Feind was directly ac-
quainted with Shakespeare's plays. It is quite likely, however, that
he had occasion at least to see one or more of the adaptations of

[102] Feind, *Dt. Gedichte*, pp. 106–109.

Shakespeare's plays performed in Germany by itinerant actors. In this connection it must be noted that the end of one of Feind's libretti, *Sueno*, certainly shows a striking similarity to *Romeo and Juliet*, a *Wanderbühne* version of which was in Velten's repertory.[103]

Both Postel and Feind endeavored to broaden the range of subjects presented on the opera stage by including topics chosen from the German past, but here, too, Feind went a few steps further than Postel: Postel's *Gensericus* is German only in name. Its setting is in classical Rome and its protagonist has no Vandal traits whatsoever but is cast in the conventional mold. The characters of Feind's *Sueno*, on the other hand, at least to some extent reflect the cunning and lust for revenge of the primitive Germanic tribes. They appear on the stage, Feind explains "um zu zeigen/ wie unser *polites Seculum* die rohe Lebens-Art der Alten gantz verworffen . . ."[104] Furthermore, by placing the action in Bergen, Feind also physically got away from the stereotyped settings of classical antiquity which Postel still clung to. Another example of Feind's originality is the fact that in his *Masaniello* he chose a plot taken from recent history, a most unusual procedure. Also, as far as the observation of the unities is concerned, Postel was somewhat more conventional than Feind. Regarding the unity of place, both librettists followed the rule laid down by Corneille[105] and indicated that the scene of action was at or near a certain city. Within these limitations, however, there are many more changes of scene in Feind's libretti, and it would appear, therefore, that here, too, this writer was influenced by the English tradition. Furthermore, while Postel observed the unity of time, Feind did not and argued against such constraints in his "Gedancken von der *Opera*."

[103] Heine, *Velten*, p. 26.

[104] Feind, *Dt. Gedichte*, p. 326.

[105] Pierre Corneille, *Discours des trois unités* (Paris, 1660).

[106] In one of his last libretti, *Simson*, Feind even went so far as to portray an action extending over a number of years.

Feind's dramatic instinct furthermore led him to rebel against the tradition of the happy end. At first he lacked the courage to flout the conventions of Italian opera to such an extent, and in the preface of his opera *Lucretia* he pointed out resignedly:

Bey unsern Zeiten ist die Gewohnheit/ Trauer-Spiele mit einem frölichen Ausgange aufzuführen/ schier zu einer Richtschnur geworden/ ob wol *Aristoteles* die andere Art/ um das Mitleiden zu vergrössern/ vorziehet . . . allein man ist in solchem Stücke abermahl gebunden/ nach dem *Gusto* der Zuschauer die Sache einzurichten . . .[107]

Feind compromised at first by introducing a tragic subplot. Thus his *Masaniello*, for example, is a strange hybrid creation in which the titular hero suffers a tragic fate at the beginning of the third act while the drama goes on to the conventional happy end. Later, however, he did muster the courage to break with tradition: In one of his last libretti, *Simson*, one pair of lovers dies, and the opera closes with an apocalyptic scene of destruction in which the temple collapses on the Philistines. Feind proudly entitled this libretto *Musicalisches Trauer-Spiel*, an unusual designation at a time when libretti were customarily entitled *Musicalisches Schau-Spiel*.

But Feind was an innovator also in other areas. Thus, unlike Postel, he vigorously condemned the antics of the harlequin on the opera stage and in his "Gedancken von der *Opera*" ruthlessly excoriated the Hamburg public for their lack of taste:

[Die] so genandte lustige Person . . . gehören [*sic*] . . . gar nicht in die *Opera*, und das *Theatrum* wird nur dadurch *prostituir*et/ denn es lässt/ als wann man mit Fleiß die Leute zum Lachen wolte reitzen/ welches nicht allein allen ehrbaren Sitten zuwider/ sondern auch eine Verachtung *involvirt*, und nicht ein wares *Plaisir*; denn was mir gefällt/ da erfreue ich mich wol über/ aber ich verlache es nicht: Nur das belachet man/ was einem verächtlich fürkömmt. In Hamburg ist die üble Gewonheit eingerissen/ daß man ohne *Arlechin* keine *Opera* auf dem Schauplatz führet/ welches warlich die grösseste *bassesse* eines *mauvais gôut* [*sic*]

[107] Feind, *Dt. Gedichte*, pp. 186–187.

und schlechten *Espirit* des *Auditorii* an den Tag leget. Was bey der gantzen politen Welt für abgeschmackt und *ridicul passir*et/ findet daselbst die grösseste *Approbation.*[108]

In keeping with his campaign to banish the clown from the opera stage, the *Pickelhering* has only a very subordinate role in most of Feind's libretti and, in the last two, *Der sterbende Cato* (1715) and *Rinaldo* (1715), he completely did away with the *lustige Person.* Thus Grout's reproach that "Feind took the lead in cultivating caricature and parody"[109] is quite undeserved and another example of the misunderstandings that have arisen in connection with German baroque opera. In fact, Feind's libretti are more serious and on a higher artistic level than those of the other librettists of the Hamburg opera.

In view of all these circumstances I cannot share Gervinus's[110] and Flemming's[111] view that Postel's work is superior to Feind's. In Feind's libretti we observe in embryonic state many of the attitudes and ideas that brought about a complete revolution in German drama later in the century. If he anticipated Gottsched in his campaign against the *Hanswurst*, he leapfrogged over him in his rejection of French neoclassicism and the observation of the unities. Feind was one of the most colorful persons of his time. Fearlessly he took sides in the political feuds raging in his native city—to the point that in 1708 his writings were burned by the public executioner, and he was hanged in effigy and banished from Hamburg— and just as courageously he fought against practices and conventions that had outlived themselves. This is the kind of writer we rediscover if we dedicate our attention to the German baroque opera libretto. I submit that it is a worthwhile task.

[108] Ibid., p. 103.

[109] Donald Jay Grout, *A Short History of Opera* (New York, 1947), p. 154.

[110] G. C. Gervinus, *Geschichte der deutschen Dichtung*, III (Leipzig, 1872), 585.

[111] Flemming, *Die Oper* (DLE, Reihe Barock, vol. V), p. 81.

THE RELATION OF MUSIC TO WORDS DURING THE GERMAN BAROQUE ERA

BY HANS-HEINZ DRAEGER

The University of Texas at Austin

To lecture on this topic is an honor and a challenge to me, for even as a student I was intrigued by the relationship between word and tone, and when I told my esteemed teacher, Professor Curt Sachs, that I would like to write a book on the history of word-tone relationships, he smiled and said, "Then you would have to write the history of music." He was exaggerating slightly because there are, of course, other challenging topics; but I believe that word-tone relationship is one of the most important problems in musicology—and, unfortunately, it is one that has been neglected. No book exists on the subject, though there are a number of interesting articles; and one of these, written by Anna Amalie Abert, the daughter of the eminent German musicologist Hermann Abert, is particularly relevant. Her paper, presented in 1956 at the Internationale musikwissenschaftliche Kongress in Hamburg, is called simply, "Wort und

EDITOR'S NOTE: When Professor Draeger delivered his contribution to the Baroque Symposium he spoke from notes only. His untimely death prevented him from preparing a manuscript copy. The text printed here is based on Draeger's notes and a taped recording of his lecture. Mr. David Dowty, graduate student in linguistics, transcribed the recording and, aided by Mr. Richard N. Franks, a student of Professor Draeger's, verified references and supplied additional annotation. Dr. Fritz Oberdoerffer, professor of music and a long-time friend of

Ton."[1] Miss Abert's idea is that there are, as she calls them, *musikbe-tonte* and *textbetonte Epochen*. She means that at the beginning of some period in music history vocal music shows a strong emphasis on texts, whereas preceding or subsequent epochs had gradually developed toward a more purely musical display. This statement, though it seems to be a simplification, is generally true. There are three epochs which are to be considered from this aspect, namely, the century from 1500 to 1600, which would clearly be text oriented; the years from 1600 to 1750, which again would be text oriented; and the period from 1750 to the romantic era, which would be music oriented.[2] The years 1600 to 1750 constitute the musical baroque, at least in Germany, and the classification of the text-music relationship coincides with this important period in the history of music as a whole.

Another attempt to classify the period of the baroque from this point of view is presented by Manfred Bukofzer. His classification, which is generally accepted, distinguishes three periods within the baroque era. In the first period we have what he calls "the most violent interpretation of the words, realized in the affective recitative in free rhythm." The second period is dominated by bel-canto style with the important formal distinction between recitative and

Professor Draeger's, generously helped the editor when the text of the lecture proved recalcitrant. Mrs. Jeanne Willson offered valuable suggestions on form and style. The editor gratefully acknowledges their assistance; nevertheless, the paper is published reluctantly in this form under Professor Draeger's name. If he had been able to do so, he would have clarified and enhanced the manuscript far beyond the results of our combined efforts. GSB

[1] Anna Amalie Abert, "Wort und Ton," *Bericht über den internationalen musikwissenschaftlichen Kongress Hamburg 1956*, ed. Walter Gerstenberg, Heinrich Husmann, and Harold Heckmann (Kassel, 1957), pp. 43–46. The title of this report will hereafter be abbreviated as *Kongressbericht 1956*.

[2] Professor Draeger describes Miss Abert's classification more precisely in his article "Musik-Ästhetik," in *Die Musik in Geschichte und Gegenwart* (Kassel, 1949 ff.), vol. IX, col. 1015: "Im Wechsel der kunstgeschichtlichen Epochen erkannte A. A. Abert, daß textbetonte Epochen schlagartig einsetzen (so um 1500, 1600 und 1750), während musikbetonte allmählich heranwachsen."

aria. During the third period, vocal music is dominated by instrumental music.[3]

What do the contemporaries, the baroque theorists or musicians, have to say about these classifications, or, rather, what would they have to say with regard to our topic? First of all, we should note that about the year 1600 there was a reaction against the Renaissance. Claudio Monteverdi (1567–1643), the great composer from Cremona, coined the terms which actually encompass the whole problem. He distinguished the *prima prattica* from the *seconda prattica*, the first practice versus the second practice. "First" and "second" here refer to chronological sequence. The first practice is the old one, the practice of the Renaissance. The second practice is the modern one. Together with these two distinctions are to be found the terms *stile antico*, which is the first practice, versus *stile moderno*, or, in other, more specific words, *stilus gravis*, the strict, old, contrapuntal style, versus *stilus luxurians*. Thus, at the beginning of the musical baroque, we have a stylistic dichotomy, a clear distinction between two styles of composition. Later in the century the distinction is made among *musica ecclesiastica* ("sacred music"), *musica cubicularis* ("chamber music" or "concert music"), and *musica theatralis*.[4] However, this classification is based on the social function of the music and not necessarily on musical technique or the musical style. While it is one of the problems of baroque music that any of these styles could be used in any of the places alluded to, the problem becomes crucial toward the end of the era, in Johann Sebastian Bach's works. At that time the differences in the musical language among opera, cantata, and even the mass had to a considerable degree disappeared.

Johann Mattheson (1681–1764), in turn bases his classification chiefly on the distinction between sacred and secular music and posits a number of subdivisions. He states very clearly that madri-

[3] Manfred F. Bukofzer, *Music in the Baroque Era* (New York, 1947), p. 17.
[4] Ibid., pp. 1, 4.

galism, that is, the musical interpretation of single words, a practice that originated in Italy, is to be found in sacred music as well as in secular music.[5] The general goal of baroque music is *expressio verborum*, and, second, *affectus exprimere* ("expression of the affections"). Bukofzer rightfully states that the new vocal music at the beginning of this epoch (and for a number of decades to follow) was subordinated to words and served only as a musical means to a dramatic end.[6] One is reminded of a remark by Wagner who, in his book *Opera and Drama*, complains that the error in the art-genre of opera is that a means of expression, namely, music, has been made the object, while the object of expression, namely, drama, has been made a means.[7] That corresponds to the attitude of the composers of early baroque opera whose main goal was the expression of dramatic truth. On the basis of the historical terminology discussed above, we may ask: First, what are the basic word-tone relationships in compositions of the baroque era? Second, and more important, what were the underlying, driving forces which created the baroque forms?

Of the many attempts that have been made to classify these procedures, these techniques, I would like to mention only two. One system of classification was devised by Curt Sachs (1881–1959), who meant to apply it chiefly to early society; but it can be applied to any period. Sachs makes a distinction between three types of word treatment. The first one he calls *logogenic*, by which he means word-born—dominated, dictated by words. The other extreme is *pathogenic*, which means passion-born. Between these two there exists a third, the *melogenic* style, and its characteristic is a flexible, melodic line. These classifications, however, appear too undifferentiated to help us in relation to our topic. A more detailed classification is provided by Donald Jay Grout, author of *A History of*

[5] Fritz Feldmann, "Mattheson und die Rhetorik," *Kongressbericht 1956*, pp. 99–103, passim.

[6] Bukofzer, *Music in the Baroque Era*, p. 8.

[7] Richard Wagner, *Opera and Drama*, trans. Edwin Evans (London, 1913), I, 27.

text is more or less only a vehicle for music	music is more or less rooted in or related to speech melody

musical sound organization music dictates linguistic pattern	*musico-linguistic* sound organization music follows linguistic pattern	*linguistic* sound organization the interpretation of the linguistic content determines the musical pattern

Figure 1

Western Music and *A Short History of Opera*. He establishes four types of relation between words and music. Type one, based mainly on declamation, is the *recitative*; type two, aiming at *decoration*, covers coloratura and melisma; type three, attempting the illustration of picturesque details of the words, is called *depiction*; and type four, the most important one, having for its goal *expression*, gives utterance to the emotional implications of the text or the situation. Sometimes all four types may occur simultaneously.[8] Grout's sequence does not appear to be very logical: a recitative can be very expressive indeed.

I have attempted to design my own classification and I would like to introduce it in the form of a tabulation (fig. 1). There are two main categories. In the first, the text is only a vehicle more or less for the music. In the second, the music is more or less rooted in or related to speech melody. In other words, on the left side of the chart we find musical sound organization: music dictates the linguistic pattern. On the extreme right is linguistic sound organization: the interpretation of the linguistic content determines the musical pattern. In between we have the musico-linguistic sound organization: the music follows the linguistic pattern. It is not the aim of this classification system to deal with musical forms. Such

[8] Donald Jay Grout, *A Short History of Opera* (New York, 1947), pp. 8–9.

an attempt would be futile, I believe, because several approaches
may occur in the same piece, the same form. In a cantata by Bach,
for example, there may be a recitative, which would be classified as
belonging to the extreme right side where music is rooted in speech
melody. There may also be a very strict old-fashioned fugue in
which the text is more or less the vehicle for the music. And in
between there may be an arioso, which is what Sachs would call
the melogenic style. What I am trying to do is to define the decisive
factors, the underlying, driving forces, or, in Calvin S. Brown's
terms, "the points of view which a composer may adopt in his set-
ting of a literary text."[9] At the left side there would be, for ex-
ample, very strict fugues. Next to this extreme, there would be
what is called depiction in music from sign to symbol; then we
would have the eighteenth-century aria, in which the text is still
more or less a vehicle for music; the *lied*, the song style, would
come in the middle; and finally we would have the recitative and
madrigalism.

The scope of baroque music with regard to word-tone relation-
ship is very wide. We must exclude only the extremes, the medieval
motet at the left side where the text is no more than the vehicle;
and on the right, any expressionistic distortions of speech inflec-
tion. But everything between these extremes is to be found in the
baroque era. Of this whole array of possible classifications I should
like to choose three points for discussion. First, music as sign and
symbol, depiction of the content of the text in the widest sense;
second, the bel-canto style; and third, the song style. Here, too, the
objection may be raised that my program is not altogether logical
because the first classification—music as sign and symbol—and the
fourth classification, the recitative, *concertato*, and *concitato* styles,
have one common root, namely, rhetoric. However, I believe that
the significance of the speech inflections is so important with re-

 [9] Calvin S. Brown, *Music and Literature: A Comparison of the Arts* (Athens,
Georgia, 1948), p. 52.

gard to the stylistic classification of baroque music that this separation is justifiable.

Let us first consider depiction. We must differentiate here between sign and symbol. Both terms, of course, are theoretical extremes, absolutes. Music is always either more of a sign or more of a symbol. To make this difference clear, I shall use an example which Professor Arnold Schering (1877–1941) used in his lectures. He said, "The cross on the tower of a church is the symbol of Christendom. A cross on the roadside, on the other hand, is a sign, because it signals that an intersection is ahead." That is, indeed, a basic difference; but, let me emphasize, it is always a relative matter; for the cross on the church steeple symbolizes a very real and cruel event, the crucifixion, and this is still expressed in the sign. Yet the cross has become more than a sign, because it is also the symbol of Christianity. Suzanne Langer makes this differentiation in "Language and Symbolism: The Logic of Signs and Symbols." She says: "There are, first of all, two distinct functions of terms, which have both a perfectly good right to the name "meaning": for a significant sound, gesture, thing, event (e.g., a flash, an image), may be either a *sign* or a *symbol*. . . . A sign indicates the existence—past, present, or future—of a thing, event, or condition. Wet streets are a sign that it has rained. . . . A smell of smoke signifies the presence of fire."[10] As to symbols, she makes the following statement: "Symbols are not proxy for their objects but are *vehicles for the conception of objects*."[11] And in Webster we find a very clear, short definition. A symbol is "that which stands for or suggests something else by reason of relationship, association, convention, or . . . resemblance; . . . as, the lion is the *symbol* of courage; the cross is the *symbol* of Christianity." These are the distinctions of

[10] Suzanne K. Langer, "Language and Symbolism: The Logic of Signs and Symbols," in *Problems in Aesthetics*, ed. Morris Weitz (New York, 1951), p. 222.

[11] Ibid., p. 225.

function we have to keep in mind when we talk about musical depiction.

I would like to make another distinction. We have to differentiate between means and function. This, I think, is important. Let me give one example: Bach composed the text "I follow Jesus" as a canon, that is, one voice follows the other. In that way he gives a clear depiction of an event. But he could also use the canon in order to symbolize the law: one voice is dependent on the other. In other words, the same means can be employed for different functions. On the one hand, the canon is used more as a sign; on the other, more as a symbol. And now let us consider a classification by James Moeser, who wrote his master's thesis on symbolism in Bach's *Orgelbüchlein* under my direction.[12] Moeser arrived at four classes of signs or symbols as listed in figure 2. The chart proceeds from action sign to language symbol. This tabulation functions well.

ACTION SIGN

(concrete, subjective, direct, simple;)

I. Onomatopoeia; (literal imitation of sound by sound;)

II. Representations of movements and directions; (Imitative representation of spatial movements and/or directions by corresponding musical movement and/or direction.)

III. Expression of a definite psychological state or emotion through the use of figures which do not aim primarily at imitation of sounds (literal or non-literal), movements, or directions.

IV. Emphasis on the *conceptual meaning* of a word or a text.

LANGUAGE SYMBOL

Figure 2. The Four Classifications of Symbols

The problem here is, of course, closely related to rhetoric and also to the theory of affections. Time and space forbid me to go into

[12] James Charles Moeser, "Symbolism in J. S. Bach's *Orgelbüchlein*," M.A. thesis, The University of Texas, Austin, 1964; the chart is on p. 20.

further detail here, although the theory of affections is an important one in the baroque era. I shall instead report on three questions which were asked me recently.

I happened to meet one of the outstanding musicologists of our time, Professor Charles Seeger, from the University of California at Los Angeles. While I did not mean to tell him about my paper, somehow the problem I am dealing with here came up. He asked me these questions: (1) Can music communicate affection, rather than affections—singular versus plural? (2) If so, how does music do it? and (3) If music can communicate affections, which ones? Thereupon Mr. Seeger drew this distinction between music and language: "Language can differentiate to a greater degree because language can name. Music does not name. But combined with language music can refer to a certain label. It can name to a certain extent. Music thus becomes a verbal symbol. Similarly a red traffic light has become a verbal symbol. The red light as such does not impose a force that can stop."

Here we have the problem *in nuce*: music becomes a verbal symbol. The limitations and the dangers of this development were known during the baroque. The Camerata (that Florentine club of amateurs who to a great extent started the whole baroque era) criticized as pedantic any depiction in a recitative; they insisted that they did not want the emphasis on single words but on the whole sentence. If mannerism can be defined as an extensive use of a stylistic device for its own sake, depiction can become mannerism even in the works of Bach. Forgive me for saying that. I know it is almost heresy to criticize Bach in any respect. But this has nothing to do with his mastery or his musicianship.

Let us look at an example in figure 3. The quotation comes from the St. John Passion,[13] and the text is ". . . die Knechte und Diener . . .": soldiers had made a fire because it was cold, and they

[13] Johann Sebastian Bach, *Passionsmusik nach dem Evangelisten Johannes* (BWV 245): *Werke* XII (Leipzig, 1863; reprinted Ann Arbor, 1947), p. 29, No. 14, meas. 19.

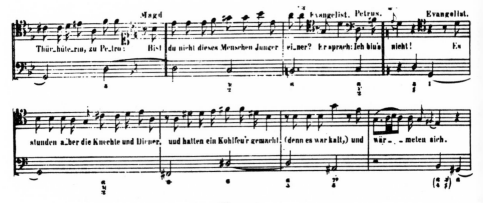

Figure 3

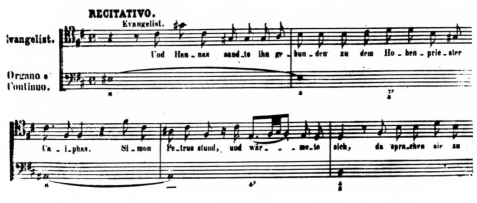

Figure 4

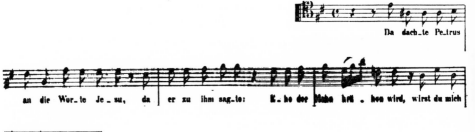

Figure 5

warmed themselves. This example is a perfect recitative that follows the speech inflection in every detail—save in one place—the nineteenth measure. The text is "und wärmeten sich" (and warmed themselves). They are shivering. This treatment is not an exception; a little later the text says that Peter was cold, he too warmed himself, and again Bach depicts this event[14] (fig. 4). Now let me ask: What does this depiction have to do with Peter's betrayal of the Saviour, one of the climaxes of the Passion? Bach interrupts a highly dramatic situation to depict the shivering of persons sitting close to the fire. In the St. Matthew Passion a similar depiction occurs, this time on the text "Ehe der Hahn krähen wird" (before the cock crows) in the eighth measure.[15] I dare say that this is depiction for its own sake. These instances clearly illustrate the problem. The matter becomes particularly difficult when we have linguistic negations. If you depict something, you show the thing: here it is and there is no doubt about it. But minor composers in the baroque era made the mistake of negative depiction, and even Bach utilizes picturesque words in basically negative sentences. In the famous chorus of the St. Matthew Passion "Sind Blitze und Donner in Wolken verschwunden?" (Have lightning and thunder disappeared in the clouds?), the basses illustrate magnificently the rolling thunder against sharp lightninglike rhythms of the higher voices. Again, in figure 6, a single word is illustrated at the expense of the evenly flowing rhythm of a chorale melody: ". . . all' sein Recht und sein' Gewalt, da bleibet nichts denn Tod'sgestalt" (. . . all his justice and power; there remains nothing but the figure of death).[16] With an isolated adagio to depict death, Bach interrupts the musical flow, continuance of which is a primary requirement during the baroque. Again, the motivation behind the pro-

[14] Ibid., p. 31, No. 16, meas. 4–5.

[15] Bach, *Passionsmusik nach dem Evangelisten Matthäus* (BWV 244): *Werke* IV (Leipzig, n.d.; reprinted Ann Arbor, 1947), p. 167, No. 46, meas. 8.

[16] Bach, Cantata No. 4, "Christ lag in Todesbanden" (BWV 4): *Werke* I (Leipzig, 1851; reprinted Ann Arbor, 1947), p. 113, No. 4, verse 3, meas. 21–29.

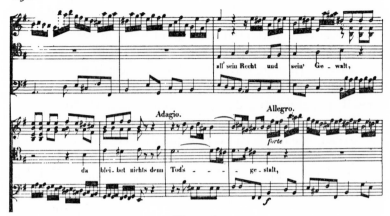

Figure 6

cedure is a problem even in the music of this great master, and it is exactly for the infraction of such rules that Bach has been criticized. Let me cite a remark by Johann Mattheson: "Die Worte: *Ich schweige der Freuden*, und *mir ist kein Lachen zu Muth*, würden übel klingen, wenn man auf *Freuden* und *Lachen* Läuffe oder hüpffende Noten zu Marckte bringen wollte."[17] For the text, "I am not in the mood to laugh," the depiction of laughter would not make sense. In Johann Adolph Scheibe's criticism of Bach's music this element might not have been without influence. I quote from the *Bach Reader* in English translation:

This great man would be the admiration of whole nations if he had more amenity (*Annehmlichkeit*), if he did not take away the natural element in his pieces by giving them a turgid (*schwülstig*) and confused style, and if he did not darken their beauty by an excess of art. . . . Every ornament, every little grace, and everything that one thinks of as belonging to the method of playing, he expresses completely in notes; and this not only takes away from his pieces the beauty of harmony but completely covers the melody throughout. . . . In short, he is in music what Mr. von Lohenstein was in poetry. Turgidity has led them both from the natural

[17] Johann Mattheson, *Der vollkommene Capellmeister* (Hamburg, 1739; reprinted Kassel, 1954), p. 202.

to the artificial, and from the lofty to the somber; and in both one admires the onerous labor and uncommon effort—which, however, are vainly employed, since they conflict with Nature.[18]

This reproach, incidentally, is one of the reasons that Bach's vocal music was not performed between 1750 and 1829. Even his sons changed Bach's music whenever they used it. W. Friedemann did it with several pieces and so did Carl Philipp Emanuel, not to mention Carl Friedrich Zelter (1758–1832), who had completely different ideas. Johann Nikolaus Forkel's statement of 1802 that Bach did not express or depict the meaning of single words is therefore incorrect, for, on the contrary, Bach did just that. Johann Friedrich Reichardt knew better and said so in 1806 when he criticized "das unnatürliche, gezwungene der Declamation, das Jagen nach auffallendem Ausdruck der einzelnen Worte." In 1829 Hans Georg Nägeli wrote that Bach's "Wortausdruck ist, im Ganzen genommen, einer der gezwungendsten." These views are not the exception. Johann Christian Lobe remarked that Bach possessed "Kraft und Wahrheit des Ausdrucks. . . . Aber Kraft und Wahrheit allein geben nun und nimmermehr ein Kunstwerk voll Schönheit." This is the general tenor of the criticism from the second half of the eighteenth century.[19] To some extent it is understandable.

Let us now come to the bel-canto style as it developed in Italy around 1650. It is an entirely different style, of course, but it belongs to the same category, in that the text is more or less a vehicle for the music. Briefly, the bel-canto style may be called the reaction of the musicians against the dictates of the poets. As Bukofzer phrased it, the immanent musical laws were restored, and music was coordinated with, rather than subordinated to, the words.[20] The

[18] Johann Adolph Scheibe, "Letter from an Able Musikant Abroad," in *The Bach Reader*, ed. and trans. Hans T. David and Arthur Mendel (New York, 1945), p. 238.

[19] All of the remarks following the quotation from Scheibe derive from an article by Georg Feder, "Das barocke Wort-Ton-Verhältnis und seine Umgestaltung in den klassizistischen Bach-Bearbeitungen," in *Kongressbericht 1956*, pp. 95–97.

[20] Bukofzer, *Music in the Baroque Era*, pp. 118–119.

style, a typical vocal idiom essentially based on the castrato voice, is very simple. The melody has a lilting flow. The rhythmic treatment is equally uncomplicated, and the harmony with its annoying insistence on the IV–V–I cadence is even simpler. The main result of this style is the differentiation—an important one—between recitative and aria. With slight overstatement it may be said that the bel-canto style is a creation of the singers as well as of the composers. For brevity's sake let me refer to Grout, who quotes Vernon Lee, from his *Studies of the Eighteenth Century in Italy*:

The singer was a much more important personage in the musical system of the eighteenth century than he is now-a-days. He was . . . its main pivot. For in a nation so practically, spontaneously musical as the Italian, the desire to sing preceded the existence of what could be sung: performers were not called into existence because men wished to hear such and such a composition, but the composition was produced because men wished to sing. The singers were therefore not trained with a view to executing any peculiar sort of music, but the music was composed to suit the powers of the singers. Thus, ever since the beginning of the seventeenth century, when music first left the church and the palace for the theatre, composition and vocal performance had developed simultaneously, narrowly linked together.[21]

That is exactly the situation; and from a technical point of view very little has to be said about bel-canto except that this was a field where improvisation enjoyed its chief triumphs. But while the matter does not touch directly on our discussion, this very concise description of the bel-canto style leads to the third problem, the song style, and more specifically, with regard to the baroque era, the *continuo lied*. Let me quote Bukofzer again: "The continuo lied represented the second great flowering in the history of the German song, its first peak being the tenor lied of the renaissance and its third the piano lied of the classic and romantic periods."[22]

The names of the composers and their compositions are well known: Heinrich Albert's *Arien* (1638–1650) were sung all over

[21] Grout, *A Short History of the Opera*, 2nd ed. (New York, 1965), p. 191.
[22] Bukofzer, *Music in the Baroque Era*, p. 99.

Germany; and a typical title is Thomas Selle's monodic collection, *Monophonetica* (1636). Although the piano *lied* of the classic and Romantic periods is still far in the future, we are now dealing with the second category of our classification (fig. 1), in which music is rooted in—or related to—speech inflection, and in which a fusion of stylized accents of natural speech with those of music takes place, as opposed to depiction and the bel-canto style. But we must also consider the directive force of tonality: clear tonal orientation is definitely an achievement of the baroque. In this basis the significance of the *continuo lied* becomes apparent: it follows the linguistic patterns. Syntactically, and semantically as well, this is *expressio verborum*; it is, however, more restrained than the recitative but less so than the bel-canto style. By the phrase "directive force of tonality" we mean that melodic and chordal progressions have a clear direction toward a goal, or away from a center. This force they have in common with spoken sentences. Detailed study of some composers of the eighteenth century confirms the impression that this directive force of tonality was used not only for structural purposes but for special expressions as well. Examples of it may be found, according to a recent dissertation, in Bach's harmonizations of chorales.

Figure 7 is a graph from the dissertation "Textual Interpretation in the Choral Harmonizations of J. S. Bach," by Michael Broyles.[23]

Figure 7

[23] Michael Everett Broyles, "Textual Interpretation in the Chorale Harmonizations of J. S. Bach" (Ph.D. diss., The University of Texas, Austin, 1967), p. 279.

Vertically, the squares of the graph indicate the steps in the circle of fifths, G, D, A, E, and so forth. Horizontally, they illustrate chordal progressions. The superimposed vertical lines represent chords, which are sometimes simple—root, third, and fifth—and sometimes complex. The internal lines connect the respective root, third, and fifth members of the successive chords. What I want to show here is that the meaning of the text is expressed or even depicted. It is not expressed as a picture in the first category, but the semantics of the text are caught in the harmonic progression as shown on the graph. The text is "Alle Täler zu erhöhen, daß die Berge niedrig stehen" (to elevate all valleys so that the mountains are lowered). This is exactly what the composers of the eighteenth century said they could do. It can be shown that such composers as Schubert and Salieri, for example, sensed the difference between German, Italian, and French, and accordingly chose different harmonic progressions to do justice to the different structures of the respective languages. The cadential formulas of the recitative make this point particularly clear.

We have now arrived at our last category, the recitative—the *concertato* and the *concitato* style, and it will be necessary to go into the connection between music and rhetoric. There has been a consistent application of rhetoric to music, at least since Pietro Aaron, the Renaissance theorist (c. 1490–1545), and particularly since Johann Cochlaeus (1479–1552), German humanist and theologian. In the thinking of these men, music belongs to what has been called *artes sermonicales* or *artes dicendi*. The relationship among music, grammar, and rhetoric becomes clearer when we read such very common definitions as *Musica est bene modulandi* (or *canendi*) *scientia* ("Music is the science of singing and composing well"). *Grammatica est recte scribendi et loquendi scientia* ("Grammar is the science of writing and talking correctly"). And concerning rhetoric: *Rhetorica est bene dicendi scientia* ("Rhetoric is the science of talking well"). Thus, rhetoric and music are closely related: *Musica est bene* MODULANDI *scientia*; *rhetorica est bene*

DICENDI *scientia. Musicus poeta* and *musica poetica* are superior to *musicus* and *cantor* as such. The classification of music generally accepted on this basis is, first, *musica speculativa* or *theoretica*; second, *musica activa*, the practice; and third, *musica poetica*, composition. J. A. Herbst, in his *Musica poetica* (1643), states that part of music represents the meaning of the text ("der Inhalt vnd Verstandt deß Textes") and not only, as was usual in Italy, the *oratoria, elocutio*, and *declamatio*.[24] Composition in this category then is *explicatio textus*: music explains the text. In other words, *ars musica* and *ars poetica* are combined into *musica poetica*. Music became the interpreter—we would say the dragoman—of poetical content. This is, incidentally, comparable to the development from the Viennese classic to Richard Wagner. And from the French *Caractères, Passions*, and *Portraits en musique* of the seventeenth century there extends a direct line to Johann Jacob Froberger (1616–1667), Johann Kuhnau, (1667–1722), the predecessor of J. S. Bach, and to Bach himself. As Magister Johann Abraham Birnbaum (quoted by Spitta) reports about Bach: "He so perfectly understood the resemblance which the performance of a musical piece has in common with rhetorical art that he was listened to with the utmost satisfaction and pleasure when he discoursed of the similarity and agreement between them." Unfortunately, no examples of these discourses have come down to us. Birnbaum continues: "But we also wonder at the skilful use he made of this in his works."[25] So Bach not only knew about this classification, this relationship, but he made, as his friend put it, "skilful use of it."

The theory of this kind of composition has been summarized by Mattheson. To him, music is *Klangrede*, speech in musical sound, not only vocal music but instrumental music as well. In several of his books Mattheson presents all the finesse and details of this art.

[24] Hans Heinrich Eggebrecht, "Zum Wort-Ton-Verhältnis in der 'Musica Poetica' von J. A. Herbst," in *Kongressbericht 1956*, pp. 77–79.

[25] Philipp Spitta, *Johann Sebastian Bach*, trans. Clara Bell and J. A. Fuller-Maitland (New York, 1951), II, 238.

To him, making a speech is the same as making a composition, a *Klangrede*. The stages are: *inventio, dispositio, elaboratio* and *decoratio*, and finally, *executio*. This sequence applies to the art of speech as well as to the art of music. No figures depicting single words should be used in the recitative, Mattheson asserts. For this reason I have separated these two categories in my own classification (see fig. 1). The left side and the right side of this classification are both closely related to rhetoric, but, in the recitative, figures have been forbidden since 1600. You will recall that the Camerata disapproved of them as pedantic: the whole sentence, not the individual word, should be understood. Mattheson is strictly against repetition of a word until the whole sentence, "der volle Wortverstand," is comprehensible. He ridicules composers who repeat the word *Amen* in five parts thirty-five times and calls them *Amenbrüder*.[26] For the same reason he berates Bach for repeating the word *ich* three times before he completes the statement "Ich hatte viel Bekümmernis" (I was sore distressed) in his Cantata No. 21. This treatment, Mattheson avers, is inadequate.[27] By following his concept of *analysis melopoetica* we are led directly to a statement in Kant's *Critique of Judgement* and the way is opened for classical esthetics:

Every expression in language has an associated tone suited to its sense. This tone indicates, more or less, a mode in which the speaker is affected, and in turn evokes it in the hearer also, in whom conversely it then also excites the idea which in language is expressed with such a tone. Further, just as modulation is, as it were, a universal language of sensations intelligible to every man, so the art of tone wields the full force of this language wholly on its own account, namely as a language of the affections, and in this way, according to the law of association, universally communicates the aesthetic ideas that are naturally combined therewith.[28]

[26] Mattheson, *Capellmeister*, p. 179.

[27] Johann Mattheson, *Critica musica* (Hamburg 1722–1725; reprinted Amsterdam, 1964), II, 368. Mattheson does not name Bach; he only writes "ein sonst braver *Practicus hodiernus*."

[28] Immanuel Kant, *The Critique of Judgement*, trans. James Creed Meredith (Oxford, 1961), pt. 1: "Critique of Aesthetic Judgement," §53, p. 194.

In my very general survey it was not possible to discuss all the varieties and diversities of musical form, and I could mention only a few works of individual composers. What I have tried to point out is the close relationship existing between music and language during the era of the baroque. What Opitz said about poetry and painting may also be said about poetry and music:

> . . . es weiß auch fast ein Kind/
> Daß dein' vnd meine Kunst Geschwister Kinder sind.[29]

[29] Martin Opitz, "Vber deß berühmbten Mahlers Herrn Bartholomei Strobels Kunstbuch," *Weltliche Poemata*, II (Frankfurt, 1644), 43, lines 5 and 6 of the poem.

JOHANN ADAM DELSENBACH

BY JUSTUS BIER

North Carolina Museum of Art, Raleigh

In Europe in the fifteenth century, as the spirit of the Renaissance awakened the public's desire for accurate documentation, the depiction of city views became an important task for the artist. Painted, drawn, or engraved views—including woodcuts, copper engravings, and etchings—of the city as a whole, or of its streets and squares, were produced. This practice continued until the second half of the nineteenth century, when photography largely superseded the work of the view painters.

Venice, the special goal of numerous travelers, inspired the greatest number of such views, which were disseminated almost as widely but not as inexpensively as photographs and picture postcards are today. A large group of Venetian artists answered this demand, including Luca Carlevaris (1665–1731); Giovanni Antonio Canal, better known as Canaletto (1697–1768); Michele Marieschi (1710–1743); Francesco Guardi (1712–1793); and Bernardo Bellotto (1721–1780), who also became known as "il Canaletto," the surname his uncle, Antonio Canal, had used. And of representatives of this branch of art in other Italian cities, Gian Battista Piranesi (1728–1778), the Roman giant in this field, should of course be mentioned.

Northern European artists devoting themselves to city views have received much less attention than the Italian *vedutisti*, although there are artists of quality to be considered in the North, too. Therefore, it would be worthwhile to single out a key figure among them, and I have chosen Johann Adam Delsenbach (1687–1765). In his engravings the image of Nuremberg is preserved as it existed in his own time. The medieval character of his native city was then still so fully intact that even in his baroque interpretation it comes through forcefully. Nuremberg was one of the few cities to retain its medieval appearance almost unchanged until the commercialism of the nineteenth century with its bulky and gross new buildings ruined major streets and squares, and until, in the twentieth century, the Second World War left the whole city a shambles.

Johann Adam Delsenbach was born in Nuremberg on December 9, 1687, the son of Adam D. Delsenbach, a *Geleitsreiter* ("municipal security guard"), who accompanied and protected Nuremberg merchants as they moved with their goods to the trade fairs at Leipzig. The son, Johann Adam, after studying the art of engraving, was trained for several years at the Nuremberg Academy of Fine Arts.

In 1708, at the age of twenty-one, Johann Adam Delsenbach moved to Leipzig to illustrate a publication for Johann Georg, Duke of Saxony-Weissenfels, but the work unfortunately was completed only after the death of his patron. He then undertook a journey to Wittenberg, Berlin, Dresden, and Prague, and finally moved to Vienna. Here the great architect Johann Bernhard Fischer von Erlach (1656–1723), then in the service of the Emperor, commissioned him to engrave the greater part of the copper plates for his famous work, *Versuch einer Historischen Architektur*, which traced in reproductions and reconstructions the history of architecture from early Egyptian times to his own day and terminated, of course, with Bernhard Fischer von Erlach's own designs.

At the same time, Delsenbach engraved views of the city of Vienna after drawings by Joseph Emanuel Fischer von Erlach, the

son of Johann Bernhard; and this activity may have suggested to him for the first time the possibilities offered him by his native city of Nuremberg. In Vienna he took the first step in this direction by drawing and engraving four views of the city, each of which was taken from the center of the city in the direction of one of its four major gates. In 1713 an outbreak of plague frightened him into returning to Nuremberg, but he did not sever his connection with Vienna. Five years later, in 1718, Carl Gustav Heraeus (1671–1730), Imperial Inspector of Antiquities, asked him to return, in order to help with Heraeus's publication of portrait medals of the ruling princes and famous men from the fourteenth to the eighteenth centuries; Heraeus assured him of an annual salary. After this engagement, Delsenbach was commissioned by Prince Anton Florian of Liechtenstein (1656–1721) to make drawings and engravings of the prince's estates and castles in Austria, Moravia, Bohemia, and Silesia—a task which kept him busy for four years. After the death of the prince, Delsenbach returned again to Nuremberg, where he was married on November 26, 1723, at the age of thirty-six. He married twice again, but in 1758 when Georg Andreas Will wrote a short biography of him for the *Nürnbergische Gelehrtenlexikon*, only one daughter was alive to solace his old age.

In 1733 Delsenbach traveled through the major cities of Holland and Zeeland with Mijnheer van Gallieris, Netherlands ambassador to the Imperial Diet, then permanently located at Regensburg. During these travels his knowledge of the Dutch language was very useful to him, and, Will reports, he came in contact with "the most famous artists." In 1733, the same year in which he undertook this journey, he was elected to the Greater Nuremberg Council, an indication of the esteem in which his native city held him.

I have already referred to the baroque character of Delsenbach's engravings, and the question should be raised here as to whether he could do justice to the medieval appearance of Nuremberg. The city even then was not as unified as it would seem. The greater part of it, at least most of the burghers' houses, had been rebuilt in post-

medieval times. However, the plan of the city, including the spatial arrangement of streets and squares, had been laid out in the Middle Ages. Because of the strong tradition of using previously developed styles, the typical Nuremberg house, even of the eighteenth century, still reflected the character of its medieval precursor, at least in its general form. Such structures were composed of a frontal building and a rear one, connected by two lateral tracts opening on galleries that flanked a courtyard between them. Also, the placement of the gate and the number of stories had probably never changed, as comparison with extant examples of medieval houses proves.

It is rewarding to discuss in detail this type of house, since most of the buildings which replaced older houses in the nineteenth century did not retain this basic shape. Their architects were satisfied to embellish these buildings with ornaments copied from medieval structures as a concession to the past.

Nuremberg was not a city of gabled houses, as Wolgemut's woodcut in Schedel's *World Chronicle* of 1498 would have us believe. The first principle followed in planning Nuremberg's houses was the positioning of them with the gutter side toward the street so that the main cornices and the ridges of the roof ran parallel with it. Only at the end of a block did the gables protrude, or where the street followed a curve to which the individual lots had had to be adjusted in stair-step fashion. (Compare, for this arrangement, the square, "Platz bey der Rosen," in fig. 1.) The second principle concerned the prevailing height of the stories, which was low by modern standards, being raised only slightly in the most stately buildings. The third principle applied to the relationship of the house and the roof: the steep span roof was nearly always as high as the house below it; a whole series of floors was thus available for storage areas, necessary in a period when grain and food for the year had to be kept. These storage floors were often recognizable by the sequence of little dormer openings admitting light into them. The windows in the façades, rectangular and of moderate height, were cut into the walls without any sculptural framing. Only the façades of the most

stately buildings, as for instance, the baroque town hall behind St. Sebald's Church (fig. 2), showed decoration around the windows. This special framing created an effect of great splendor when seen against the quiet background of the other houses.

The only marked accent on the larger houses was a bay window, which was usually placed asymmetrically at the second-story level. Placing the bay window to one side made it correspond generally to the portal, which was usually located on the opposite side of the façade. The portal was always larger than an ordinary door, for it had to admit carriages, sleds, and horses, and it served as a passage-way into the courtyard. The façade was further accented by the placement of an oriel window in the slanting front of the roof. This window provided entry to the storage space under the roof. A pulley was used to lift the loads from the ground. The oriel window projected over the façade in the center, making it necessary to place the bay window to the side, since it would otherwise be in the way when loads were elevated to the storage areas. The number of win-dows in each story differed greatly from house to house. Small houses had from two to four windows in each story and larger ones might have nine, eleven, or even thirteen windows per story. The majority of Nuremberg houses had four stories—a ground story and three upper ones; however, in lesser streets and in the outlying quarters of the city smaller houses prevailed, with only two upper stories.

"Medieval" Nuremberg has to be seen, of course, with other eyes than Delsenbach's. His perspective, although much closer to the natural view of a scene than the one which can be produced by the wide-angle lens of a camera, is still a rapid one in the baroque sense. The streets and squares are seen as "spacious," and their depth is stretched beyond their appearance in reality. The breaks and bends in the streets prove that they are not designed for such a rapid move into depth and should be felt as a quiet, peaceful space. Another element of baroque interpretation can be found in the way Delsen-bach exploits the rhythm of windows, showing them in such rapid

succession that it often becomes difficult to count their numbers in his engravings. These rhythmic sequences seem to have a life of their own. In the North of Europe one is always responsive to the charm of such rhythms, even where houses of different shape, as for instance, stone and half-timbered houses, are preserved side by side. Delsenbach's eye sees such different façades as mutually enlivening and moves without stopping along their surfaces. However, the single house in medieval times must have been considered a much more independent unit than Delsenbach shows it to be, as is evident from all representations of streets and squares in fifteenth-century paintings or woodcuts.

Even admitting such baroque modes of interpretation, Delsenbach must be credited with having depicted the smallest details faithfully and with great accuracy. His training in engraving from models by other artists might have educated him to this accuracy, but his natural talent also moved in this direction. This is shown, for instance, in his engravings of the treasure of the German empire where he is able to reproduce medieval designs with a real feeling, rare in his own time, for the style of another period. In his views, the whole picture of the Nuremberg of his day is unrolled with good humor: Nuremberg nobility in stagecoaches and sedan chairs; the simple people working or merrymaking; peasant women with carts and baskets; beggars and noble lords intermingling; dogs and horses; and a variety of incidents of street life all are shown. His talent for depicting hurried and spontaneous movement is unusual, though typically baroque. He always viewed his subject from a window, and this perspective enabled him to portray the scene as it might have appeared to a medieval Nuremberger looking out of a bay window at the everyday life below. The human activity in street and square is also of some importance for the appearance of the architecture depicted, since it establishes a proportion against which the size of the buildings can be judged and fills the emptiness of wide spaces with vibrant life.

Earlier the question was raised as to whether Delsenbach could

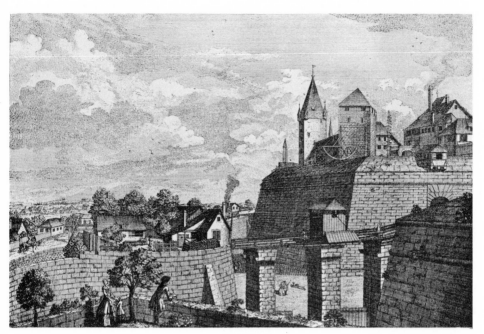

A view toward the Nuremberg Castle from outside the city, near the Castle Gate Tunnel entrance, showing in full the enormous bastion on which the castle stood: the curved bridge supported by piers which led across a moat into this bastion, the curved outer walls of the moat, and the towers at the side of the Emperor's stable building, the "Luginsland" (literally, look into the country) or watch-tower with its tall steeple and the five-cornered Romanesque tower, so called from a fifth corner [sketched-in] not actually visible in our view. On the bastion in front of the building appears some of the apparatus of the astronomical observatory erected there by one of Delsenbach's teachers at the Nuremberg Academy, Georg Christoph Eimmart. At the end of the bridge leading into the bastion appears the opening of the Vestnertor tunnel, which cuts through the bastion. Above the bastion is the small gate that separated the so-called Swedish court-yard, where, to the right, the residence of the castle custodian is located. Behind the five-cornered tower, the oldest part of the castle, appears the Imperial stable, on the ground floor, and, on the upper floors, a granary for castle and city in case of siege, a structure with the shape of a greatly enlarged Franconian peasant house. On the wooden bridge leading from the outside of the city to the bastion stands a hut with machinery to raise the drawbridge. The bridge is operated from the guardian's small half-timbered house above the tunnel entrance. On the outside, where the bridge reaches the open land, is the tollkeeper's booth.

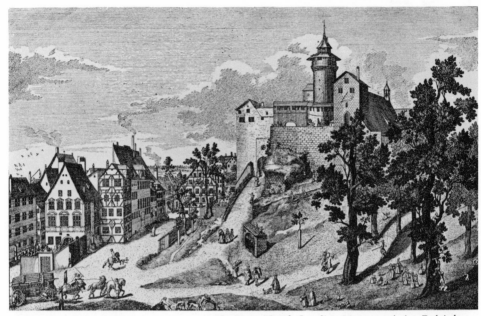

A view of the Imperial Castle from the east, showing the rocky hill on which the castle is located, above the city. (To the side of the roadway leading to the gate is a small arched building which contains the "Mount of Olives" by Adam Kraft.) Old linden trees flank the hill. Visible to the left of the castle is the Hasenburg, named for a family which held the office of castle custodian. The Freiung in the center is supported by a high wall from which the whole city can be seen. Behind the Freiung, winding around the Vestnerturm, is a wall with a gate leading into the outer courtyard of the castle. The quarters of the city fire guard are located at the top of the Vestnerturm, the highest tower of the castle. Behind this tower, to the left, can be seen the castle's Romanesque tower, which contains the chapel choir. To the right of the Vestnerturm is the Church of St. Walburgis, with a little bell tower on the top of its gable. On the eastern tower of the church a sundial can be seen. Among the houses below the castle are several in half timber, the usual manner of construction of middle-class houses during the later Middle Ages. (Only houses of the nobility were constructed completely of stone in the shape of towers.) The whole scene is enlivened by animals and people: birds flying, dogs frolicking, a cart loaded with wood being driven uphill toward the castle with extra horses and men helping it to take the incline. Some elegant people stroll about the grounds outside the castle; a woman with a bundle on her back walks toward the gate. A group of soldiers carrying guns and swords marches up to the castle. Among the lindens children play ring-around-a-rosy, while the adults look on, and several boys try to climb one of the biggest trees.

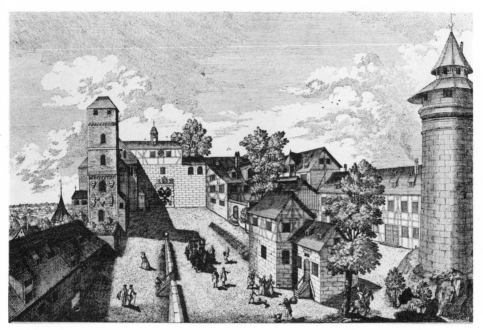

A view into the exterior courtyard of the Imperial Castle from the walkway atop the fortified wall which separates the castle from the outer terrace of the castle hill called the "Freiung." Another view of the same wall topped by the walkway appears in Delsenbach's engraving, "Vorstellung der Kaiserlichen Burg gegen den Berg hinauf" reproduced above as No. 2. Among the buildings surrounding this courtyard appears, to the left, the Himmelsstallung, ("Heavenly Stable") so called because of its location at the "Himmelweg," the steep roadway leading up from town. Behind it can be seen the castle proper with its Church of St. Margaret, which is housed in the two lower stories of the square, and the Romanesque tower on the left. In Delsenbach's time this tower was thought to be a very old Temple of Diana. However, all the sculptures on the outside of it are of the Romanesque period and do not represent heathen gods. In the stone wall to the right, topped with a half-timbered story and a small clock-tower, a large Renaissance gateway of 1562 is prominent; this leads into the inner courtyard and the double door is decorated with the Hapsburg double eagle topped by three smaller heraldic shields; among these can be discerned the coats-of-arms of the counts of the castle and of the city of Nuremberg. In the center of the courtyard is a square stone building, the Well House. It has a half-timbered top story and grills secure its windows. It is referred to as the Well House because it rests atop a deep well, which ensured an adequate water supply for the castle, even in times of siege. At the far right is seen the big circular tower called the Vestnerturm, the castle's "dungeon." Its top stories served as watch-tower for permanent guards, who would report any activity outside the city calling for alarm, as well as watch for smoke that might indicate a fire inside the city. The half-timbered buildings in the background to the right contained dwellings for the personnel retained on the castle grounds. As always in Delsenbach's engravings, the lively scenes of people sightseeing or carrying out menial tasks on the castle grounds should be observed. A large coach has just drawn up near the Well House.

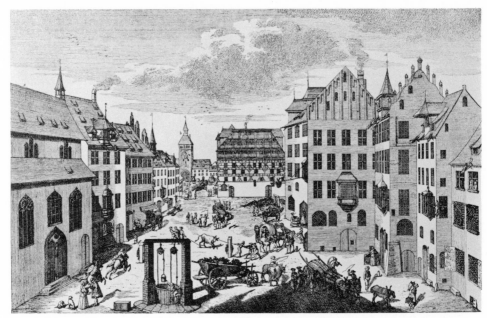

The Square formerly called "Bey der Rosen," or sometimes, "Grain Market," today called "Josefs Platz," looking toward the White Tower. (This is one of the most beautiful engravings by Delsenbach.) The square was named Bey der Rosen for a house, "Zur Rosen," which had a rose as its emblem. To the left is the Church of Our Saviour, a building that no longer exists; however, the third house on the left, with its corner tower and the Madonna at the corner of the house, is still in existence. The long vista is terminated by the White Tower. The square proper ends with the broad, seven-story, half-timbered house with open balconies in the upper three stories. It is the house of a tanner who needed space for hanging skins to dry. The strange shape of the house can be explained as a double gable, the two gables connected by open balconies. Along the right wall of the square, which is set back and ultimately leads to the Charles Bridge, are individual gables: a Gothic gable with horizontal divisions; another gable with a baroque, undulating outline above which rise small turrets; and a simple triangular gable. On the gutter side, copper gargoyles shaped like flying dragons lean downward. The house at the extreme right shows handsome grills in front of the windows. The shutters on the ground floor windows are painted, like pages in a picture book. To the left two mailmen gallop away on horseback. They have come from the post office just behind the Church of Our Saviour. Wagons filled with wheat and vegetables are also in the square, and six men can be seen trying to rope a stubborn bull.

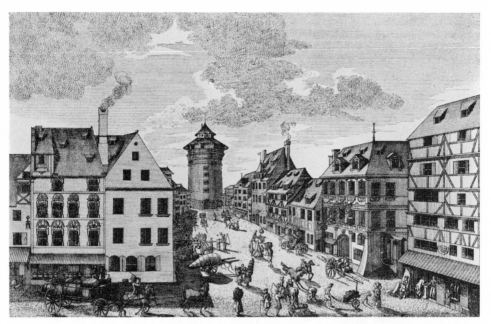

An engraving of the Platz bey dem Neuen-Thor ("Square near the New Gate") showing today's "Neutorstrasse," the street leading to the "Neutor," the outer gate of the city at its northeast corner. In Delsenbach's time it was called "Platz" and the word *square* was characteristic of the quiet spaciousness of the city then. In those days, within the city walls, there were only Plätze ("squares") and Gassen ("alleys"); the term *strasse* ("street" or "road") was reserved for thoroughfares beyond and leading away from the city and its gates. The suburban quality of this square is very evident: simple, half-timbered or stucco houses are the rule, with one exception; the second house on the right is of stone; its sign proclaims it to be a hostelry. In the alley between it and the half-timbered house in the immediate foreground, identified by its sign as a cooper's house, can be seen a big well with two wheel drafts over the shaft. A shop in the cooper's house sells scythes, sickles, and shovels. In front of the inn stands a cart with some barrels, while farther down there is a carriage awaiting the departure of its owner. Close by, a man is transporting a small potted tree in a wheelbarrow. On the left we notice an elegant house with window embellishments. Judging by a series of small barrels under the attached awning, it is probably a wine shop. A wagon with a load of barrels is just pulling away from it

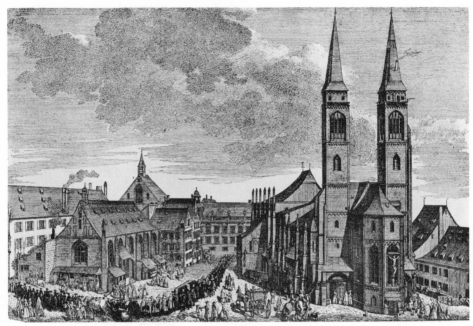

A view of the main church at St. Sebald, from the west. Across its grounds a funeral procession is moving toward the Neutor Gate on its way to the new cemetery, the Johannis-Friedhof, some distance from the city. To the left is the chapel of St. Maurice. Close against its north side is the "Bratwurstglöcklein," a small inn which is said to have served delicious pork sausages broiled over a charcoal grill, and to have been in operation as early as 1519. Under a lean-to roof in front of the chapel some stalls have been placed. The broad gable of the Dominican church rises in the background, its western front showing a tripartite window, an airy spire rising from the ridge of its roof. A small cluster of houses is tucked in behind the chapel. A section of the Renaissance façade of the Town Hall, built by Jacob Wolf the Younger in 1616–1622, appears between these houses and St. Sebald's Church, with one of its three pavilions to the left. The two town houses to the right of St. Sebald's stand on lower ground, for St. Sebald's was built on a terrace, due to the sloping terrain. Under their high, sweeping roofs would be stored, as in most town houses, a year's supply of grain and enough firewood for the stoves and fireplaces during the long, cold winter.

St. Sebald's western choir is flanked by two portals which lead into the church. On the wall outside in front of its central window, hangs a huge crucifix. This choir was modeled after the western choir of the Cathedral of Bamberg. The architects of St. Sebald's, as its close relationship to Bamberg Cathedral makes evident, were former members of Bamberg Cathedral workshop. The body of the church behind the western façade, erected about 1230–1273, looks rather low when compared with the huge Gothic hall choir which was added in 1361–1379 and which completes the church on the east.

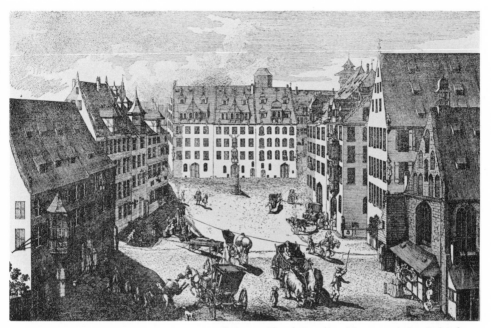

The former Milk Market, renamed Albrecht-Dürer-Platz when Christian Daniel Rauch's bronze monument of Dürer was placed there in 1840 to commemorate the 300th anniversary of Dürer's death. The monument stands in the exact spot where Delsenbach shows a draw-well. Delsenbach must have viewed the square from St. Sebald's Church, perhaps looking out from an opening in the roof. Of the castle which lies to the upper right only the Romanesque tower and the Vestnerturm are high enough to appear. The two gables of the chapel of St. Maurice and the house that stands next to it, seen here in the foreground to the right, contrast effectively with the quiet horizontals of the other houses surrounding the square. The square seems completely self-contained, mainly because of the shadows on its eastern front, particularly heavy on the parsonage of St. Sebald's, in the lower left; not even streets opening in the two upper corners detract from this feeling of completeness.

As always in Delsenbach's engravings there is plenty of activity within the square: on the upper left a patrician is greeted with a big bow and scrape, on the upper right a sedan chair is carried by two bearers. A well is being cleaned and a large rope being used there crosses the whole square. An elegant carriage sweeps along, past a peasant leading his oxcart to market; the peasant's wife, surrounded by all her baskets, is allowed to ride. Finally, half hidden in the shadow of the parsonage, a horse shies from a barking dog.

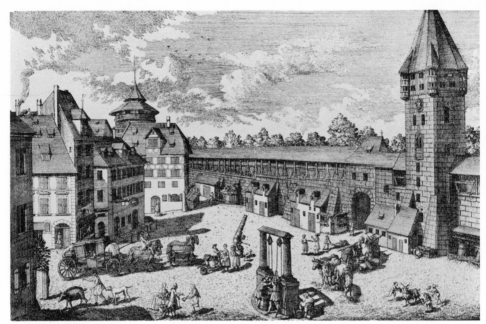

A view of the square near the Tiergarten Gate. We see on the right the Tiergarten Gate Tower and to the left of it the gate which, before 1538, opened through the tower itself. The walkway on the city wall is open on the side toward the city; wooden posts carry the roof. Solid buttresses support the wall as well as the tower. In the background the top of the circular New Gate Tower can be seen. The building in the background is the house of Albrecht Dürer. It has half-timbered upper stories under a hip roof and a closed-in lower section of stone. The group of houses between the Zisselgasse, today named Albrecht-Dürer-Strasse, and the Bergstrasse, identified by Delsenbach as "Der Weg nach dem Milchmarckt," is enriched by the contrast between the broadly set houses and one narrow, high, very small house flanked by them. Animals and people abound in the scene, and it contains all kind of amusing detail: note, for instance, the coach drawn by four horses moving toward the gate and on to the road to Bamberg; the beggar holding out his cap to a noble couple; in the foreground three boys chasing a goat, a large oxcart being loaded, and water being drawn from the well.

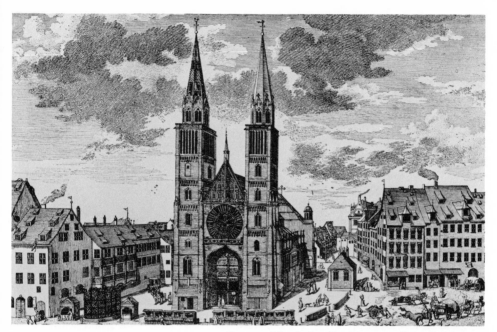

A view of the Church of St. Lawrence, here seen from the west, with the site of its former cemetery and the houses surrounding it. Even though the old cemetery had long since been given up, the low walls in this engraving still show its former boundaries. The site is now partially taken up by small stalls and shops. The Fountain of the Cardinal Virtues, enclosed by an elaborate fence and flanked to the right and left by store buildings, is also on its boundary line. The tiny building to the south of St. Lawrence's is the "Poor Children's School," long since gone, which in its turn had replaced a chapel that by its very smallness had served well to offset the great size of St. Lawrence's Church with its slender towers and broad hall choir. Behind the choir can be seen another building— also long since gone—the small chapel of St. Anne. Animals and people in lively motion abound.

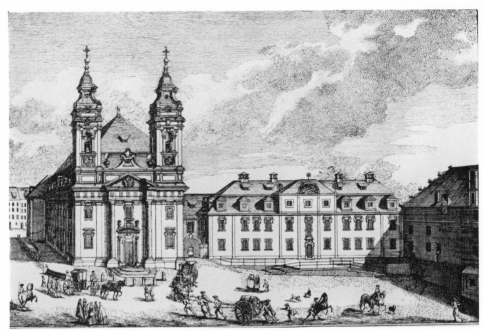

The Church of St. Aegidius (St. Giles) and the high school, rebuilt in 1711–1718, after a fire in 1696 had destroyed the Romanesque monastic church and the group of buildings formerly making up the "Schottenkloster" founded by Scottish Benedictine monks. The architect of the new buildings was J. Trost. The whole complex is located somewhat back toward the eastern side of the square, which descends toward the Pegnitz River valley. Although an accurate enough presentation of the baroque nature of the buildings, this engraving seems to lack the life that Delsenbach's medieval views of Nuremberg offer. But the goings-on within the square at least add some sparkle: two coaches are crossing the scene; a barrel of wine needs the combined efforts of six men, pulling and pushing. Horses are led around, a group of people passes the time of day, dogs romp, a horse shies, ladies gossip.

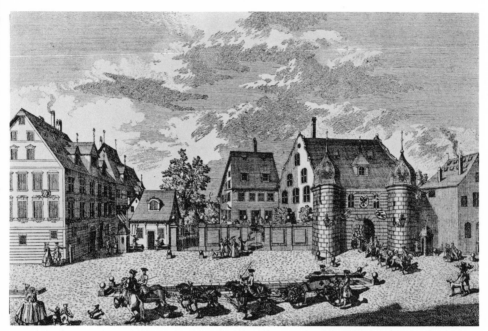

A view of the rusticated façade of the arsenal with its large round gate flanked by two round towers, capped with Italianate, puffed-out roofs. In the center of the main roof appears a small, crowning dormer window. Lamps on movable arms are attached to both towers. Forming a large triangle above the round arch of the gate are three coats-of-arms: the imperial double eagle in the center signals the fact that Nuremberg is a free city of the empire, while the two other emblazonments represent Nuremberg and its territory. Attached to the far corner of the lateral gable with its curved outline and big rounded windows is another high-gabled building. At the corner of the arsenal and in line with the façade there is a small guardhouse with a sentry box and guardsmen in front of it. There is a second sentry box on the other side. Out of the gate one of the big guns is being drawn by six horses, and another piece of ordnance, drawn by six horses commanded by an officer on horseback, is being moved along the open trench of a rivulet called the Fischbach, which runs through town. Small groups of strollers and on-lookers, including dogs and children, complete the scene.

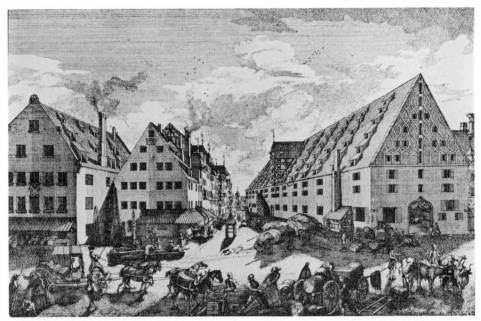

The Customs House and Depository of Goods, commonly called the Big Scale House. Here we see the Hallplatz with the Mauthalle, ("customs house"), opposite a pleasant group of houses, the latter much changed today. The view is from a house in the Königstrasse. Three ponderous gables dominate the scene while in a deep perspective between the group of houses on the left and the massive customs house on the right we have distant view of the Spittlertorturm in the very rear. Today's customs house, rebuilt, and housing a row of shops on its ground floor, cannot vie with the beauty of the original building seen here, so solid in its form, with but one festive portal as opening. The enormous gable, behind which stretches the roof space with its six stories, has a vertical series of cargo hatches in the center, and lateral triangles on its sides, decorated by large twisting bands. A half-timbered cross structure, which facilitates the hoisting of goods to the central section of the floors under the roof, rises in the middle of the long side. In addition, a stairway in half-timber, serving the lower floors, is attached to the building. In spite of the wide perspective, the pictorial space appears closed in, an effect produced by the crowding of the immediate foreground with wagons, horses, and cattle, which stand darkly silhouetted against the evening sun. The shadows help further to narrow the wide opening of the Hallplatz.

do justice to Nuremberg's medieval character. In answer to this it should be stated emphatically that in his *oeuvre* of 114 Nurembergian views—including those of estates and sites outside the city—he proved again and again his unusual ability to depict truthfully the medieval character of the city without denying himself a lively baroque interpretation through skillful handling of perspective and space, through dramatic use of light and shadow, and, finally, through the contemporary Nurembergian life with which he filled his streets and squares.

Delsenbach's views of Nuremberg were not the only ones produced in that city. Preceding him was Johann Andreas Graff (1637–1701), who had executed a series of them mostly in collaboration with the engraver Johann Ulrich Kraus. Theodor Hampe called Graff's drawings "mit Sorgfalt, aber offenbar ziemlich schwunglos ausgeführt" (executed with care, but obviously in a fairly dull manner), a judgment which clearly indicates their inferiority to Delsenbach's views.

NOTES ON THE CONTRIBUTORS

LEONARD FORSTER was born in 1913 in London, England, and took his undergraduate work at Cambridge University. He then studied in Leipzig, Königsberg, and Bonn, and received his doctorate in Basel with a dissertation on Georg Rudolf Weckherlin. After military service during World War II he taught at Cambridge, then at the University of London, and since 1961 again at Cambridge as Schröder Professor of German. In 1967–1968 he was visiting professor at McGill University, Montreal, and, later in that academic year, held the de Carle Lectureship at the University of Otago, New Zealand. He is a member of the Maatschappij der Nederlandse Letterkunde and of the Deutsche Akademie für Sprache und Dichtung. One of the most widely known German scholars in the English-speaking world, Professor Forster was in 1970 elected president of the Internationale Vereinigung für Germanische Sprach- und Literaturwissenschaft.

His publications include an edition of the poems of Conrad Celtis, the *Penguin Book of German Verse*; the edition of Lipsius's *De Constantia* in the German translation by Viritius; *The Temper of Seventeenth-Century German Literature*; *Janus Gruter's English Years*; *The Icy Fire: Five Studies in European Petrarchism*; and *The Poet's Tongues: Multilingualism in Literature*. In addition to publishing many articles in scholarly journals, Leonard Forster is the editor of *German Life and Letters*.

BLAKE LEE SPAHR, born in 1924 in Carlisle, Pennsylvania, attended Dickinson College and Yale University. He received his Ph.D. at Yale

with a dissertation on Sigmund von Birken. He is one of a small but distinguished group in whom the late Professor Carl von Faber du Faur inculcated a love of German baroque literature

Since 1955 Professor Spahr has been teaching at the University of California at Berkeley, with time out for research and a year as guest professor in Geneva. Besides a considerable number of articles in learned journals, Spahr has two books to his credit: *Archives of the Pegnesischer Blumenorden*, 1960; and *Anton Ulrich and Aramena*, 1966. He is, incidentally, the only member of the Pegnesischer Blumenorden in the Americas.

JOHN D. LINDBERG, born in 1922 in Vienna, received his academic training at the University of California at Los Angeles. After obtaining his Ph.D., in 1964, he taught at Pomona College, University of California at Irvine, and is at present chairman of the department of foreign languages at the University of Nevada, Las Vegas. He has held various offices in regional and national professional organizations, is the editor of *Nachdrucke deutscher Literatur des 17. Jahrhunderts* and chairman of the executive committee of the editorial board of the *Internationale Bibliographie der deutschen Barockliteratur*. He is coeditor of *Colloquia Germanica* and of *Daphnis: Zeitschrift für mittlere deutsche Literatur*. His most ambitious undertaking to date is the critical edition of the works of Christian Weise, whose *oeuvre* runs to some twenty volumes; so far vols. I and III have appeared.

HANS-HEINZ DRAEGER (1909–1968) was born in Stralsund, Germany. He studied musicology, art history, and philosophy at the University of Berlin, where he received his doctorate in 1937. When World War II broke out he was acting director of the Berlin Museum of Musical Instruments. After 1945 he taught in several German universities and was connected with RIAS, the U.S. radio station in Berlin. During the academic year 1955–1956 he was Fulbright Exchange Professor at Stanford University. In 1961 he was called to The University of Texas at Austin as guest professor of musicology and in 1962 he became professor of music. He is the author of many articles, some rather extensive, in *Die*

Musik in Geschichte und Gegenwart; he contributed to various journals and Festschriften, and he spoke frequently at meetings of musicologists. He died on November 9, 1968.

Justus Bier was born in 1899 in Nuremberg, and studied in Munich, Erlangen, Jena, Bonn, and Zurich. After receiving his doctorate in Zurich, he taught in his home town, and from 1937 to 1960 at the University of Louisville, in Kentucky. He was associated with the Institute for Advanced Study at Princeton and has held two Guggenheim fellowships and a Fulbright award. As visiting professor he taught at the Free University in Berlin, at the University of Southern California, and at the University of Würzburg. From 1961 to 1969 Dr. Bier was director of the North Carolina Museum of Art at Raleigh. At present he is the museum's director emeritus and curator of research. At Duke University, which conferred on him the honorary degree of Doctor of Fine Arts, he is adjunct professor of Art History. He wrote the monumental work *Tilmann Riemenschneider*, two volumes, with a third one to follow; his *Tilmann Riemenschneider, ein Gedenkbuch* has run to six editions. He is also the author of a book on the city plan of Nuremberg and of one on the architect Ernst Schweizer.

In place of the illustrated lecture on baroque Würzburg which Dr. Bier presented at the Symposium, he has written for this volume on Johann Adam Delsenbach, an artist whose work he previously interpreted in *Delsenbachs Nürnberger Ansichten*, Munich, 1924.

INDEX

Aaron, Pietro: 140
Abert, Anna Amalie: 125, 126
Abraham a Sancta Clara: 76, 78 n.
Abschatz, Hans Aßmann, Freiherr von: 72 n.
accentuation, doctrine of: 14
actors: itinerant English, 120
Albert, Heinrich: 139
Alexandrines: Opitz's reform in, 13; authors of, before 1624, 13, 15; exchange of, by Opitz and Buchner, 14; Coler published, in 1628, 15; broadsheet of 1625 almost in Opitzian, 16; frequent appearance of, in broadsheets, 17, 19; on battle of Breitenfeld, 18 n., 19; by Gloger and Fleming, 19; sonnets in, 20, 25 (French), 28; not as Palatinate propaganda for Winter King, 21; on Dutch model, 22; *hollandsche maet* as, 23–24; acceptance and use of, in Dutch, 25; in Holland and Germany by 1607, 27; examples of German (in Holland), in 1605, 28; couplets in, in French, 29, in German, 31, 32, 33, in Dutch, 33; rendering of, by *vers commun*, 31 n.; public acquainted with, before Opitz, 35; pre-Opitzian, 37; and mirror structure, 83
Alsace: 35
Amsterdam: Rijksprentenkabinet holds *Arbor Religionis* in, 25; three Reformed broadsheets by Antoine Lancel issued in, 28; parallel in, to Antwerp in publication of broadsheets, 34; pamphlets issued in, by Reformed German-writing authors, 35
Angelus Silesius: 70 n., 71, 77, 84

Anton Florian, Prince of Liechtenstein: 149
Anton Ulrich, Duke of Braunschweig: as founder of Braunschweig opera, 98; vain expectation of, of profit, 98; mentioned, 99, 100 n.
Antwerp: as home of Wierix brothers, 22; relations of, with Cologne, 23; publishing in, and Amsterdam, 25, 34
apocope: 26, 32
Arbor Religious: as allegorical print, 23; text of, 24–25
aria: Italian, in German libretti, 101; eighteenth-century, 130, 138
arioso: 130
Aristotle: 121
Arminiaensche Slange. SEE *Clare Afbeeldinghe*
Arminians: 32
Arndt, Johann: 76, 78
Ars Magna Lucis et Umbrae (Kircher): 69
Augustus, Duke of Sachse-Weissenfels: 105
August Wilhelm, Duke of Braunschweig: 99
Auserlesene Gedichte deutscher Poeten (Zincgref): 13

Bach, Philipp Emanuel: 137
Bach, Johann Sebastian: emphasis and styles of, 127, 130; and use of canon for sign or symbol, 132; St. John Passion of, 133; mannerism in works of, 133–136; St. Matthew Passion of, 135; Cantata No. 4 of, 135 n.; Mattheson et al., on, 136–137, 142; neglect of,

Ulm, Stadtbibliothek: 26
unities: dramatic, 120, 122

vedutisti, Italian: 147, 148
Velten, Magister Johannes: 102, 103, 120
Venice: 92 n., 110, 147
verbal symbol: music as, 133
verse ictus: accentuation, 14; mentioned, 13
vers commun: 20, 21, 23, 26, 29, 30, 31, 34, 35
Versailles: hall of mirrors at, 80
Vervins, treaty of: 26
Vienna: 92 n., 107, 148, 149
Viennese classical music: 141
villanelle: 20
"Violieren, De": 22
Vitellius, Regnerus: 28 n.
Vooys, C.G.N. de: 24

Wagner, Richard: 128, 141
Waniek, Gustav: 90 n., 106, 107
Weckherlin, Georg Rudolf: epitaph by, on Obentraut, 15; mentioned, 31, 35, 37
Weise, Christian: as clever but uninspired dramatist, 113; as proliferous dramatist, 114; play *Masaniello* by, 116–117; compared to Feind's libretto on the same subject, 117–118.

Weiße, Christian Felix: 90 n.
Weissenfels: 91, 105, 106, 107
Werder, Dietrich von dem: 13
Werner, Arno: 105 n., 106
White Mountain, battle of the: and broadsheets, 21
Wich, Cyrill von: 95
Wierix brothers: 22, 31
Will, Georg Andreas: 149
Winckel van den grooten Hooghe-Priester van Roomen, De (broadsheet): 27
Winter King. SEE Frederick V.
Witkowski, Georg: 36, 68 n.
Wittenberg: Buchner in, 14; Delsenbach in, 148
Wolfenbüttel: 25, 89 n., 99, 101, 110
Wolff, Hellmuth Christian: 89 n., 96 n., 97
Wolgemut, Michel: 150
word stress: and Opitz's reform, 13
Wriezen: 35, 64
Württemberg: 108

Xanten, treaty of: 36

Zauberflöte, Die: Schikaneder's, mentioned, 90 n.
Zeeland: Delsenbach in, 149
Zelter, Carl Friedrich: 137
Zesen, Philipp von: 83
Zincgref, Julius Wilhelm: 13, 17, 21 n.